THE MAGIC OF LINES II

Line Illustrations By Global Artists

Kuang Chu

CYPI PRESS

This Time, We Want More Lines

In October 2014, the book *The Magic of Lines* was published by CYPI Press. Before that, I spent two years researching the art of lines with the broadest vision possible, searching tirelessly for artists all around the world who take lines as their main approach of creative art. I persuaded them to provide their works, so that I could put together a comprehensive book containing up to 200 artworks from 25 artists, all of whom are highly regarded in their fields.

Given all these pieces of art provided by the participants and the great work of CYPI's editors, it's no surprise that the result of these efforts is an excellent product. Seeing that the book was well received by both the market and critics, CYPI and I decided to embark on another journey. In March 2015, a *Magic of Lines* "sequel" received its green light.

During the process of writing and collecting the artworks, a question was raised that wasn't easy to answer: What is the Art of Lines? As we know, almost all visual arts consist of dots, lines and planes, what do I want to pursue with the term "line art"?

Although wrestling with different concepts is often a trek in futility, I gave it a shot. Firstly, I chose artworks in which the lines play an outstanding, self-contained role. You can find examples in some fine pencil drawings, in which myriad lines were rendered on the paper only to merge into a big plane. I prefer the lines highly visible, though in some works they are highly organized to convey a plane, but the orderliness can be intoxicating; and in some other works, the lines are growing and roaming at large on the paper, often appearing to the eye as more than just storytelling images.

Secondly, I took pains to choose the most complex artworks. Although a single dancing line can be graceful — and more often than not giving a "highbrow" feel, such as in the case of Chinese calligraphy — I prefer a plethora of lines.

Thirdly, I wanted artworks that meshed with modern times, so I excluded a vast quantity of fine brush paintings and pen drawings of a traditional feel. Another thing I want to tell the readers of this second

book is I tended to chose a whole new array of artists who were not showcased in my first book, but with one exception. DZO Olivier, a good friend of mine who has been featured in my first book, wrote to me while I'm editing the second one, and provided his new works voluntarily. Since the publication of *The Magic of Lines*, DZO's works, which were already excellent, have made great progress. That improvement is what the second book wants to show.

Last, but not the least important, I'd like to say something about myself. When I was 18, a doctor diagnosed that I had red-green color blindness, which meant that I would not be accepted by any art school. But the aura of art was never far away from me. After the doctor's diagnosis, I began teaching myself how to draw, knowing that I wouldn't be able to study it at an art school. In 2011, I was tired of being an "amateur artist", so I quit my job to focus full time on art. Without the background of art school, I chose the most simple and direct approach — drawing lines on paper. Even without knowing the difference between acrylics and oil, and the dexterity on canvas-stretching, I was still able to convey all those uncanny images in my mind by simply drawing lines.

In this book, I took the liberty of choosing several of my own artworks. This doesn't mean that my pieces are comparable to the first-rate works of our time. What I want to share is the simple powerfulness of lines, and how it can affect one's life.

Kuang Chu

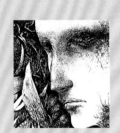
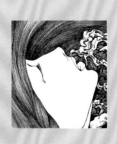

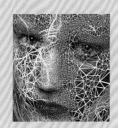
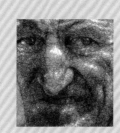

DZO OLIVIER

Nationality: France
behance.net/dzo
facebook.com/dzoartwork

DZO Olivier is a French graphic designer and artist. "I am a paradox! Introverted, unable to appear in public, but with a strong desire to share some creativity!" says DZO. "I'm lucky to be born in an environment conducive to creativity."

"Today, I draw and I think. This introspection assisted by drawing made me discover amazing possibilities. After some time, this work attracts other people in the same state of mind, open and extremely conscious. A beautiful reward of life."

Q: Why did you choose lines as the expressional tools for your artworks?

A: It's not a choice. I'm naturally working like this! On second thought, I think my mother has influenced me.
Then I like the simplicity of black and white. A black pen, any support and breathing is enough to become creative. I like the power of simplicity.

Q: Where do your inspirations come from? Can you tell us about some of your favorite artists?

A: Inspiration comes from nature. Everything is beautiful when you observe nature.
I also studied human unconsciousness. I think design is a kind of active and instinctive meditation at the same time. Part of the inspiration comes from within.
I don't really have favorite artists. For cons, I am very sensitive to Asian artists, traditional or modern, and ethnic arts. Gaia, Goddess of Earth, is the only real artistic source.

Q: Could you give us some tips on how to draw beautiful lines? Does it take much practice and patience?

A: Breathing is important to drawing fine lines. Concentrate, breathe and let go.
Naturally, the more you practice, the more beautiful the lines are!

Q: How would you describe your works to the gallery, client, or potential buyers? How well do you think line art performs in the market, such as in galleries, and in the illustration market?

A: Line art is an emerging art. The galleries don't need to ask whether this art is a good investment or not. It is a form of very careful art, applied, technical and often very thoughtful. The market does not correspond to this art as it is a voluntary choice going against the flow. You have to be passionate to engage in this artistic practice. Therefore, the galleries will not find a new source of financial product but a real talented artist's nest. Today we do nothing by hand. Everything is computer-assisted. The line artists working with their hands are the guardians of a higher human capacity that computers will never have: the sensitivity and imagination. Their work is valuable because it is unique and inimitable. Each line is a ferment of life that contains part of the soul of the artist. This is our value.

1 **Into the Fog**
Size: 300mm × 420mm
Media/Materials: inkpen and pencil on paper
Creative Purpose: cover art for "Stonebirds" album

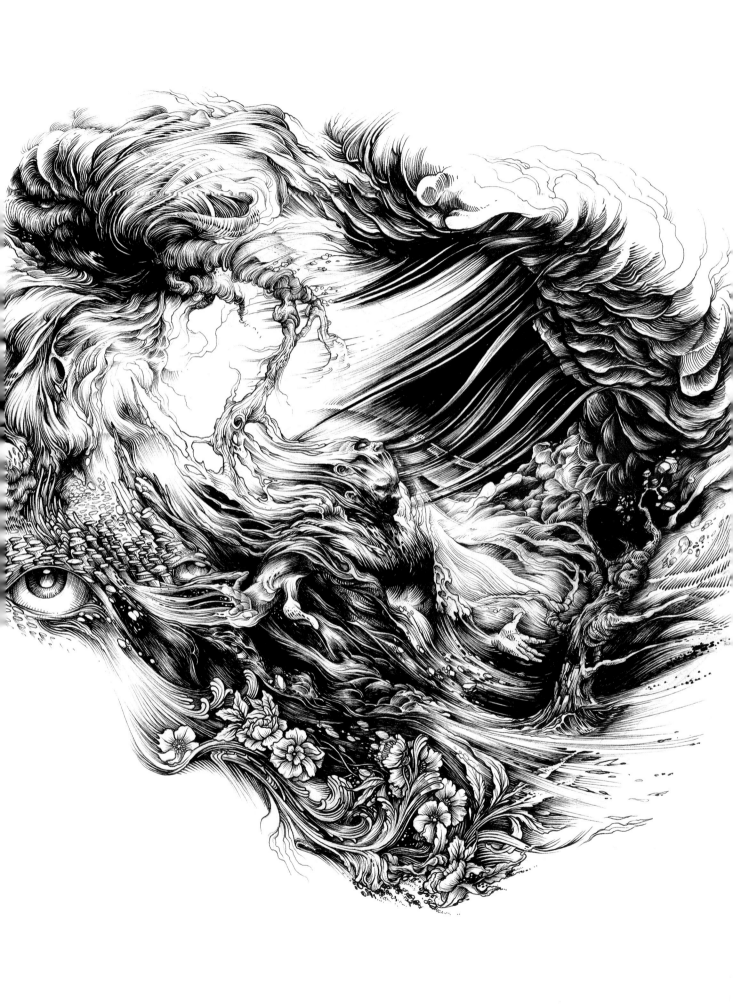

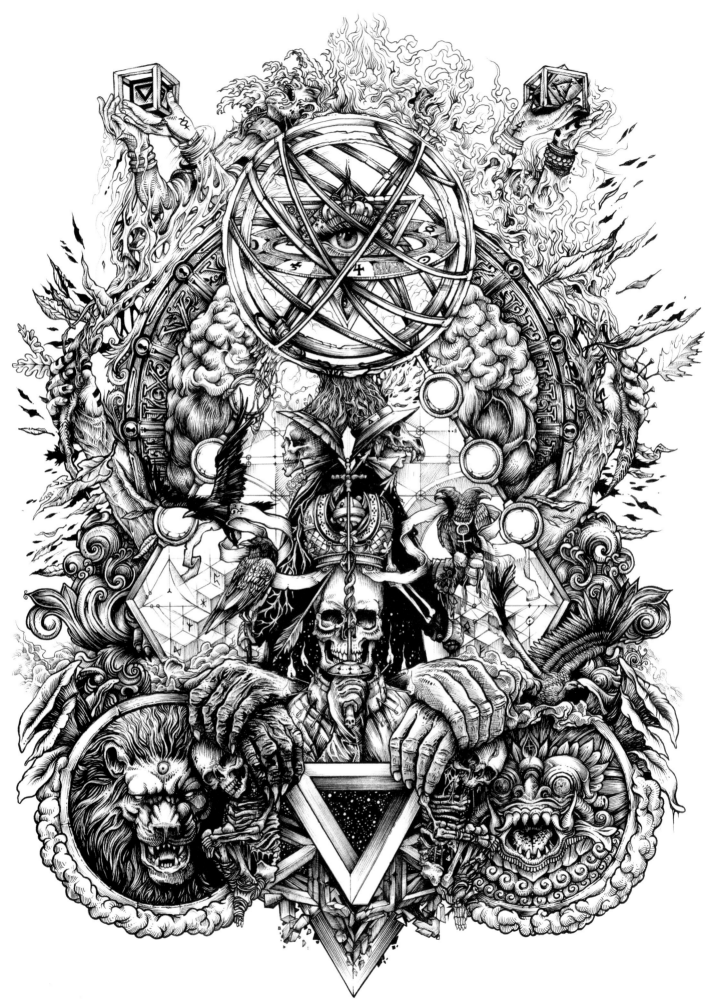

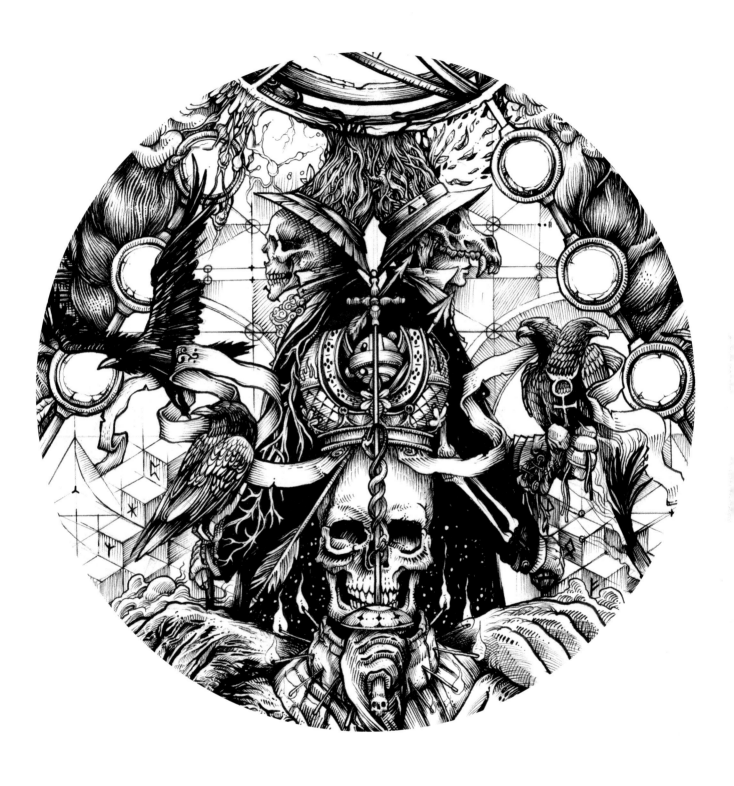

1 **Metachronos**
Size: 300mm × 420mm
Media/Materials: inkpen and pencil on paper
Creative Purpose: personal

2 **Metachronos (detail)**

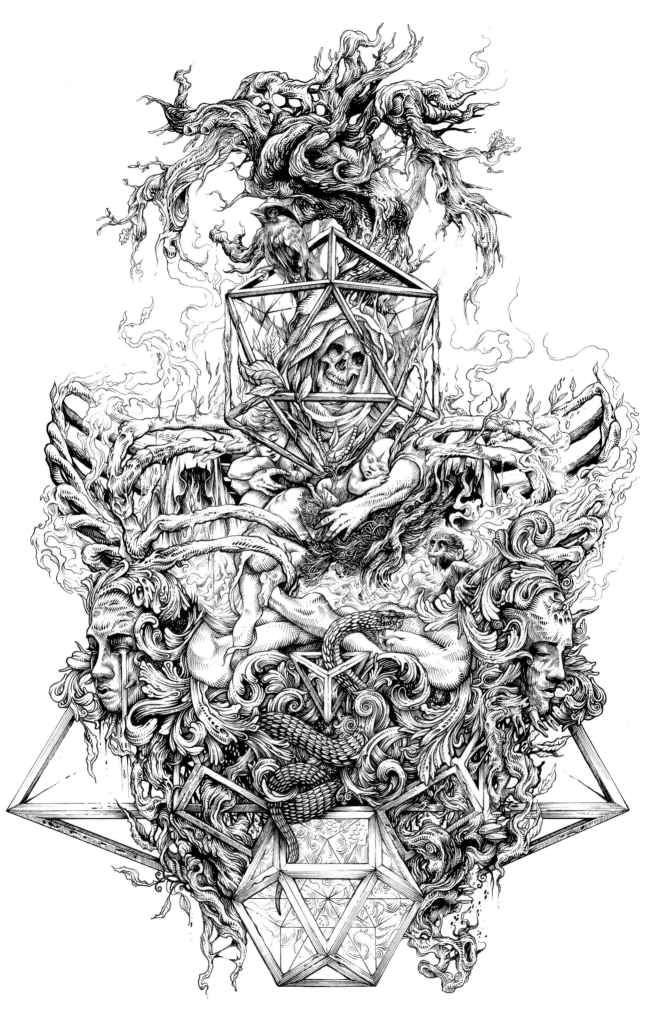

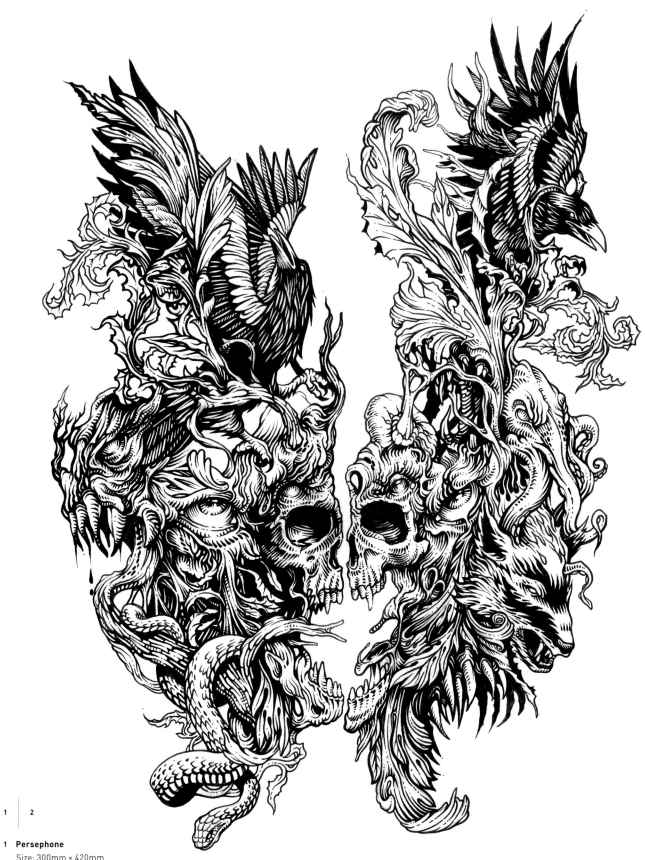

1 Persephone
 Size: 300mm × 420mm
 Media/Materials: inkpen and pencil on paper
 Creative Purpose: cover art "Adam Crossman" album

2 Chtulu Tattoo
 Size: the size of a woman's forearm
 Media/Materials: inkpen and pencil on paper
 Creative Purpose: tattoo

KUANG CHU

Nationality: China

A proficient storyteller, artist and writer based in Beijing, Kuang Chu graduated with a bachelor's degree in engineering, and had a long career as a reporter. In 2011, Kuang Chu quit his job and dedicated all of his time to making dark, quaint images in his head visible to other people. In each piece of his "Red Balloon" series, a young girl faces something odd, which apparently possesses some power of mystery, darkness and evil. There is always a red balloon in her hand or tied on her braid. The balloon gives off a feeling of hope and brightness, which balances with the darkness and evilness of the strange things.

Q: **Why did you choose lines as the expressional tools for your artworks?**

A: Because I have never studied in any art school, I have no knowledge in the material side of arts. Therefore it's natural for me to choose the simplest tools — needle pens and lines to create my own art.

Q: **Where do your inspirations come from? Can you tell us about some of your favorite artists?**

A: I just draw what I like, say, girls or animals. The girl on my paper is both my sex object and a mirror image of me at the same time. The feeling of each work comes from my view about life: "darkness" and "brightness" are the two aspects of human nature and life itself. One must face and grow up with the companion of both of them. On the question of which artist I like the most, I will pick James Jean and Gary Baseman.

Q: **Could you give us some tips on how to draw beautiful lines? Does it need much practice and patience?**

A: Just draw and draw and draw. Besides that, I think some chiaroscuro skill would be very helpful, because though the lines have their own mojo, some photographic black-and-white rendering would enhance the shock power of your artworks greatly.

Q: **How would you describe your works to the gallery, client, or potential buyers? How well do you think line art performs in the market, such as in galleries, and in the illustration market?**

A: In China, an item in the art market is always described by its material, such as traditional Chinese brush painting, oil painting, water color, and so on. Therefore, I will tell people I'm making "hard pen drawing." My works are not mainstream in both the illustration and fine art markets, but they perform OK in both of them. On the term of "art school," I think I belong to "pop surrealism." In China, my works are not accepted as good-selling items, but have been recognized as something cutting edge, I think that's better than many banal mainstreamers.

1 **Red Balloon: The Swing**
Size: 600mm × 800mm
Media/Materials: ink on paper
Creative Purpose: fine art

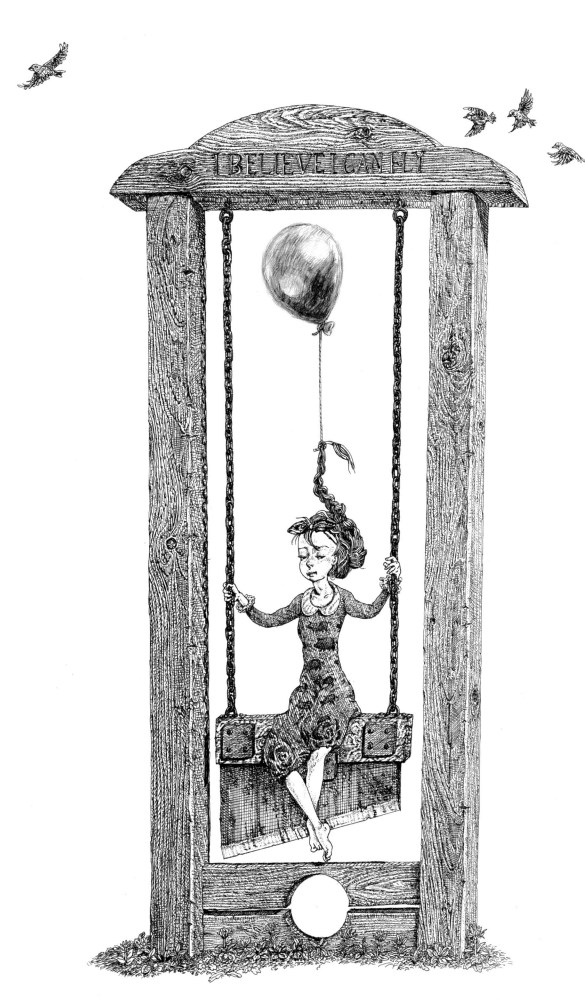

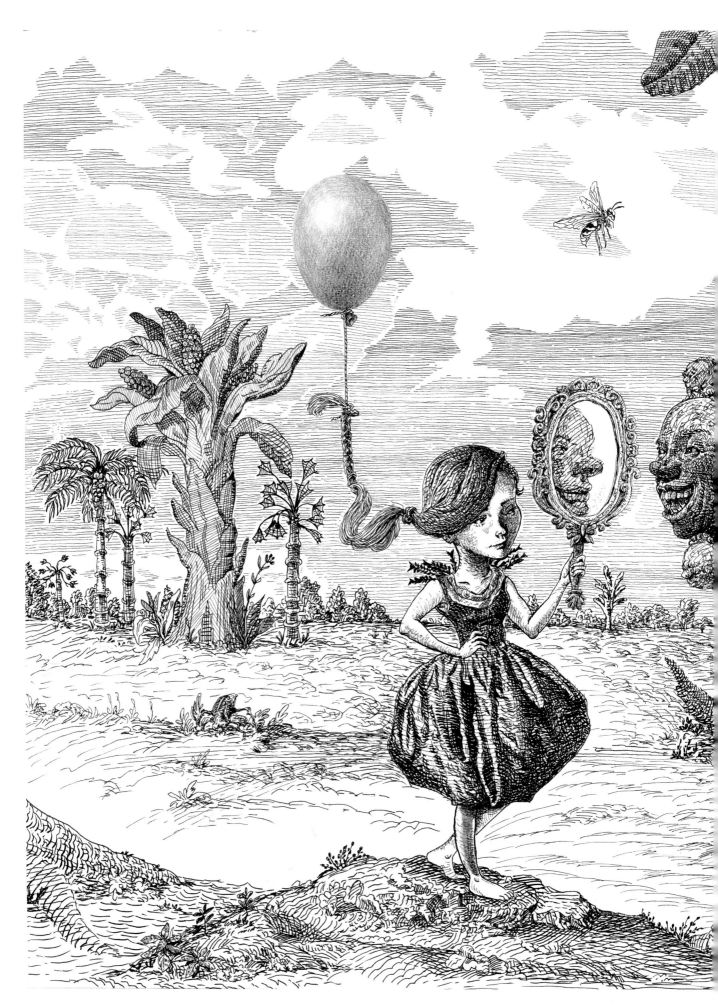

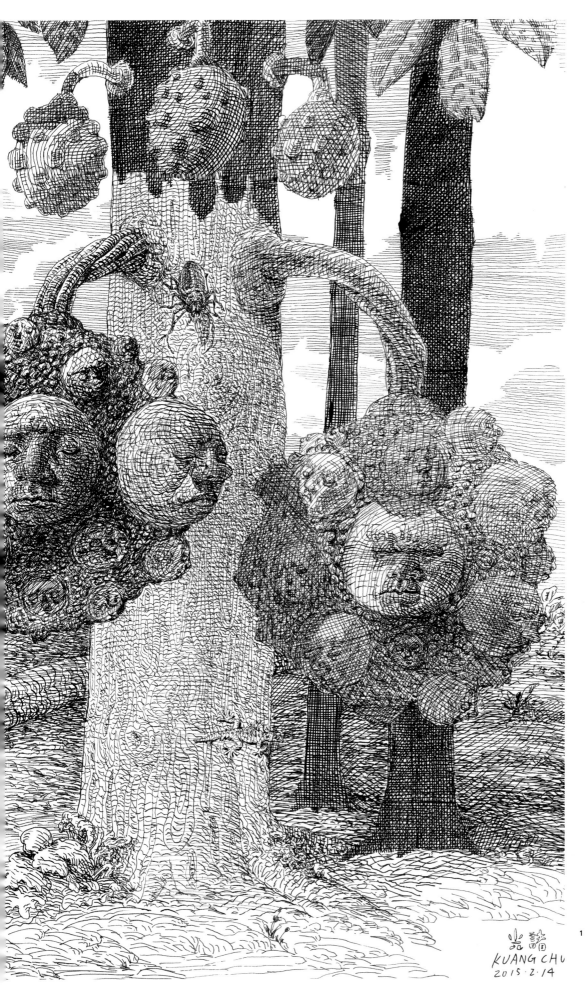

1 Red Balloon: Fruit of Faces
Size: 800mm × 600mm
Media/Materials: ink on paper
Creative Purpose: fine art

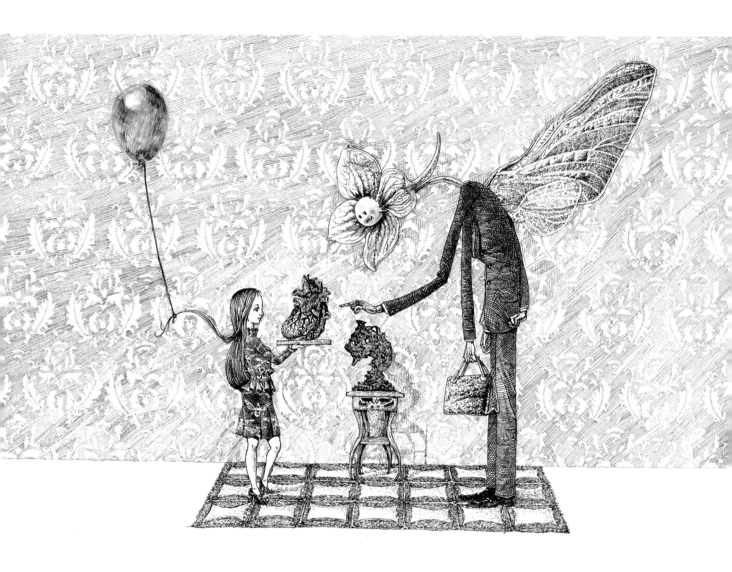

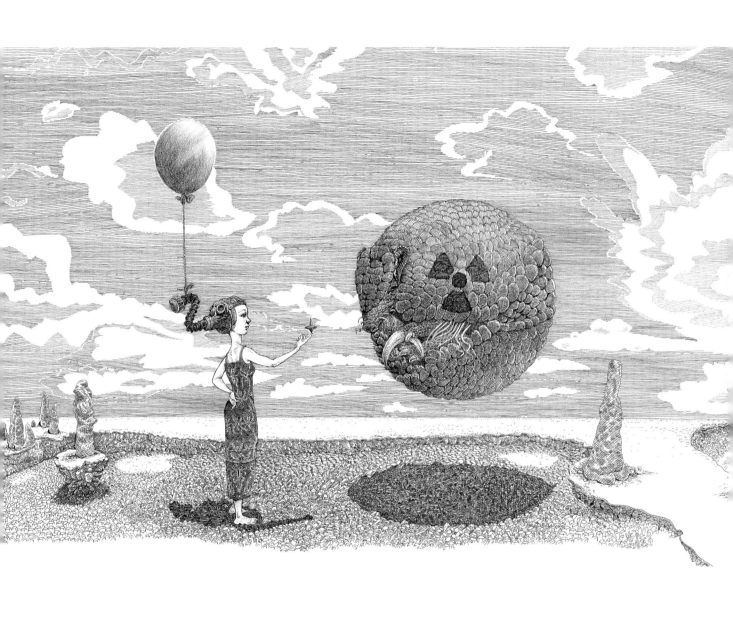

1 | 2

1 Red Balloon: Heart Connoisseur
Size: 800mm × 600mm
Media/Materials: ink on paper
Creative Purpose: fine art

2 Red Baloon: Armadillo
Size: 600mm × 800mm
Media/Materials: ink on paper
Creative Purpose: fine art

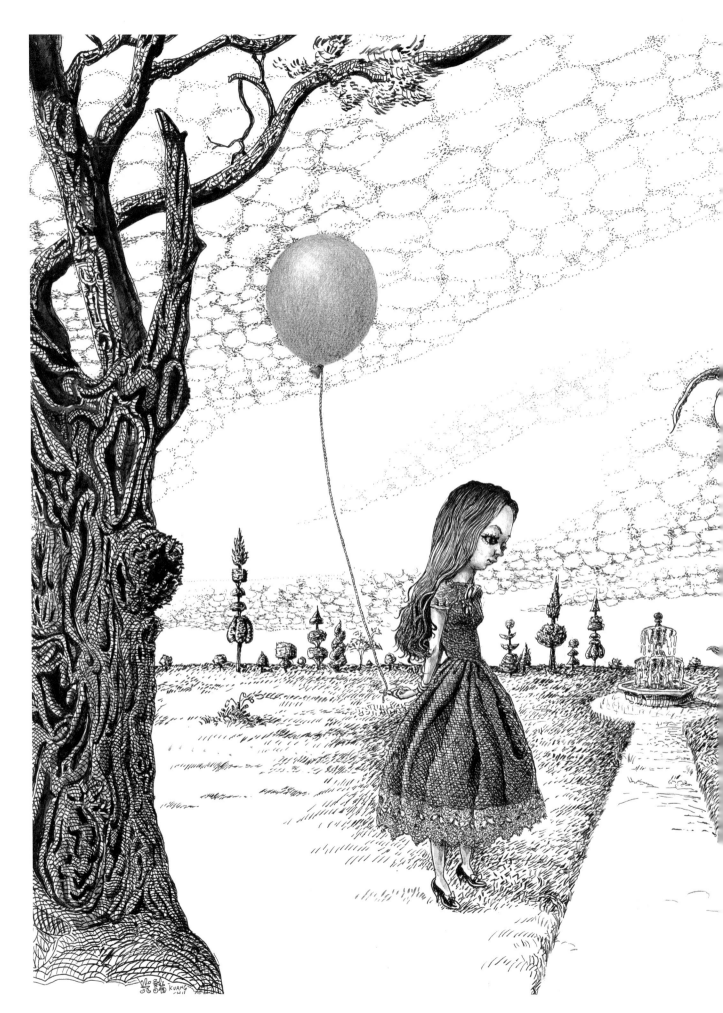

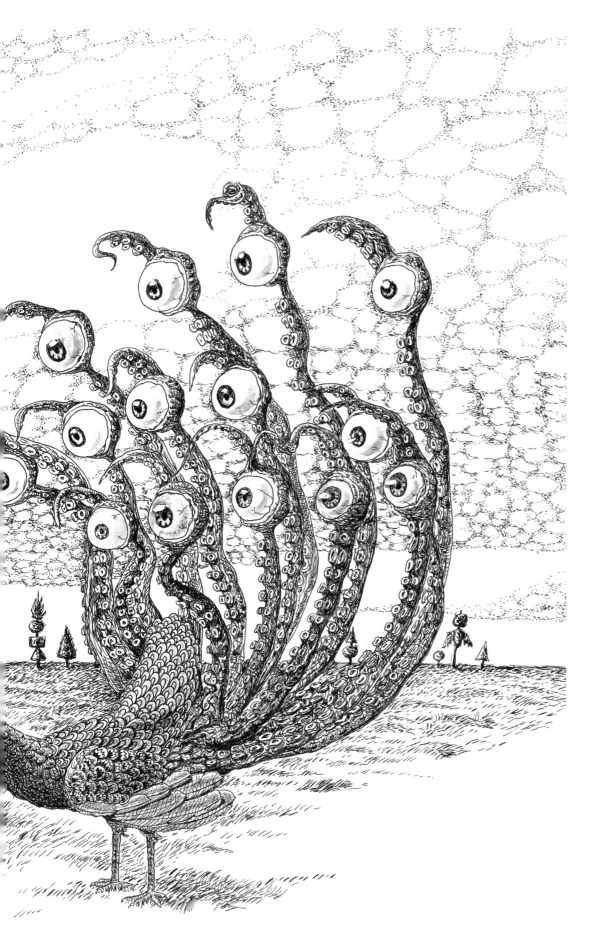

1　**Red Balloon: Peacock Octopus**
Size: 800mm × 600mm
Media/Materials: ink on paper
Creative Purpose: fine art

HUANG
SONGSHENG

Nationality: China
zcool.com.cn/u/1591094

Huang Songsheng, a postgraduate student in China, is on his way to become an illustrator and songwriter.

"I have done nothing but study in schools for 23 years, during which there were both ups and downs. In university, I spent the majority of my time studying, and filled the rest with creative works. What I tag as 'creative' includes drawing, writing, and music composing, through which I can keep free and sober, tranquil while sometimes emotional, and hold the urgent hope of the future in secret."

Q: **Why did you choose lines as the expressional tools for your artworks?**

A: When I reached maturity cognitively and drew with lines for the first time, I felt "this is it." I am a person of quick temper, but drawing lines makes me quiet and patient. I feel a kind of harmony and relaxation, just like being with a good old friend.

Q: **Where do your inspirations come from? Can you tell us about some of your favorite artists?**

A: My inspirations come from every second, all the aspects of life itself. Therefore every time I show a work of mine to a friend, I would talk a lot.
I love Wu Guanzhong, Beibang, Noco Delort and Manabu Ikeda, and many other artists.

Q: **Could you give us some tips on how to draw beautiful lines? Does it take much practice and patience?**

A: I think the criterion on what lines are greatly varies from people to people, but keep practicing is helpful to everyone. Besides hard work, never forget that the beauty you draw from the different lines is the upmost priority, and never let your senses be blunted by your sweat.

Q: **How would you describe your works to the gallery, client, or potential buyers? How well do you think line art performs in the market, such as in galleries, and in the illustration market?**

A: If I was introducing myself to friends whose professional field is not art-related, I would say I'm creating "pen drawings."
Given the style of my drawing, my clients are highly limited. Only those who are certain that my style would fit them could be my partner; thus to them, I don't need to describe what my works look like. I believe in this time of growing tolerance and diversity, the line art would perform better and better in the market. I'm looking forward to a great future!

1 Outlier series: Pervasive Desire and Ram
Size: 270mm × 390mm
Media/Materials: needle pen and fountain pen on paper
Creative Purpose: personal

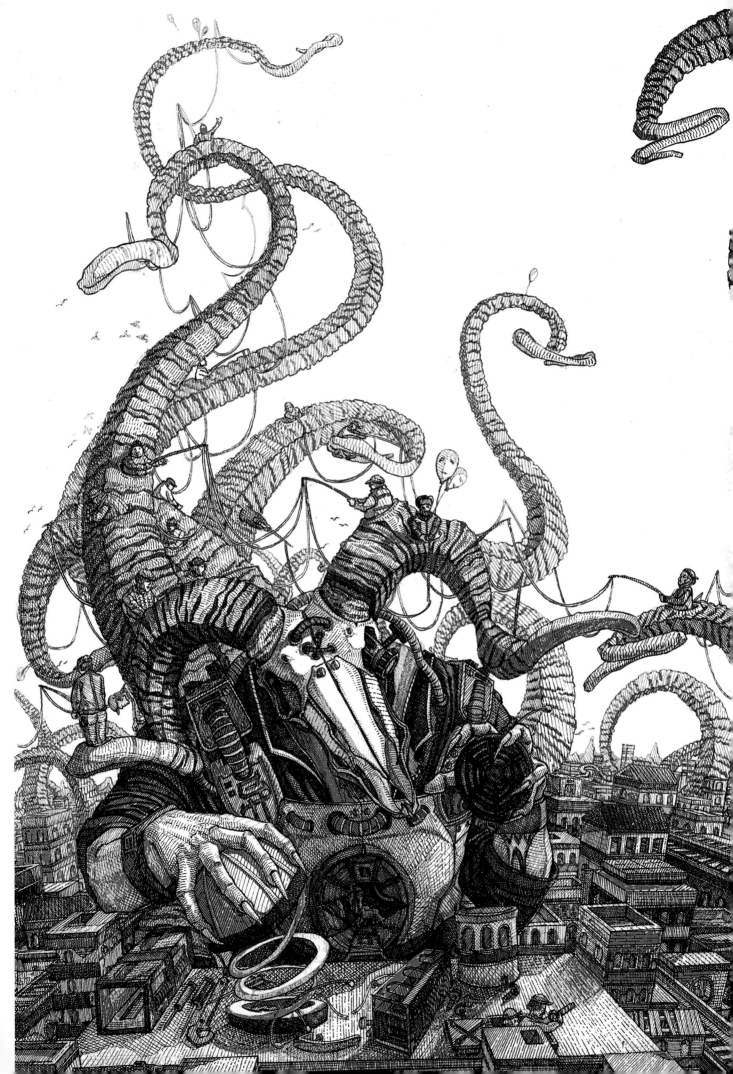

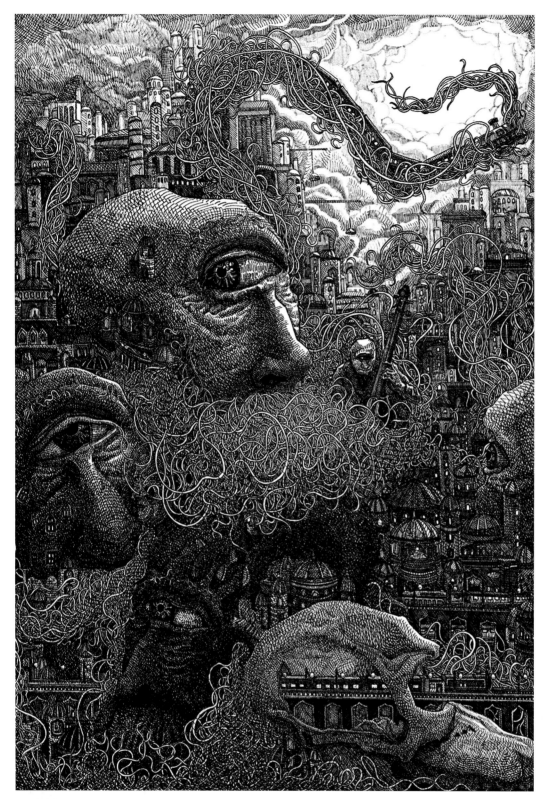

1	3
2	

1 Dream, Insights and Twilight
Size: 270mm × 390mm
Media/Materials: needle pen
and fountain pen on paper
Creative Purpose: personal

**2 Dream, Insights and Twilight
(detail)**

3 Dream and Delight Speaking
Size: 270mm × 390mm
Media/Materials: needle pen
and fountain pen on paper
Creative Purpose: personal

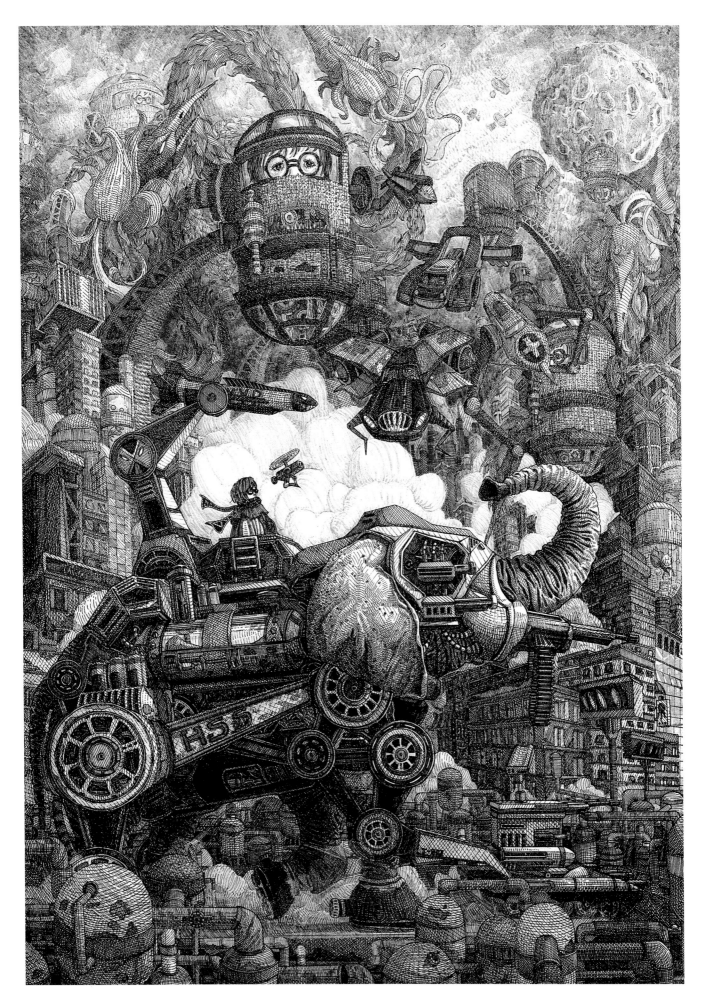

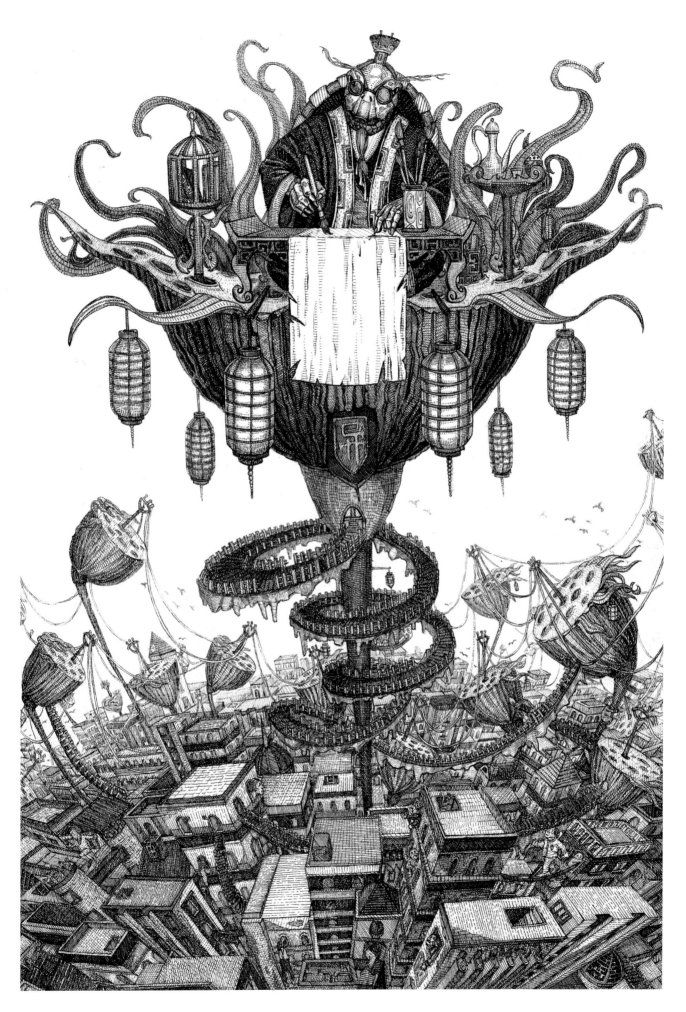

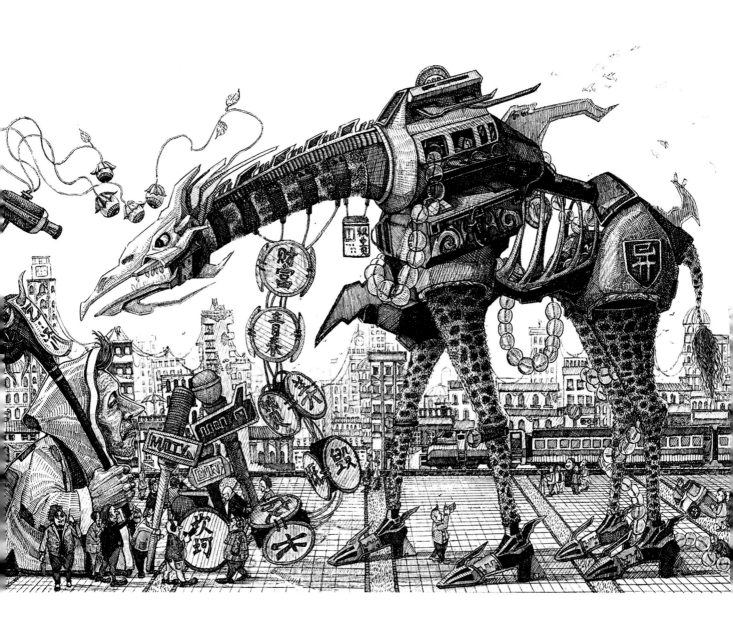

1 Outlier series: Another Life and Mr. Turtle
Size: 270mm × 390mm
Media/Materials: needle pen and fountain pen on paper
Creative Purpose: personal

2 Outlier series: Avarice and Giraffe
Size: 390mm × 270mm
Media/Materials: needle pen and fountain pen on paper
Creative Purpose: personal

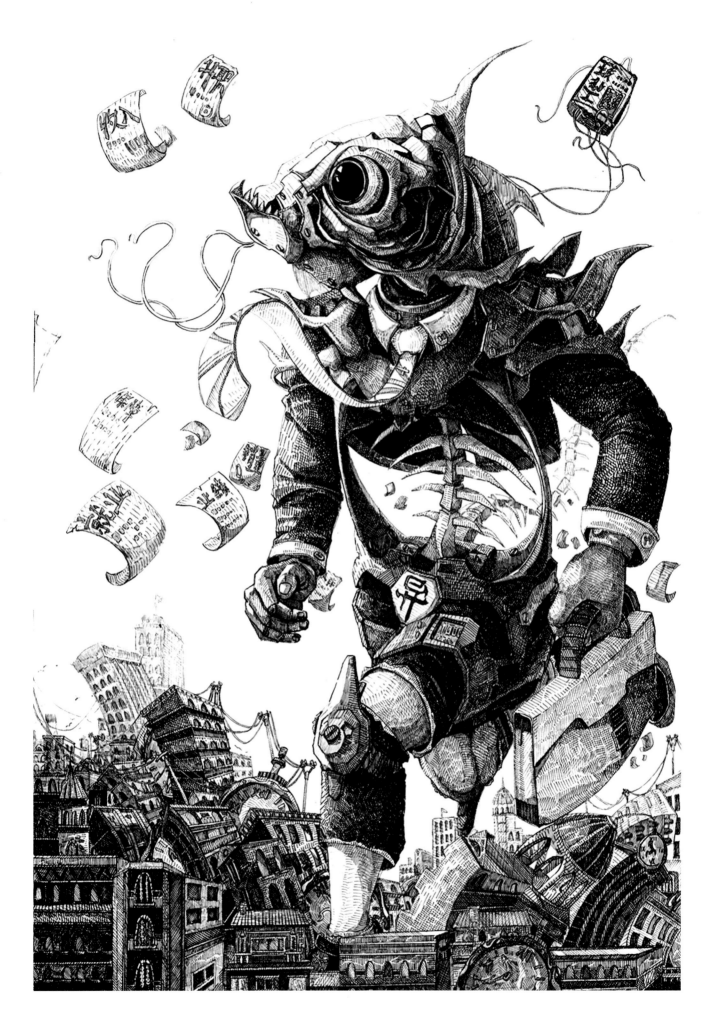

1 **Outlier series: Stiffness and Fish Head**
Size: 270mm × 390mm
Media/Materials: needle pen and fountain pen on paper
Creative Purpose: personal

2 **Outlier series: Rage and Pig Head**
Size: 270mm × 390mm
Media/Materials: needle pen and fountain pen on paper
Creative Purpose: personal

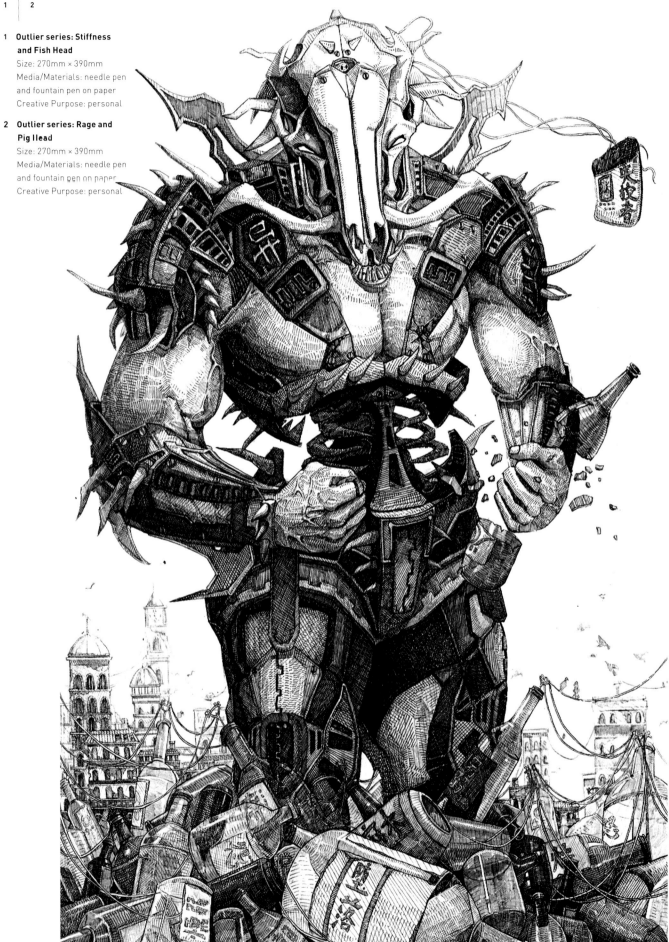

NAO IKUMA

Nationality: Japan
ikumanao.tumblr.com/

Nao Ikuma is a Japanese artist.

"I am searching for an 'ideal density'," she said. "I am also researching copperplate engraving techniques at the same time."

Q: Why did you choose lines as the expressional tools for your artworks?
A: The method of drawing lines allows me to accurately express the images I have in my mind.

Q: Where do your inspirations come from? Can you tell us about some of your favorite artists?
A: I like Rodolphe Bresdin. He was a great French draughtsman and engraver in the 19th century, and the master of Odilon Redon.

Q: Could you give us some tips on how to draw beautiful lines? Does it take much practice and patience?
A: I create copperplate engravings, so the needle that I use is very important.

Q: How would you describe your works to the gallery, client, or potential buyers? How well do you think line art performs in the market, such as in galleries, and in the illustration market?
A: I want my viewers to enjoy the details, so I allow them to hold the works and to see them from up close.
In Japan, I believe that expression using lines is often used in manga.

1 Sanctuary
Size: 210mm × 295mm
Media/Materials: copperplate print, etching
Creative Purpose: personal

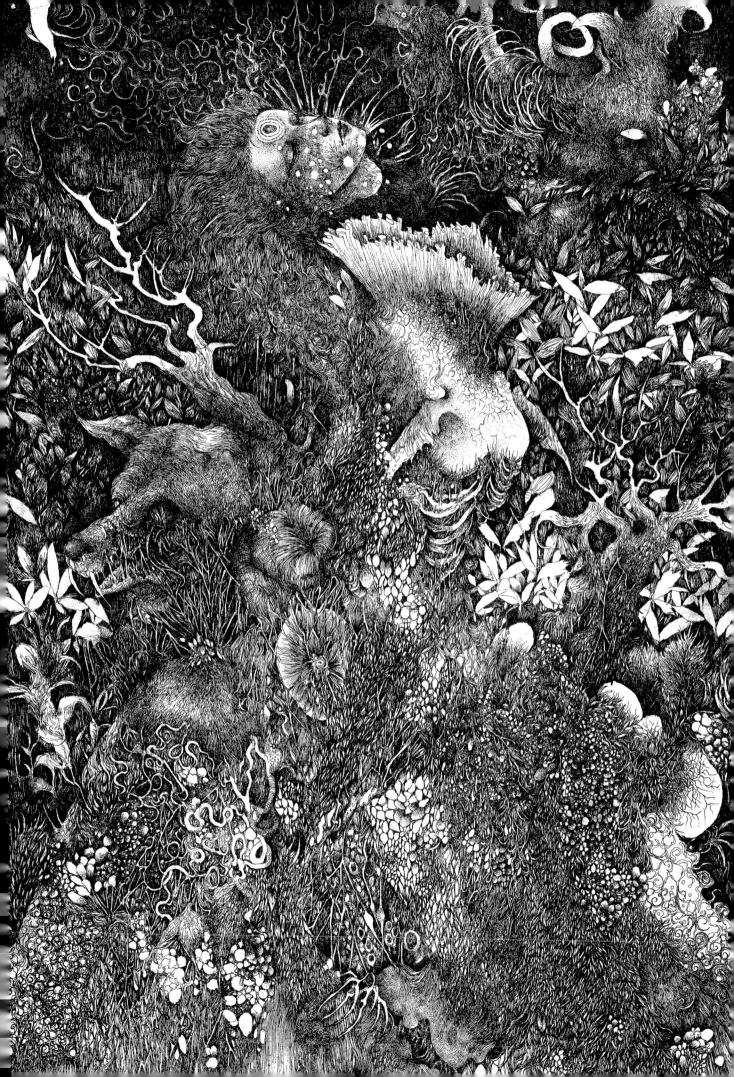

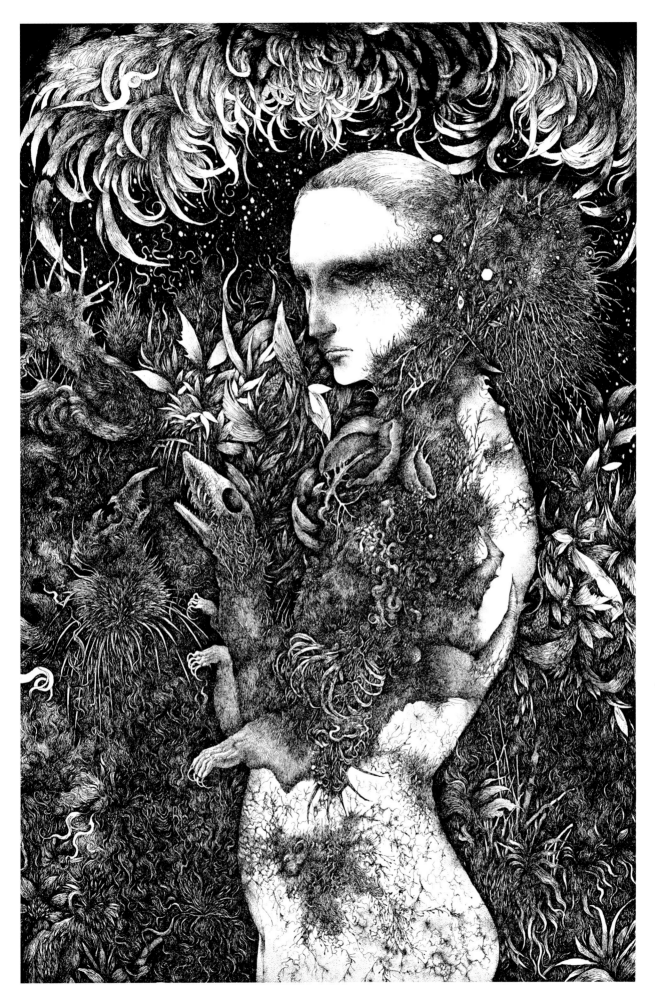

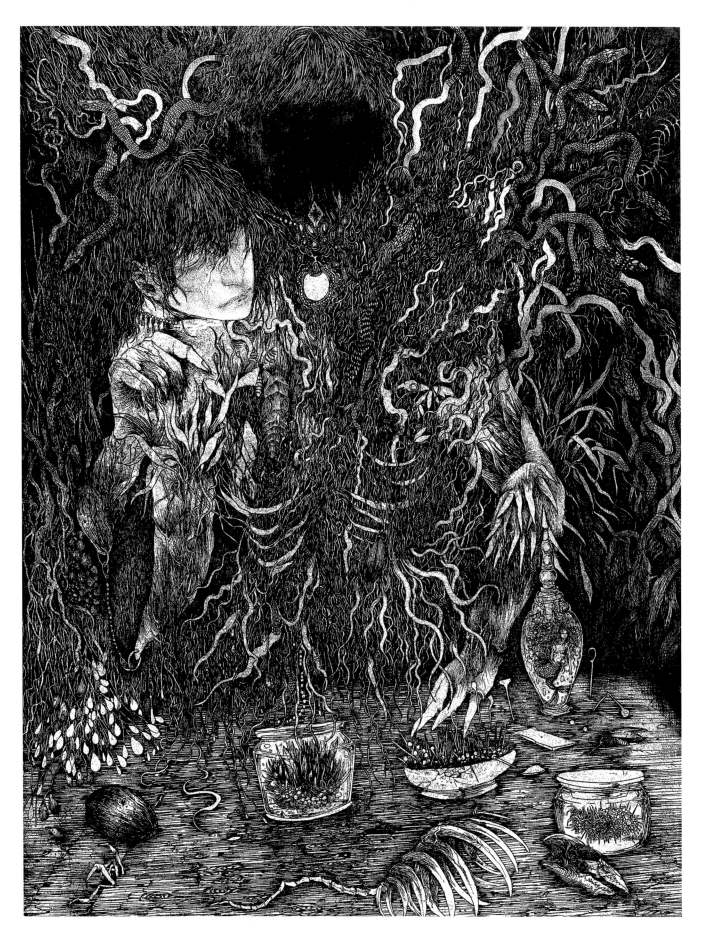

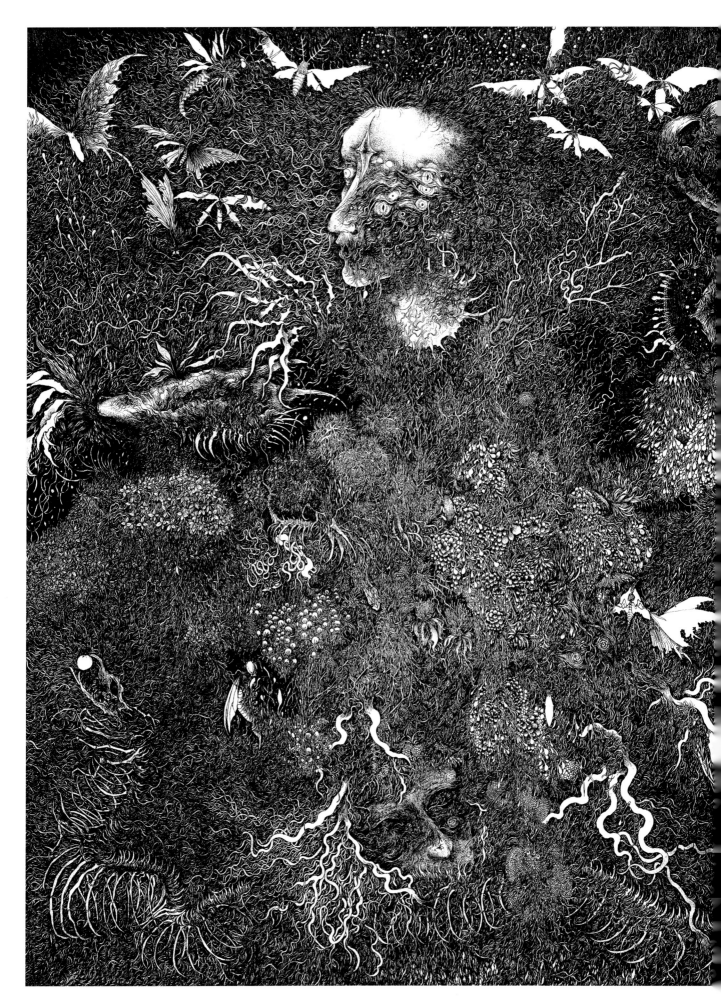

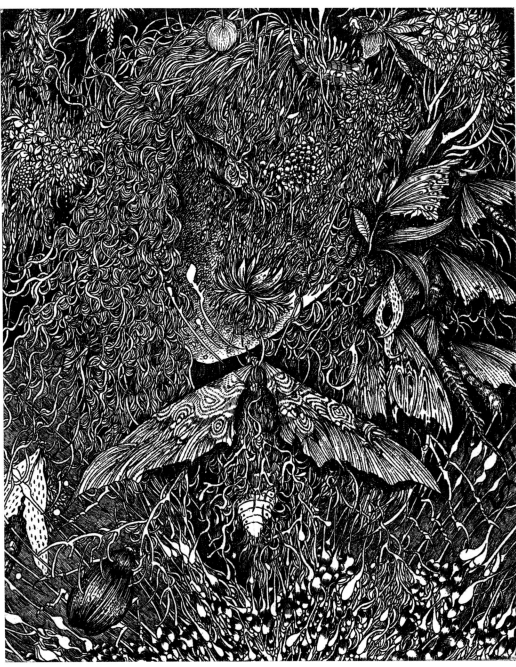

1 | 2

1 Habitat
Size: 300mm × 300mm
Media/Materials: copperplate print, etching
Creative Purpose: personal

2 Woman
Size: 80mm × 100mm
Media/Materials: copperplate print, etching
Creative Purpose: personal

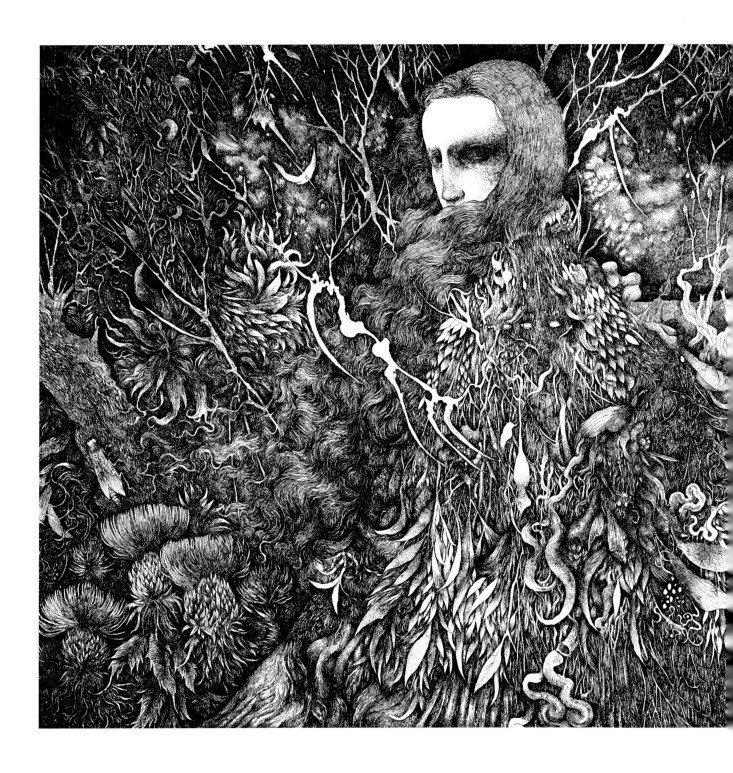

1 Winter
 Size: 450mm × 300mm
 Media/Materials: copperplate print, etching
 Creative Purpose: personal

2 Kuchihusa
 Size: 150mm × 130mm
 Media/Materials: copperplate print, etching
 Creative Purpose: personal

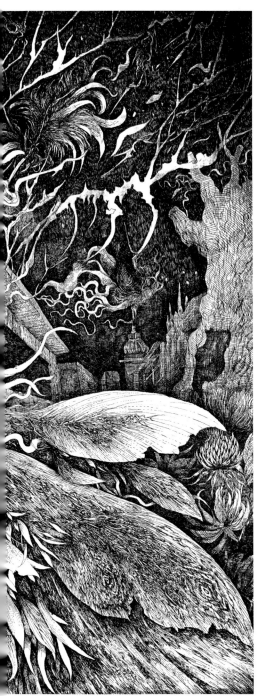

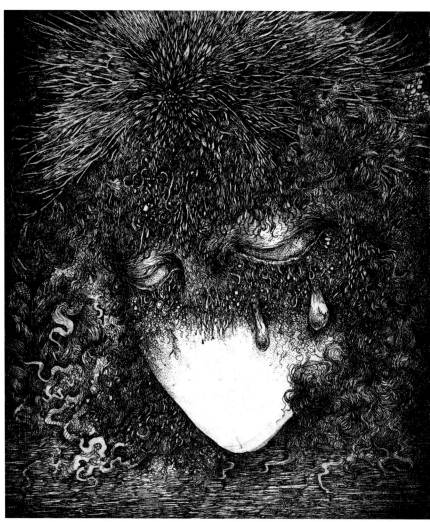

ARTYOM TARASOV
(LEOPARD MOTH)

Nationality: Latvia
leopardmoth.tumblr.com
instagram.com/leopardmoth/
pinterest.com/leopardmoth/

Born in 1991 in Riga, Latvia, Artyom Tarasov (aka Leopard Moth) studied fiber art and is currently studying printmaking at the Latvian Academy of Arts.

"As with many quiet people, my childhood revolved around books, studying illustrations of animals and insects and taking lone walks in nature which developed my curiosity for the unexplained," he said. "Driven by desire for getting to the essence of things, it was only logical that I would become either a scientist or an artist. My works deal with the abstract side of human condition, delving into the world of the subconscious and emerging with images of the unspoken."

Q: **Why did you choose lines as the expressional tools for your artworks?**

A: First of all, I have a fascination with masterful pen work. Line is just one of the various visual elements I explore in my work, but nonetheless one of the most important. Line is very direct, spontaneous, versatile and self-sufficient.

Line is special to me, it is like a living being, one to be respected and taken care of, if you want to unfold its full character. What fascinates me about the process of line drawing is the tension that goes into breaking down the plane of paper, creating a fragile visual balance, sense of space and movement. It's almost like music to me.

Q: **Where do your inspirations come from? Can you tell us about some of your favorite artists?**

A: I am fascinated by things that can't be perceived consciously and grasped by words, by ideas that make your mind turn inside out when you think about them, make you question reality. I get endless inspiration from scientific discoveries and theories, also philosophical discussions, basically anything that sets my mind on a journey. Talks can be the best background noise for drawing, better than music even.

I've always had a special connection to works of H.R. Giger and Zdzislaw Beksinski. But talking about current favorites, lately I feel kinship for artists who use drawing in combination with performance practice like Kevin Townsend and Sougwen Chung.

Q: **Could you give us some tips on how to draw beautiful lines? Does it take much practice and patience?**

A: There is no single recipe for drawing a beautiful line. The key is not rushing with your work, but being mindful of the way ink flows from the pen, letting your line move freely, playing around with shapes and proportions, taking note of what feels right to your eyes. I personally prefer some amount of visual noise in line artwork; if it's too clean, then it's boring.

Q **How would you describe your works to the gallery, client, or potential buyers? How well do you think line art performs in the market, such as in galleries, and in the illustration market?**

A: Describing my own work is never easy. From my experience, line drawings never stop getting reaction from people, and they seem to like line artworks. I believe people like line art because it's an exhibition of drawing in its purest form. It feels accessible, easy to understand and there is certain warmth and spontaneous energy about it. I don't think I am in position to talk about the market as a whole, but there is definitely always an audience for this kind of work.

1 **Process 08**
Size: 160mm × 210mm
Media/Materials: pen on paper
Creative Purpose: personal

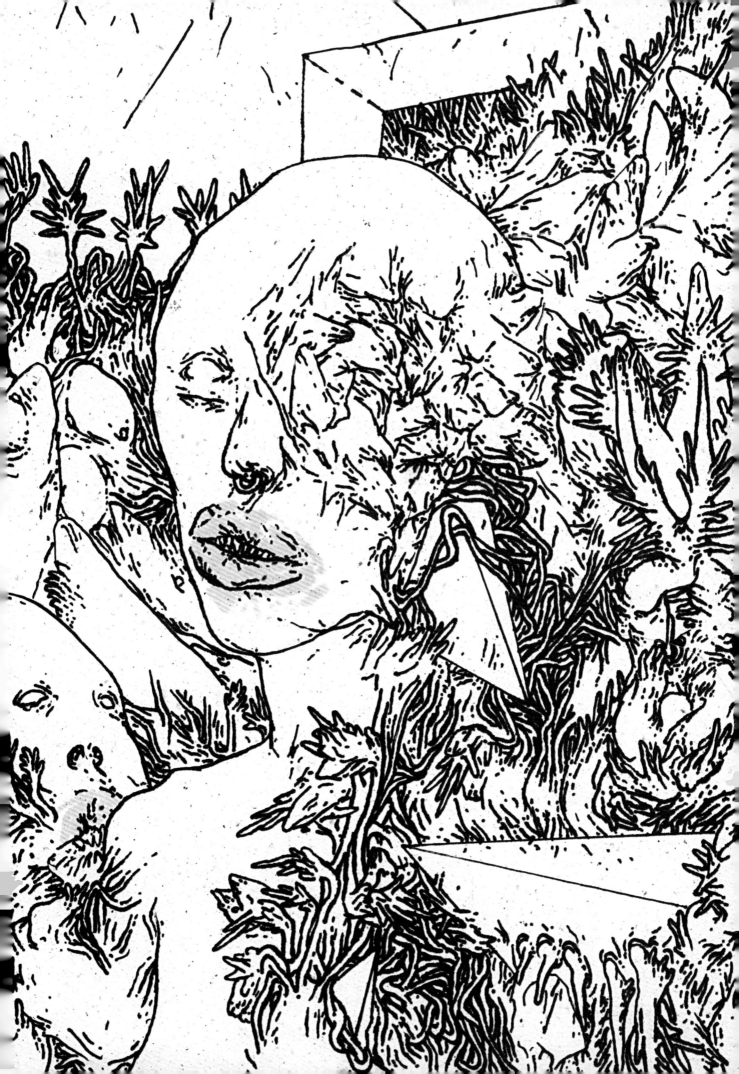

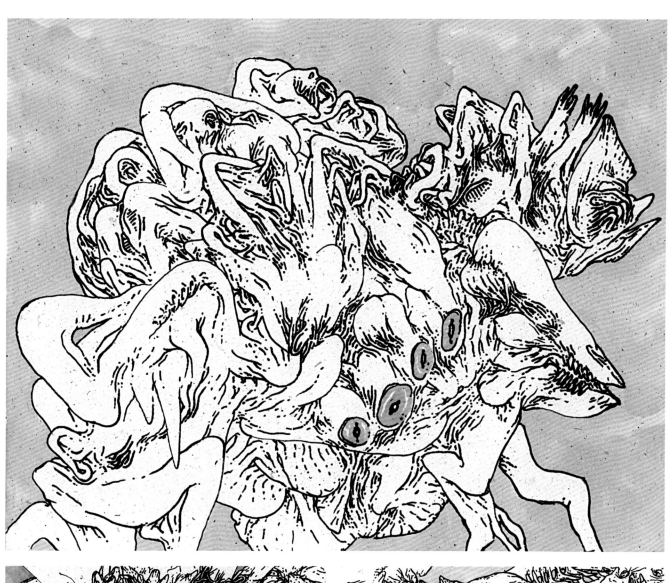

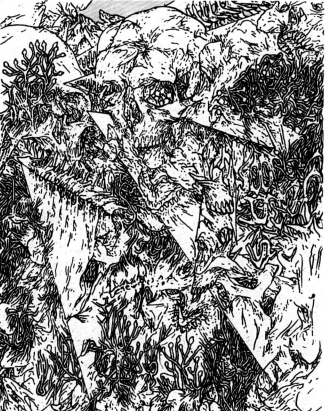

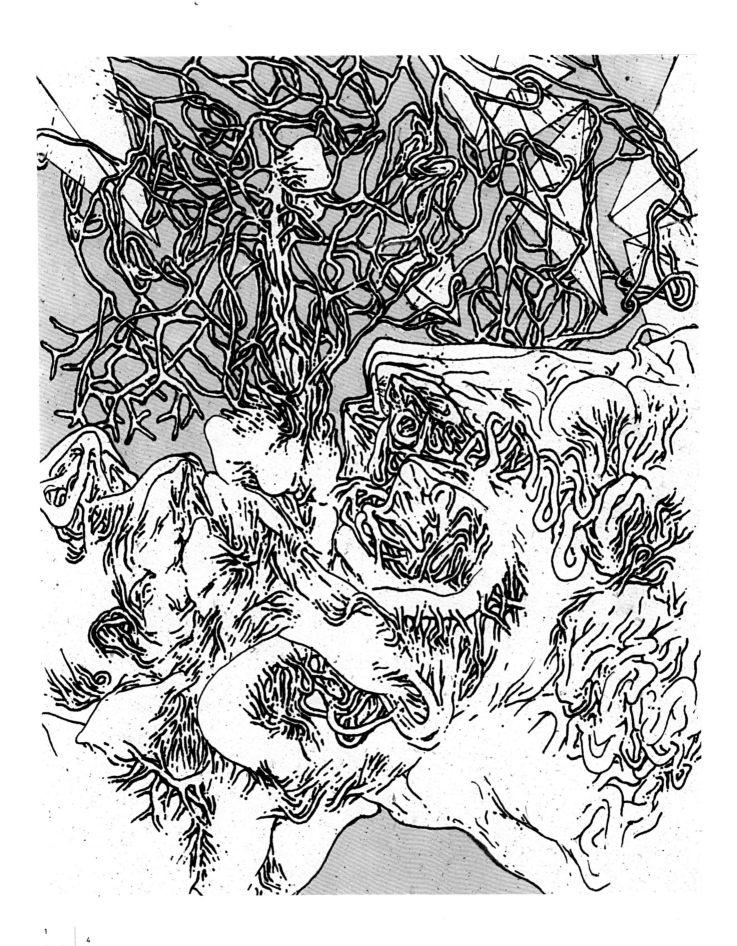

1 Process 11
Size: 160mm × 210mm
Media/Materials: pen on paper
Creative Purpose: personal

2 Process 07
Size: 160mm × 210mm
Media/Materials: pen on paper
Creative Purpose: personal

3 Process 02
Size: 160mm × 210mm
Media/Materials: pen on paper
Creative Purpose: personal

4 Process 09
Size: 160mm × 210mm
Media/Materials: pen on paper
Creative Purpose: personal

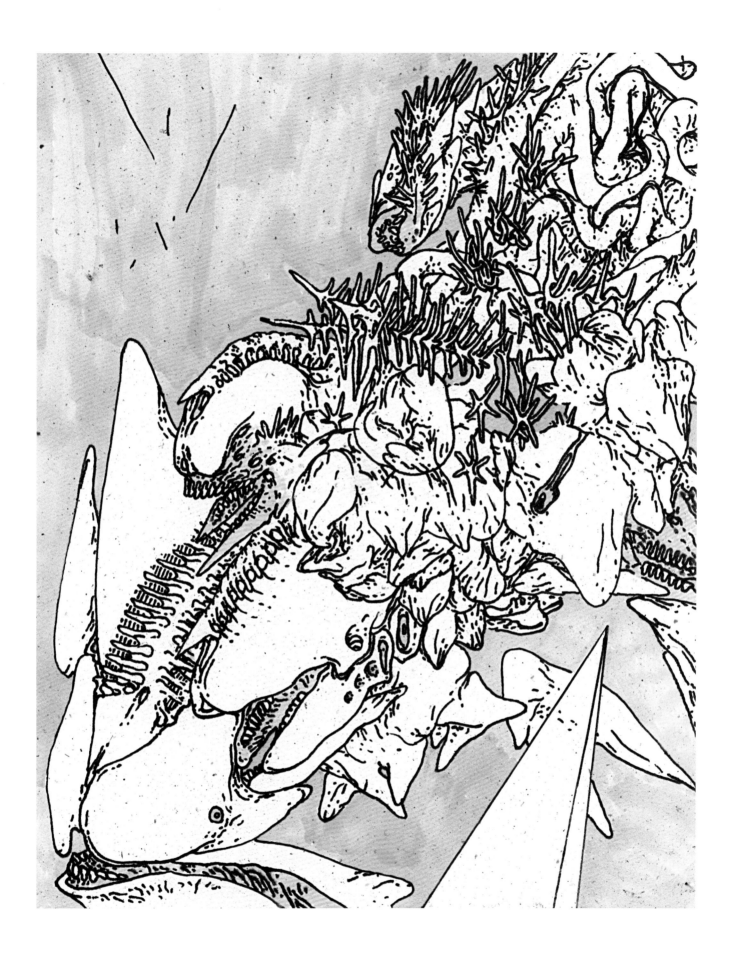

1　2

1　**Process 01**
Size: 160mm × 210mm,
Media/Materials: pen on paper
Creative Purpose: personal

2　**Process 03**
Size: 160mm × 210mm
Media/Materials: pen on paper
Creative Purpose: personal

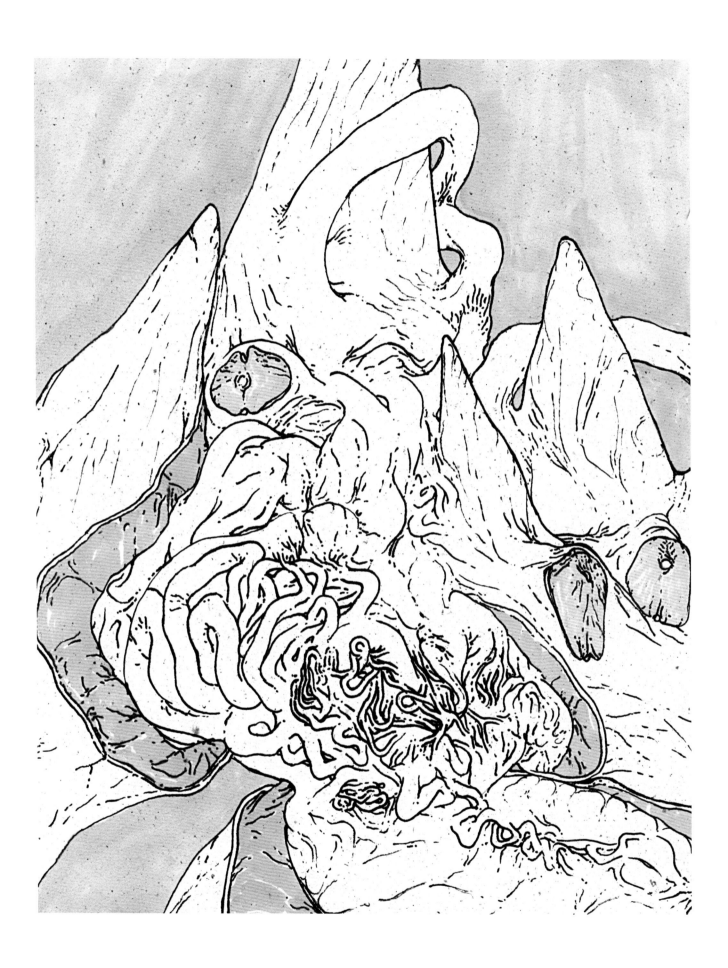

ZHOU CHUNLEI

Nationality: China

Zhou Chunlei is a Chinese artist who graduated from the China Central Academy of Fine Arts, and she has worked as a graphic designer for four years. But the dream of art — to draw quietly and directly — has never died. Today, she is a full-time artist. In her artworks, we can see riveting main theme, as well as endless details.

Q: **Why did you choose lines as the expressional tools for your artworks?**

A: For me, lines are the most direct way of expression. I don't know why. You may say it's due to my character and experience.

Q: **Where do your inspirations come from? Can you tell us about some of your favorite artists?**

A: I don't believe there is something like "inspiration" in the world. Better than that, I think the very source of art creation is to dig into yourself deeper and deeper, until you touch the core at the bottom. As for my favorite artist, I like Klimt the most.

Q: **Could you give us some tips on how to draw beautiful lines? Does it take much practice and patience?**

A: I don't think there is any shortcut. Everybody can draw lines that belong to him or her, only if you are confident enough.

Q: **How would you describe your works to the gallery, client, or potential buyers? How well do you think line art performs in the market, such as in galleries, and in the illustration market?**

A: I just let them see my works, and feel my works by themselves. I don't think additional words are needed.

1 **Damn the Genitals;**
Size: 210mm × 280mm
Media/Materials: needle pen on paper
Creative Purpose: fine art

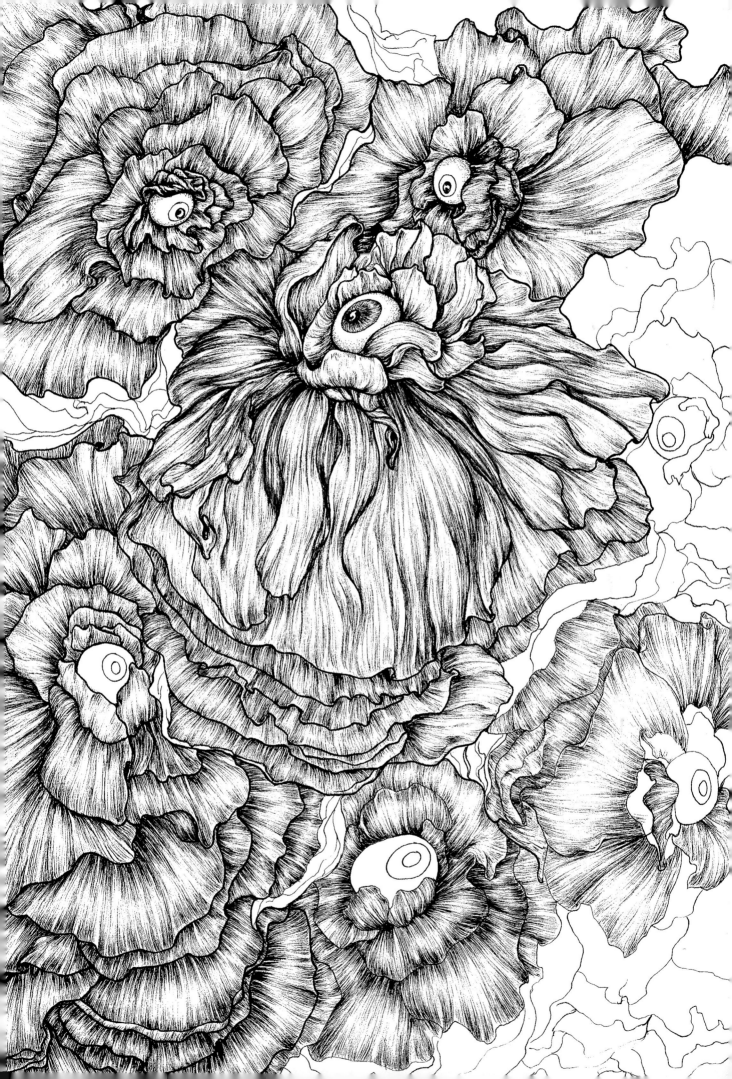

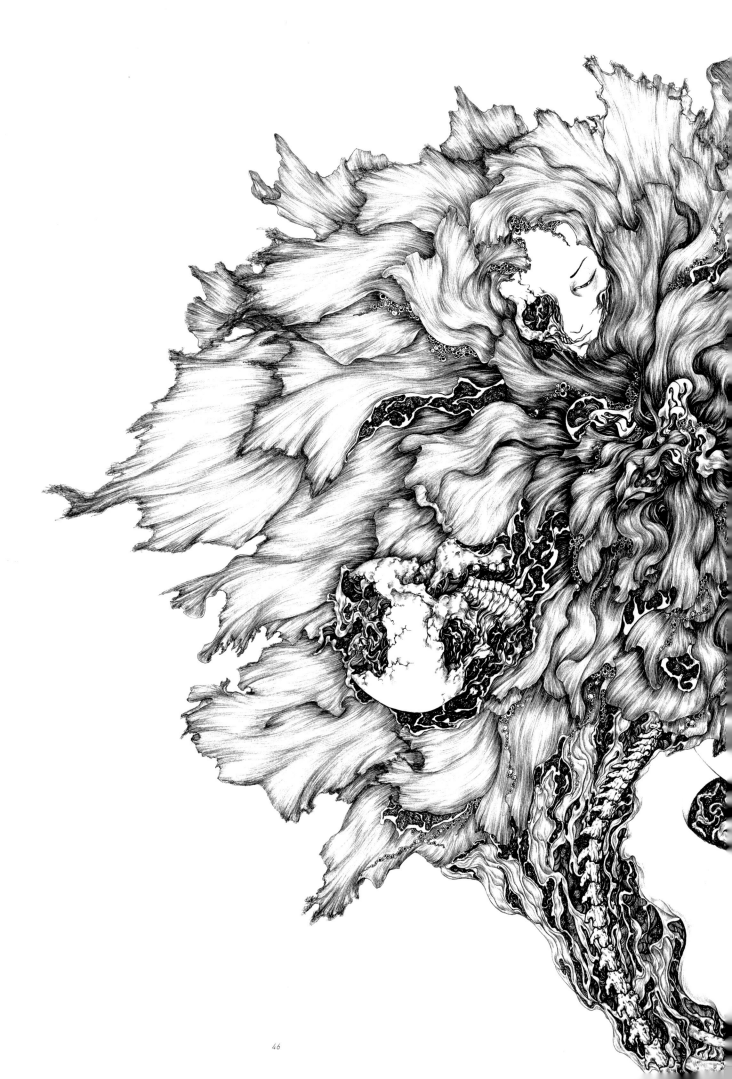

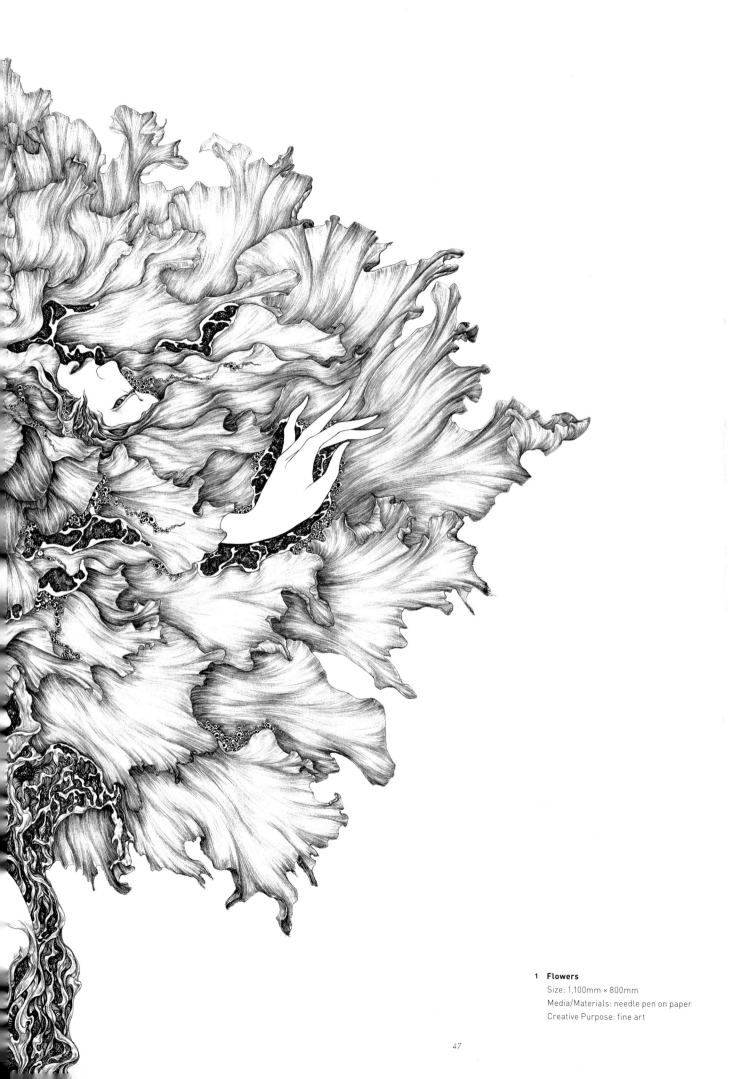

1 Flowers
Size: 1,100mm × 800mm
Media/Materials: needle pen on paper
Creative Purpose: fine art

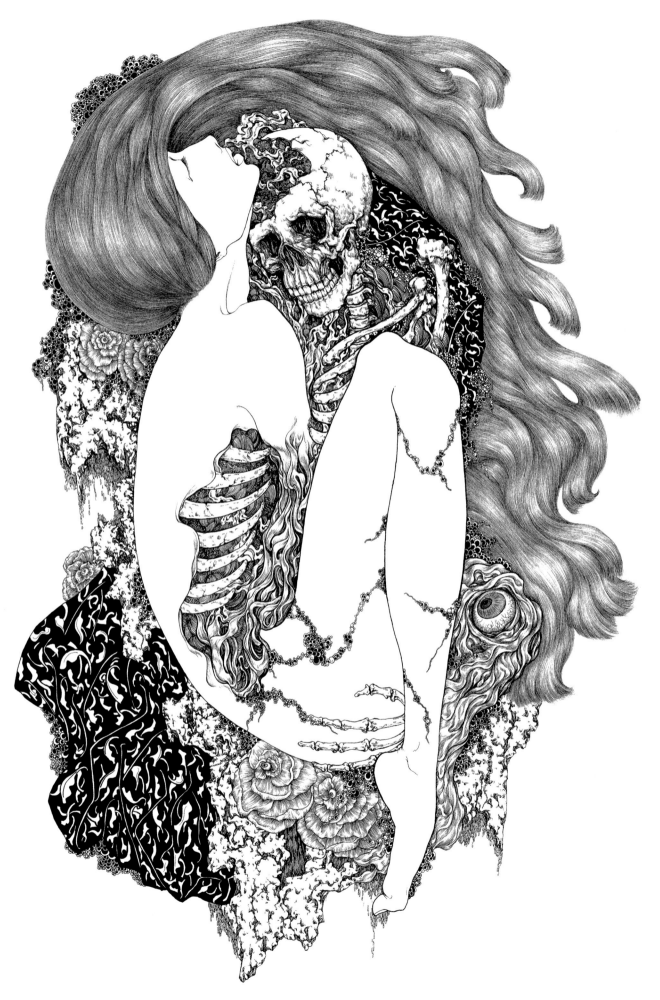

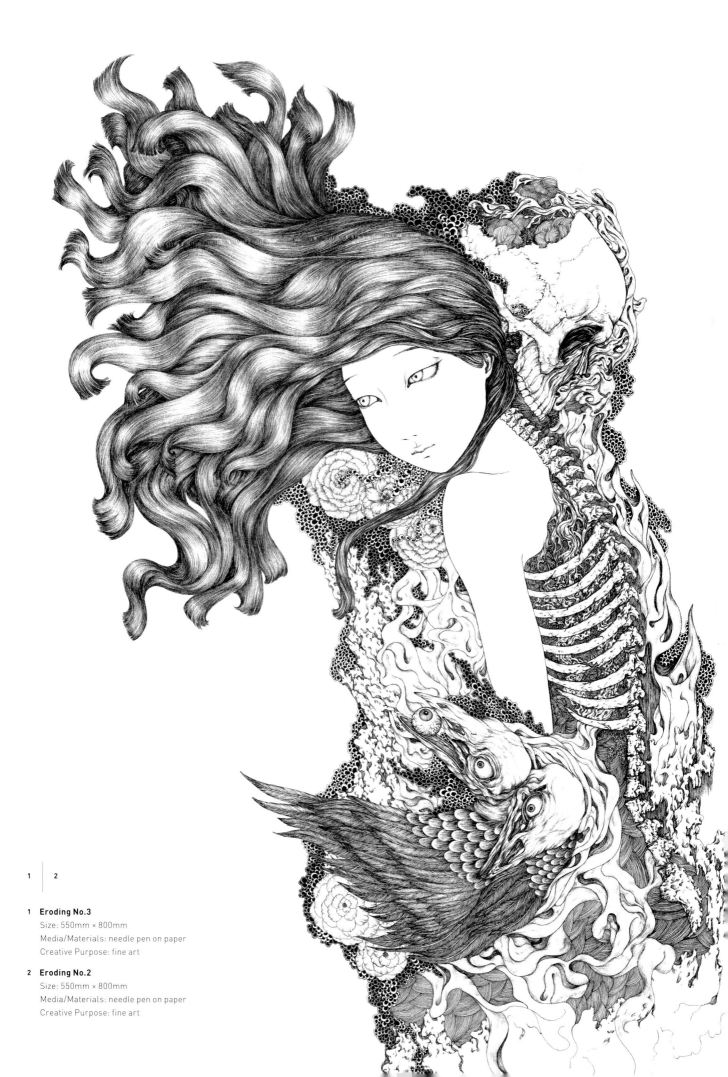

1 Eroding No.3
Size: 550mm × 800mm
Media/Materials: needle pen on paper
Creative Purpose: fine art

2 Eroding No.2
Size: 550mm × 800mm
Media/Materials: needle pen on paper
Creative Purpose: fine art

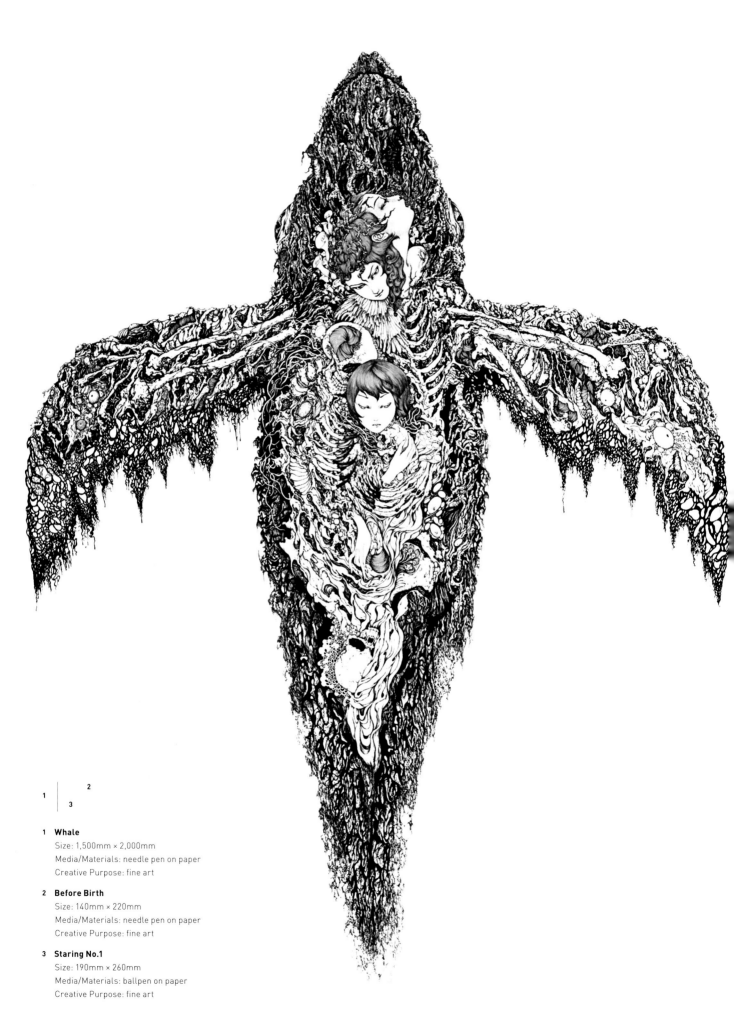

1 | | 2
 | | 3

1 Whale
Size: 1,500mm × 2,000mm
Media/Materials: needle pen on paper
Creative Purpose: fine art

2 Before Birth
Size: 140mm × 220mm
Media/Materials: needle pen on paper
Creative Purpose: fine art

3 Staring No.1
Size: 190mm × 260mm
Media/Materials: ballpen on paper
Creative Purpose: fine art

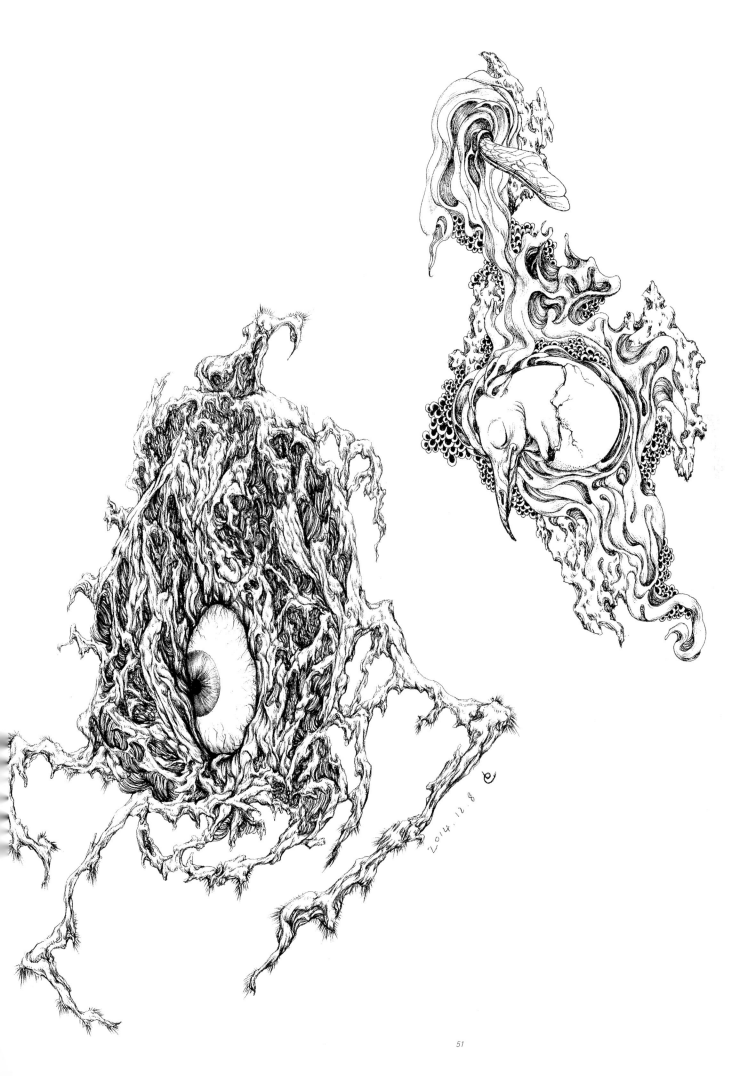

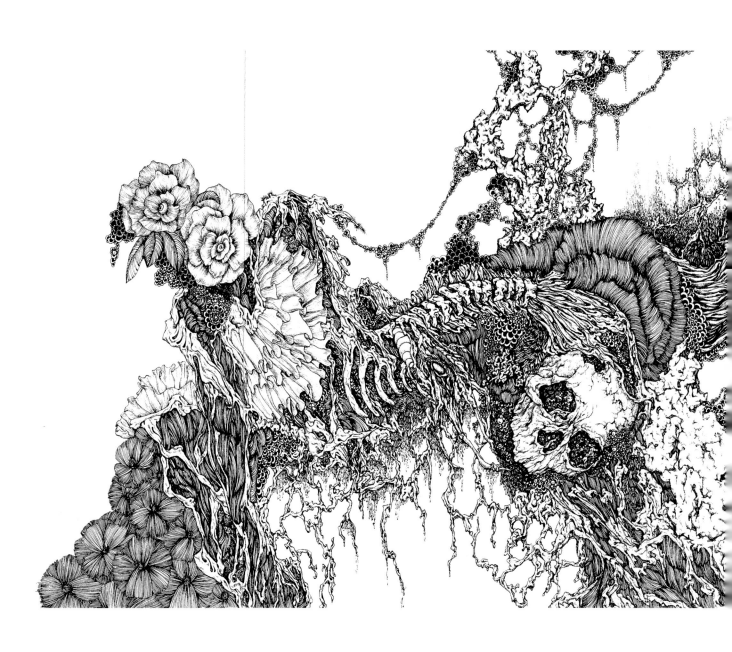

1 Spring Thunder
Size: 1,550mm × 320mm
Media/Materials: needle pen on paper
Creative Purpose: fine art

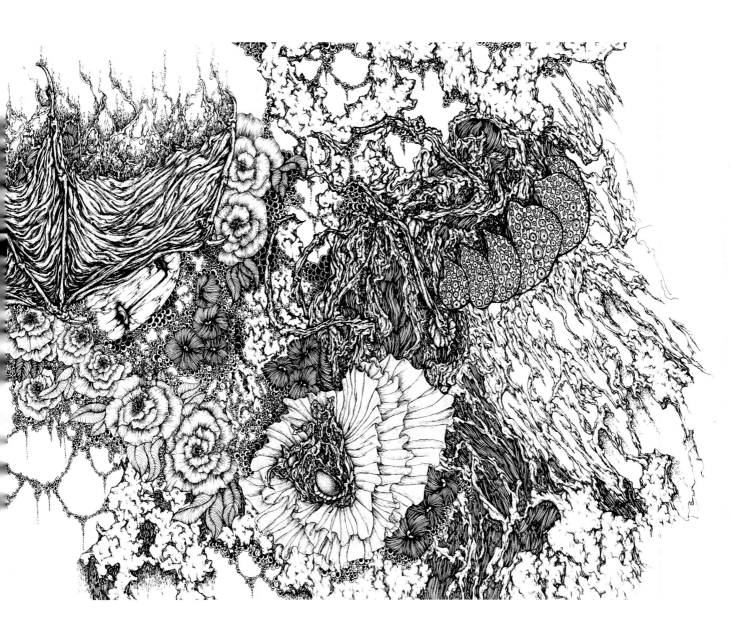

MARIJIA TIURINA

Nationality: United Kingdom
marijatiurina.com
facebook.com/tiurinart
instagram.com/marijatiurina/

Marijia Tiurina is a British artist and illustrator who traveled from Lithuania to the UK in 2009 to start a university course at Brunel, West London. She said, "After graduation I have joined a London-based games studio and have been a games artist in residence ever since. A lot of my personal time is spent on creating original art and working on interesting commissions."

Q: Why did you choose lines as the expressional tools for your artworks?

A: Line art is a great way of controlling shapes. It's really satisfying being in control of what you draw. And it takes a long time to perfect the steadiness of the hand and its ability to understand what the brain wants.

Q: Where do your inspirations come from? Can you tell us about some of your favorite artists?

A: Inspirations can be found anywhere. I mainly find mine on the internet where there are my favorite art blogs and artists. Some masters of the line are James Jean, Ozabu, Sachin Teng, Macbess and others.

Q: Could you give us some tips on how to draw beautiful lines? Does it take much practice and patience?

A: Drawing is something methodical and well-controlled, while painting would be a lot more impulsive and spontaneous. I think that this is why drawing takes a lot of practice and patience to perfect the skills of line control.

Q: How would you describe your works to the gallery, client, or potential buyers? How well do you think line art performs in the market, such as in galleries, and in the illustration market?

A: Linework is quite in demand at the moment, especially in the area of design or advertising. Good detailed drawings attract attention quite well, so they're being used in posters, illustrations and typography a lot. I wouldn't consider my own work as heavily line-based, but I definitely appreciate good linework and am trying to perfect it all the time.

1 **The Town of Thoughts**
Size: 420mm × 600mm
Media/Materials: ink on paper
Creative Purpose: personal

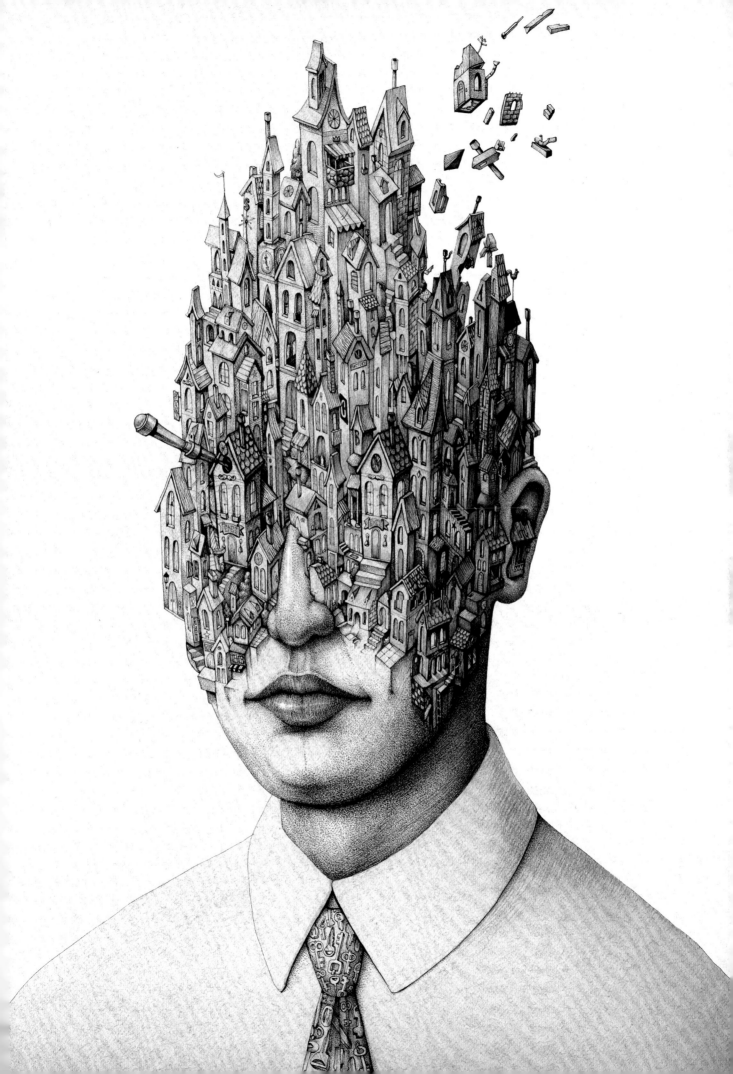

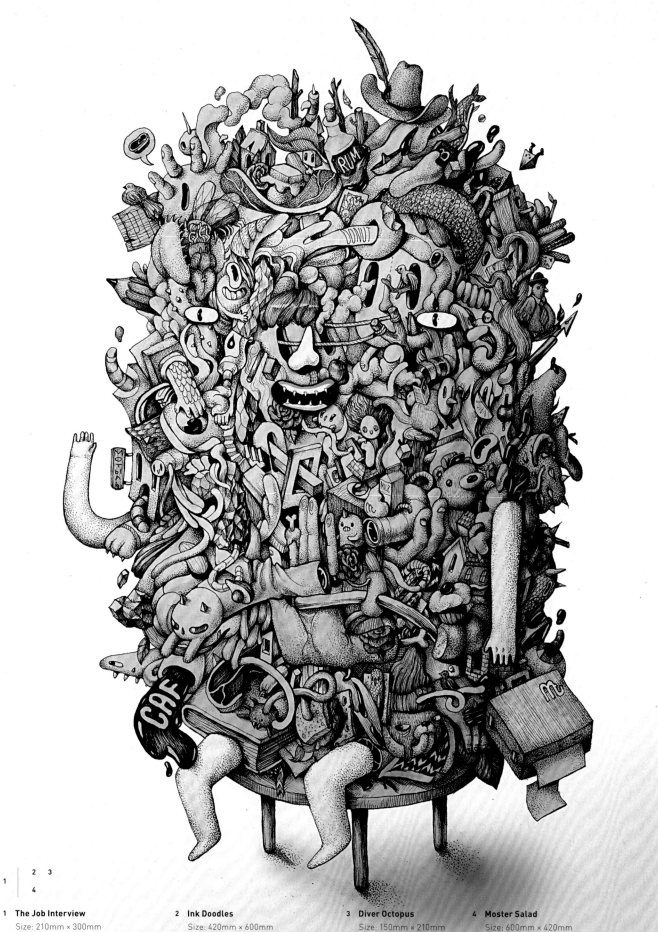

1 **The Job Interview**
Size: 210mm × 300mm
Media/Materials: ink and marker on paper
Creative Purpose: personal

2 **Ink Doodles**
Size: 420mm × 600mm
Media/Materials: ink and marker on paper
Creative Purpose: practice

3 **Diver Octopus**
Size: 150mm × 210mm
Media/Materials: ink on paper
Creative Purpose: practice

4 **Moster Salad**
Size: 600mm × 420mm
Media/Materials: watercolor and ink on paper
Creative Purpose: personal

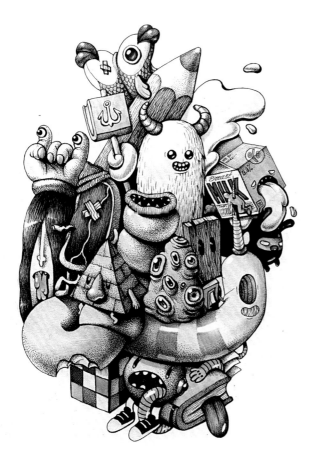

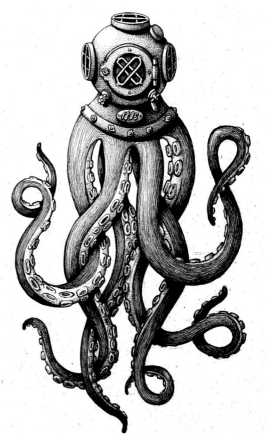

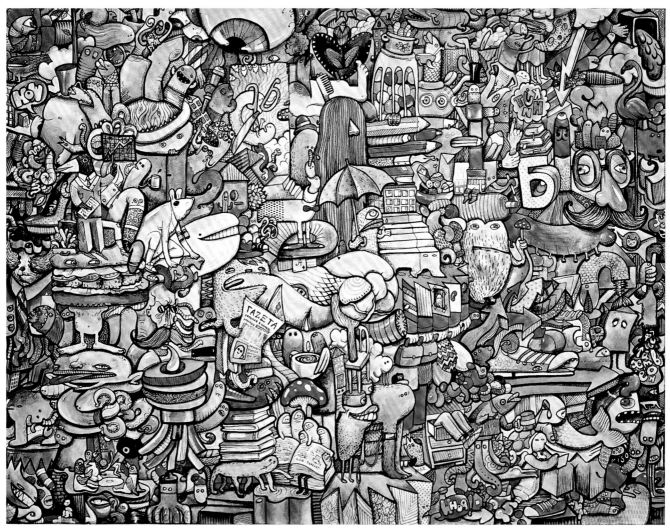

LEE JOHN PHILLIPS

Nationality: United Kingdom
leejohnphillips.com
twitter: @ leejohnphillips
instagram.com/leejohnphillips

"I'm currently working on an extensive personal project to visually catalogue every item in my late grandfather's tool shed," he said. "I will illustrate every hand-tool, empty every container and draw every last nut, bolt, screw and used staple. I estimate there to be over 100,000 items in the shed and have documented over 4,700 to date. I estimate the project to take over 10 years to complete. "

Q: Why did you choose lines as the expressional tools for your artworks?

A: This technique allows me to vary my marks to suit the materials and textures I am depicting. Also, the tools are very portable. I move around a lot, and draw outside. The pens are perfect for my lifestyle.

Q: Where do your inspirations come from? Can you tell us about some of your favorite artists?

A: I am inspired by a range of artists from a range of disciplines. I love painting as much as designing or collage. However, I am very keen on the illustrations and engravings from vintage French dictionaries. Layout, composition and negative space play an important role in my sketchbook works.

Q: Could you give us some tips on how to draw beautiful lines? Does it take much practice and patience?

A: My current project is all about patience. I never use pencils, rubbers or rulers — I draw straight in ink. I do find that working on a drawing board or tilted/elevated surface helps a lot. I use varying weights of pen and hold my breath a lot!

Q: How would you describe your works to the gallery, client, or potential buyers? How well do you think line art performs in the market, such as in galleries, and in the illustration market?

A: I think people are starting to appreciate line work more and enjoy the "handmade," personal aesthetic it can deliver. Line art is the most basic of techniques. In a digital era, I feel traditional skills and a more "human" approach will prevail.

I would consider my work to be culturally sensitive; depicting the most basic objects that played an important role in the industrial heritage of Wales. I feel my line work illustrates these items in the simplest and purest form.

1 **Page 37**
Size: 210mm × 297mm
Media/Materials: ink on paper
Creative Purpose: personal

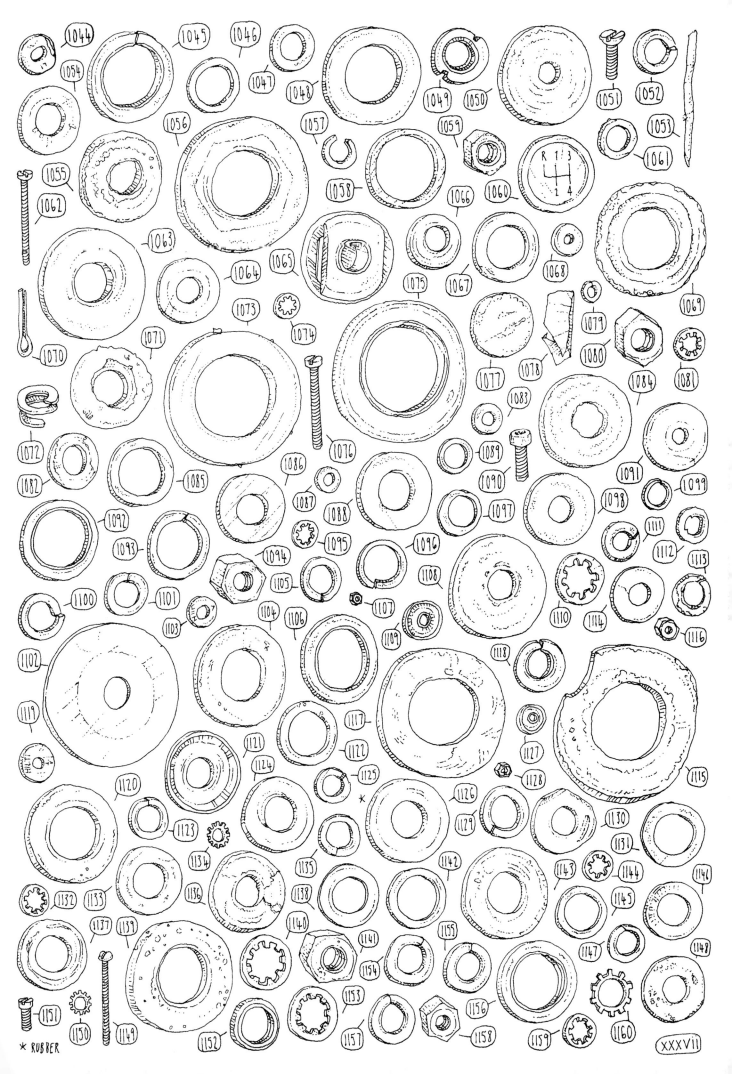

* RUBBER

XXXVII

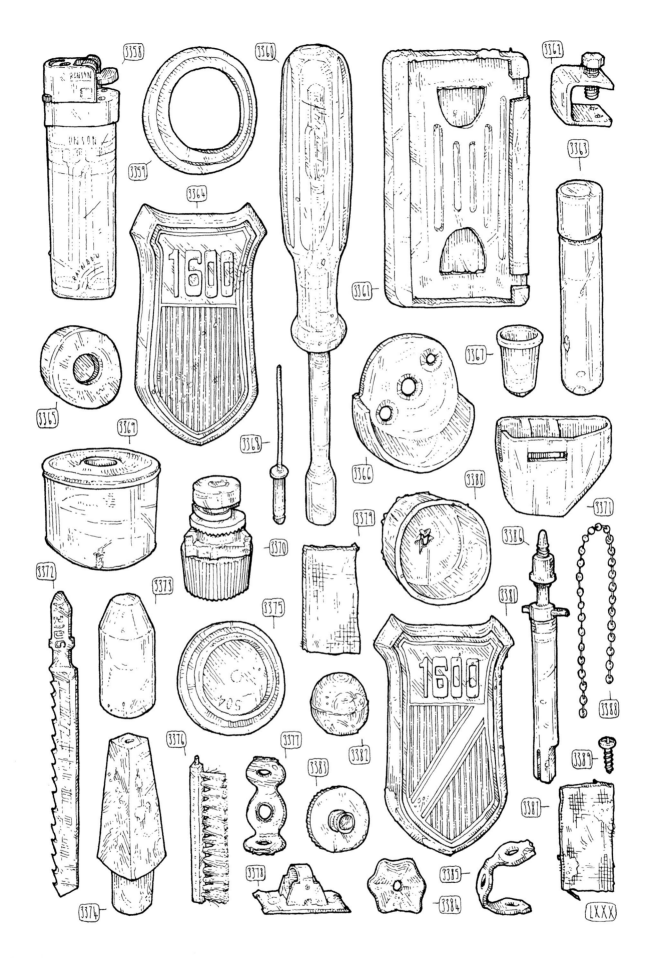

1 **Page 80**
Size: 210mm × 297mm
Media/Materials: ink on paper
Creative Purpose: personal

2 **Page 98**
Size: 210mm × 297mm
Media/Materials: ink on paper
Creative Purpose: personal

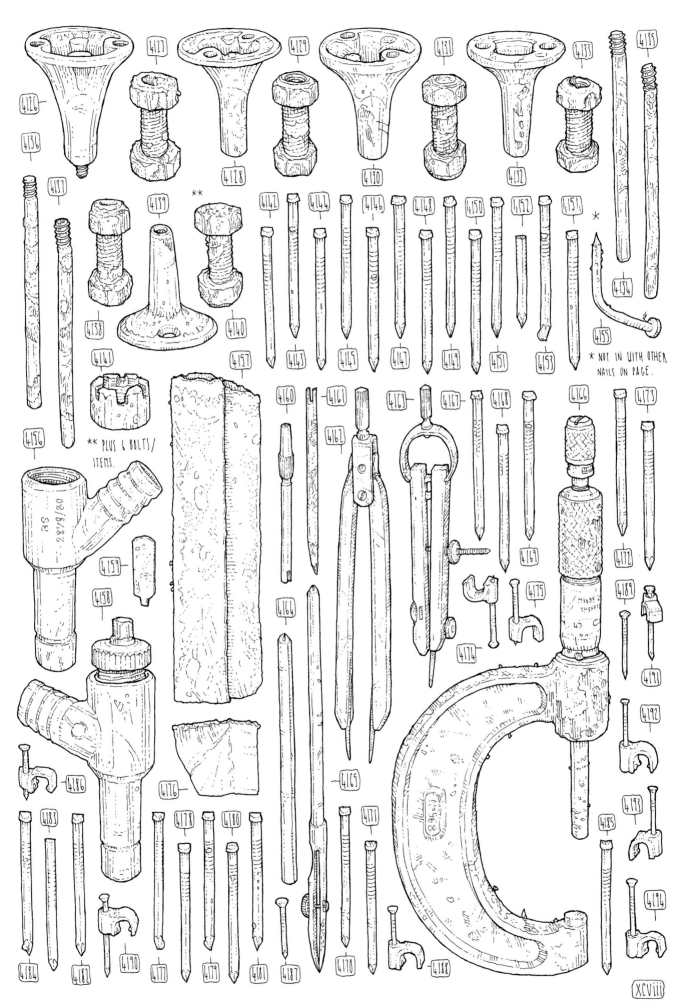

4126 4127 4129 4131 4133 4135 4136 4128 4130 4132 4137 4138 4139 4140 4141 4142 4144 4146 4148 4150 4152 4151 4134 4155 4156 4157 4160 4161 4163 4167 4168 4166 4173 4162 4169 4172 4189 4159 4175 4191 4158 4174 4192 4186 4176 4165 4171 4193 4185 4183 4178 4180 4177 4179 4181 4187 4170 4188 4194 4184 4182 4190 4143 4145 4147 4149 4151 4153

** PLUS 6 BOLTS/ ITEMS.

* NOT IN WITH OTHER NAILS ON PAGE.

XCVIII

JANUSZ JUREK

Nationality: Poland

januszjurek.info

behance.net/januszjurek

Janusz Jurek was born in 1972 and still lives in Ostrów Wielkopolski, Poland. Since 1996 he started his own NEO Graphic Design Studio. He does commercial projects such as 3D designing, photography, graphic designing, animation and other new forms of visual arts. He has won many local and international prizes, among which the most important is the first prize in 2015 during Independent Festival of Creative Communication in Chroatia in 3D category for Papilarnie part I. All the Papilranie works are the part of Borderline series which is shown to the public during his first solo exhibition in November, 2015, in Modern Art Gallery in Ostrów Wielkopolski.

Q: Why did you choose lines as the expressional tools for your artworks?

A: When I started 3D design, it was very difficult and consuming but it was interesting at the same time. I spent all of my free time learning new techniques to make things look more and more real. When I achieved my aim, it came to me that I could do something completely opposite — I could use my 3D skills for simple, pure art purposes. And that was the moment when I chose lines as the most basic way of art expression. When you draw, the only thing you need is a sheet of paper and a good pencil. But what if paper was not enough? What if the pencil can leave traces in the air? I had this crazy idea on my mind. I wanted to create the way of connecting drawing and sculpting. So I created my virtual environment and introduced the lines into that three-dimensional space.

Q: Where do your inspirations come from? Can you tell us about some of your favorite artists?

A: The technique I created is sophisticated, and this is why I wanted the subject to be simple. The human body has always been the most popular subject in drawing, so my choice was quite obvious. Generative art is about motion, and the human body is about motion, even motionless it has the complicated nervous system and the blood vessels, which work all the time. You know that a fingerprint, which identifies the person, consists of lines. So it is true to say that the subject found me.

Do I have favorite artist? Of course I do. I like Jan Saudek's photography, and admire David LaCahpelle. I enjoy Banksy, sort of. As far as my favorite painter is concerned, I love Pablo Picasso for his form fascination; among sculptors I admire Igor Mitoraj's works. They are outstanding, beautiful and powerful.

Q: Could you give us some tips on how to draw beautiful lines? Does it take much practice and patience?

A: As a kid I was very good at drawing, it calmed me down. Perhaps 3D design has the same effect on me now. Anyway, during my studies I had drawing lessons for five years. I felt it had not been my thing, but I practiced all the classical rules that are so helpful in my works now. I don't know what tip I could give. I just follow my vision using the basic rules of drawing.

Q: How would you describe your works to the gallery, client, or potential buyers? How well do you think line art performs in the market, such as in galleries, and in the illustration market?

A: I don't have big experience in selling my works. I am in generative art for less than two years. I am just at the beginning so I hope we will return to that question at a later date.

1 **Voronoi 1**
Media/Materials: 3D CGI
Creative Purpose: personal

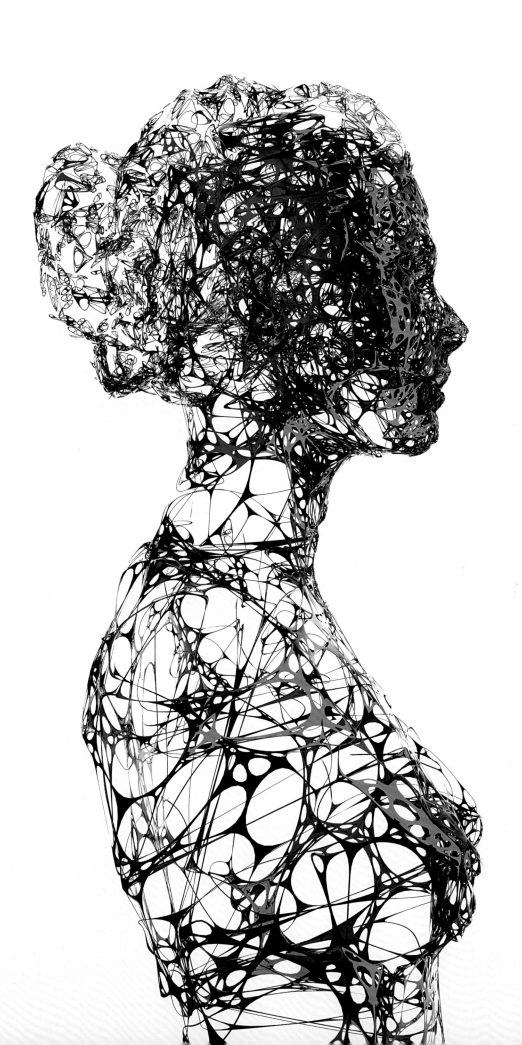

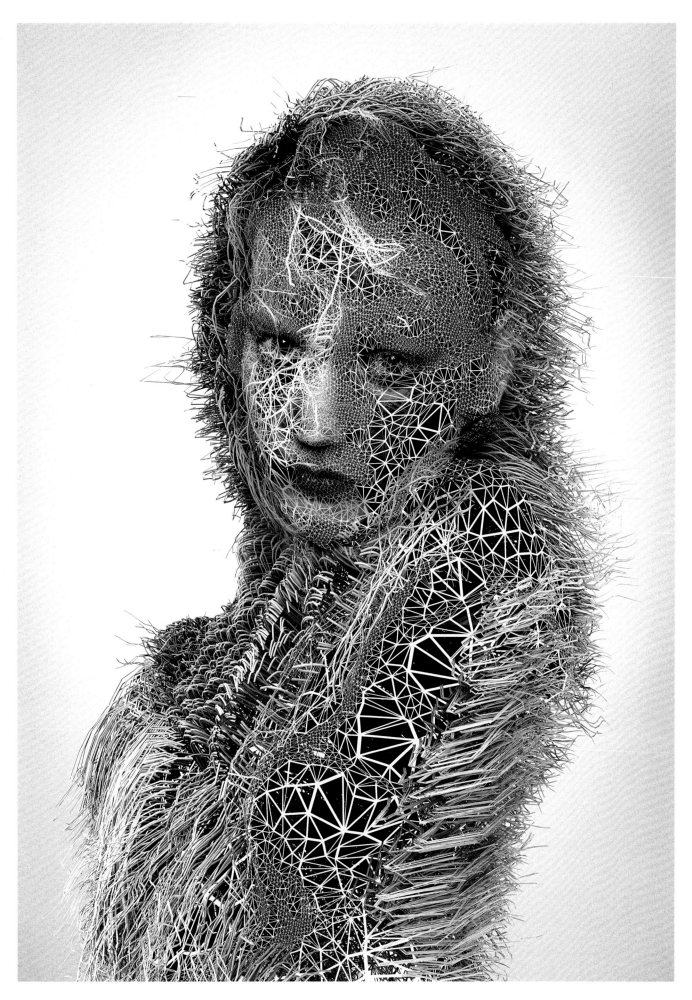

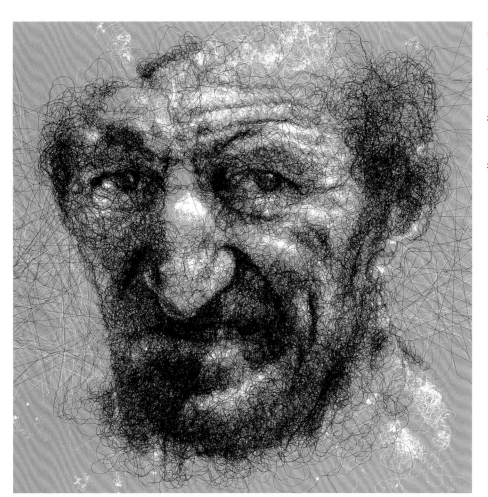

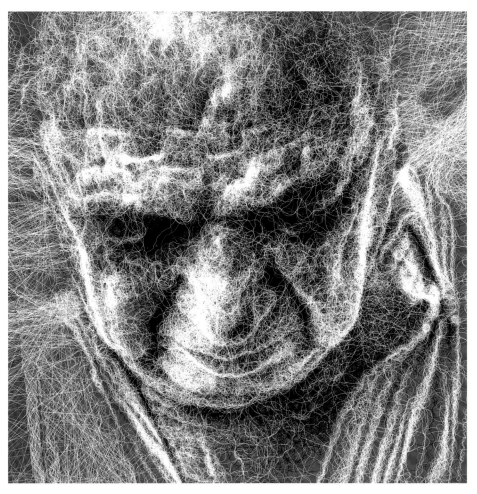

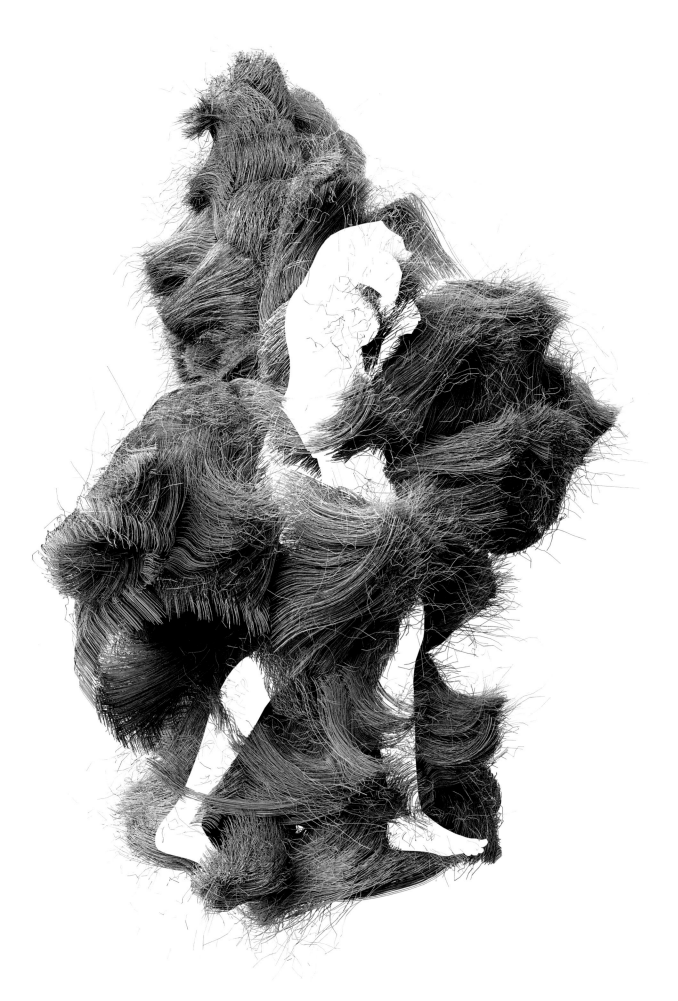

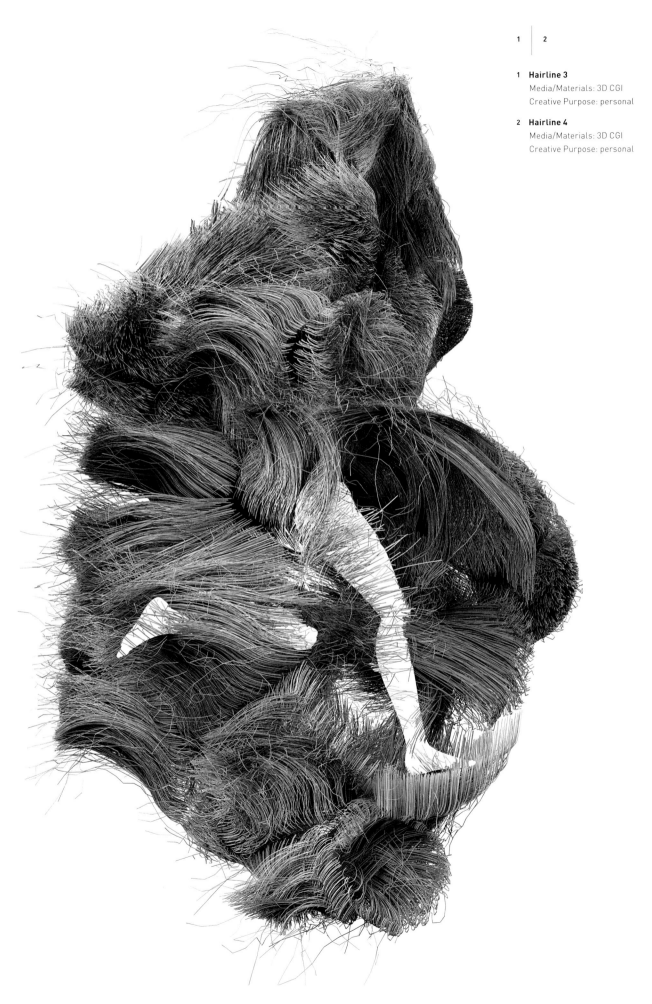

1 Hairline 3
Media/Materials: 3D CGI
Creative Purpose: personal

2 Hairline 4
Media/Materials: 3D CGI
Creative Purpose: personal

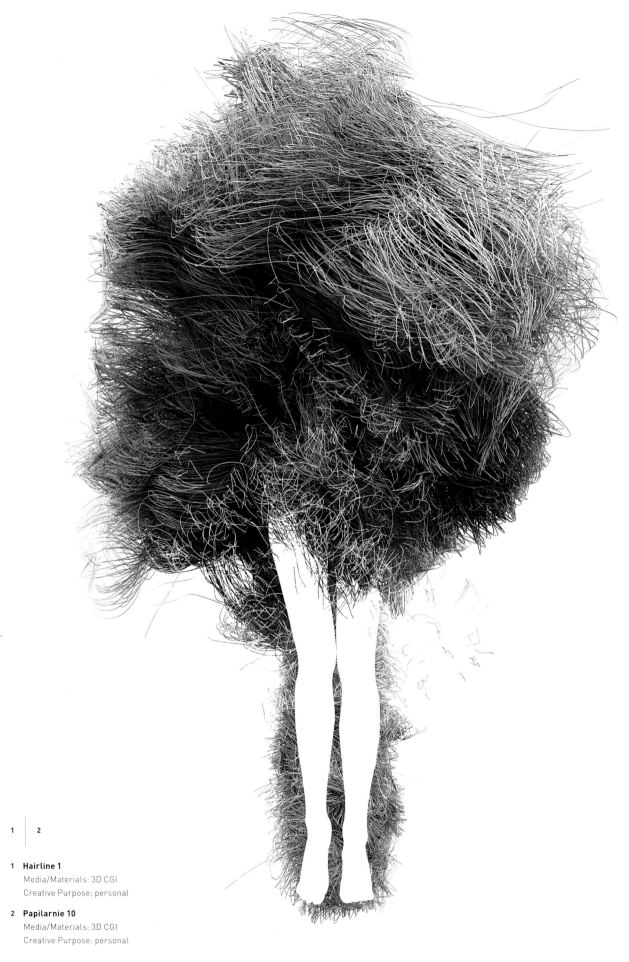

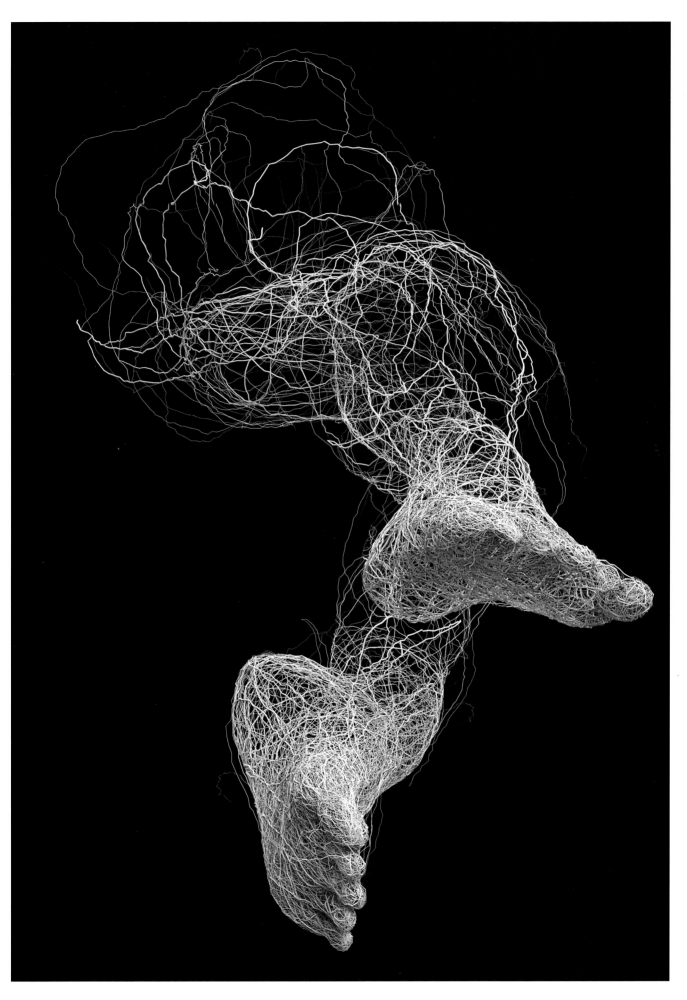

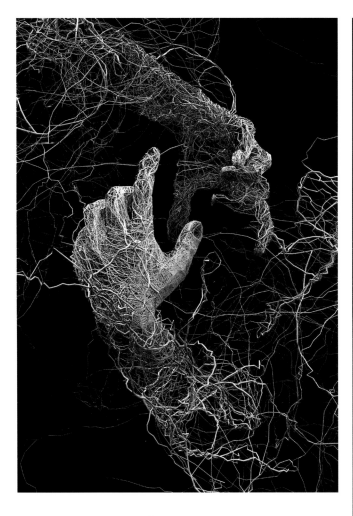

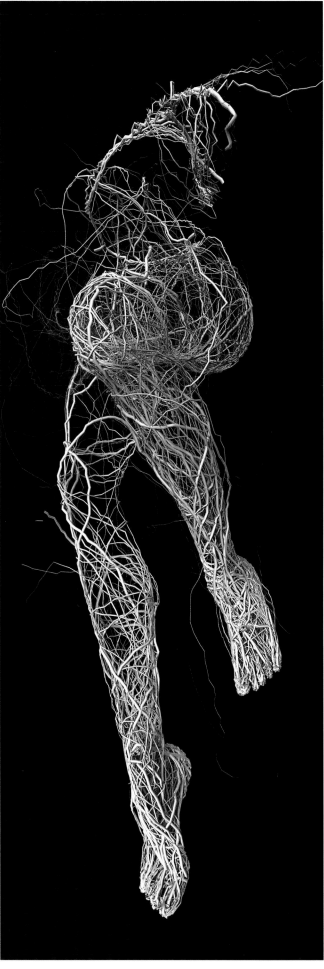

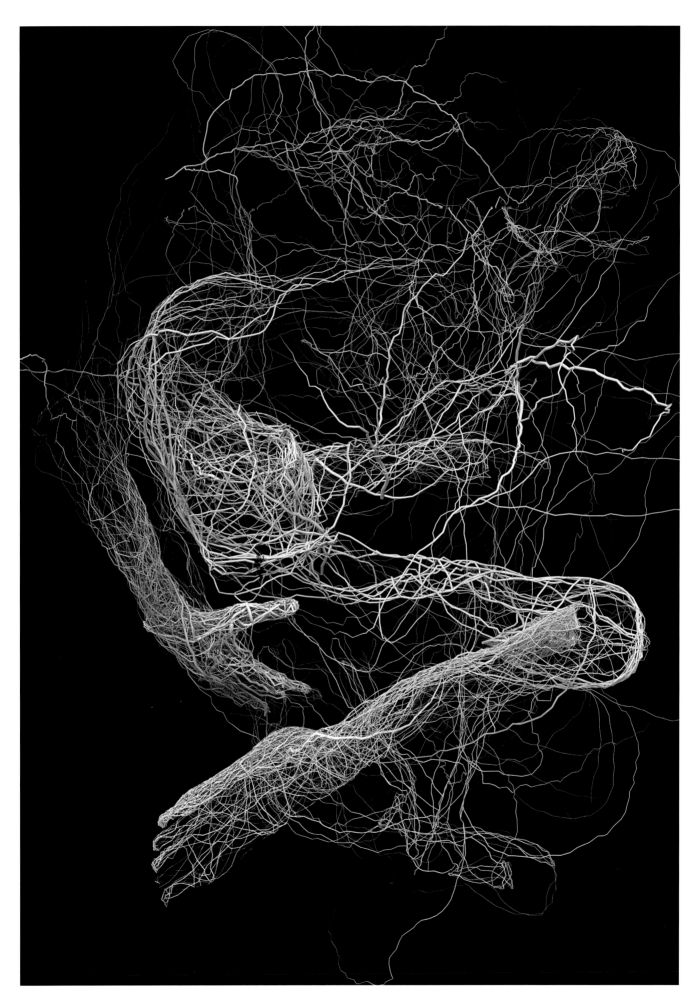

WEI WANLI

Nationality: China

Wei Wanli is an artist based in Beijing, China.

His lines are quaintly beautiful, twining about the evanescence of human nature and the relentless carnal lust preceding and asking a question like: After the flesh vanishes, is there really a religion that could be taken as the last shelter? Maybe that's why his works give us a feeling of agony that humans could not hold great desires after the death of flesh.

Q: Why did you choose lines as the expressional tools for your artworks?

A: I think lines are warm, and their direction, angle, length, curve, and force is aimed and premeditated. It's never icy or solitary.

Q: Where do your inspirations come from? Can you tell us about some of your favorite artists?

A: The artist I love the most is Henri Rousseau. His works are wonderful! When I was in college, I saw his works such as "The Rainforest", "War" and "The Sleeping Gypsy" for the first time. I was captivated by the dreamy and mysterious atmosphere in his paintings. The things that inspire me are just like Rousseau's paintings, which give me uncharted, complicated and mysterious feelings. I can't convey them in words. But if I pick up my pen, I can draw them.

Q: Could you give us some tips on how to draw beautiful lines? Does it take much practice and patience?

A: I think the force of the wrist is the most important of all.

Q: How would you describe your works to the gallery, client, or potential buyers? How well do you think line art performs in the market, such as in galleries, and in the illustration market?

A: I think my works are really hard to describe. I hope I don't give a presupposition at the beginning, because all the descriptions are pallid. The best way is to let the viewers feel by themselves. And I want to express my special thanks to my wife. Each piece of my work was named by her, and she's full of sensibility.

1 **Harmony and Grace**
Size: 787mm × 1,092mm
Media/Materials: ink on paper
Creative Purpose: fine art

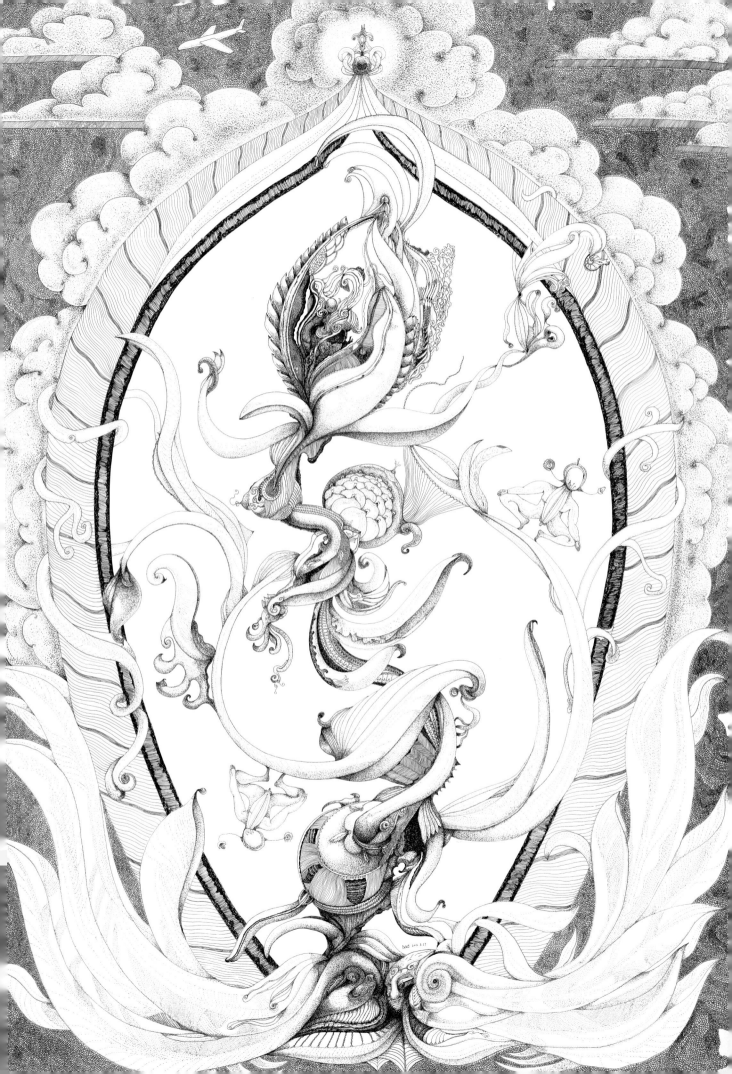

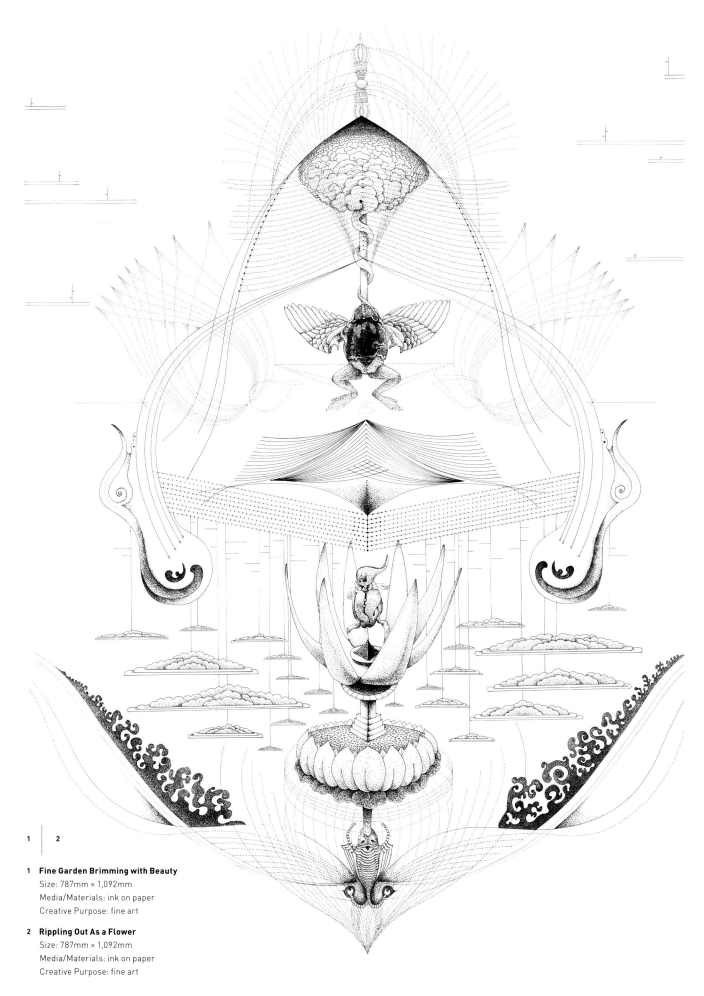

1 Fine Garden Brimming with Beauty
Size: 787mm × 1,092mm
Media/Materials: ink on paper
Creative Purpose: fine art

2 Rippling Out As a Flower
Size: 787mm × 1,092mm
Media/Materials: ink on paper
Creative Purpose: fine art

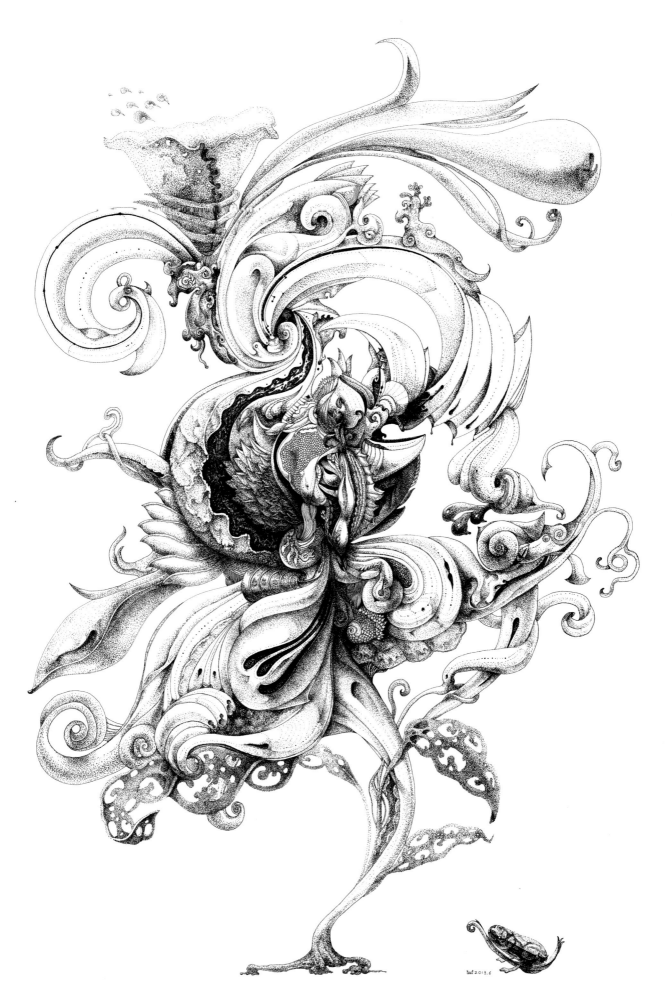

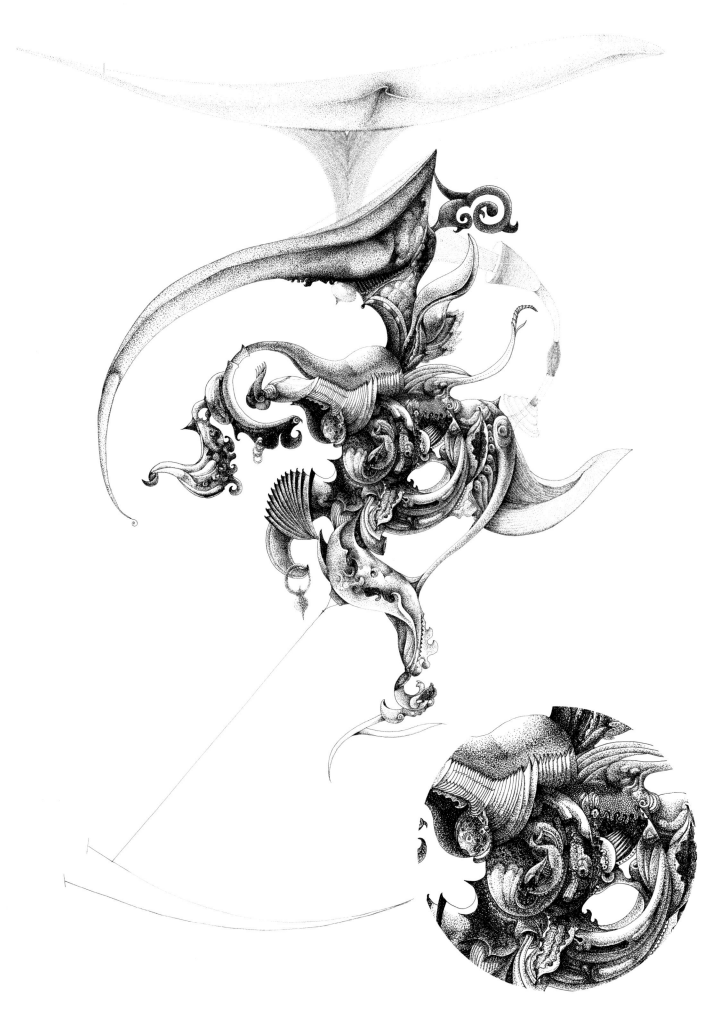

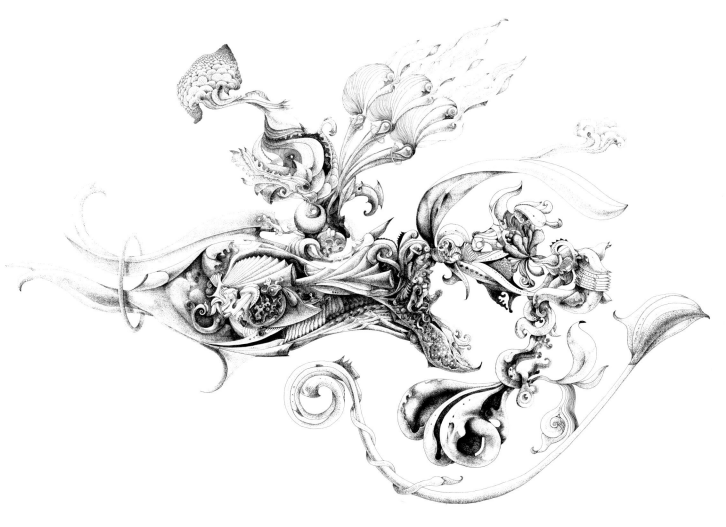

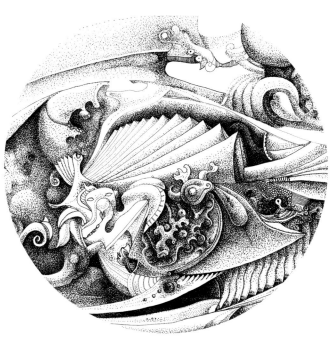

| 1 | 3 |
| 2 | 4 |

1 Dissipating Carelessly and Ceaselessly
Size: 546mm × 787mm
Media/Materials: ink on paper
Creative Purpose: fine art

2 Dissipating Carelessly and Ceaselessly (detail)

3 Bamboo Bridge and Flowing Water
Size: 787mm × 1,092mm
Media/Materials: ink on paper
Creative Purpose: fine art

4 Bamboo Bridge and Flowing Water (detail)

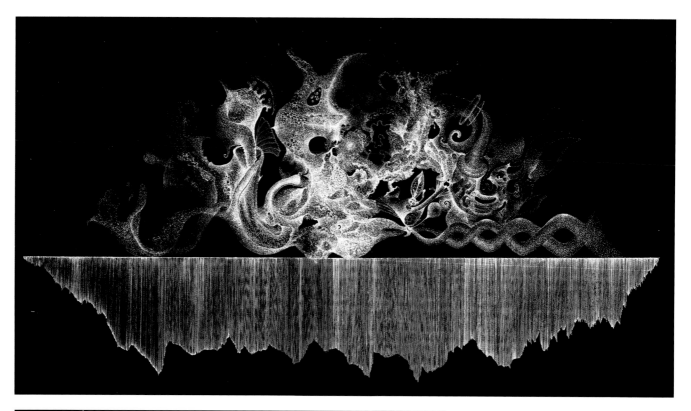

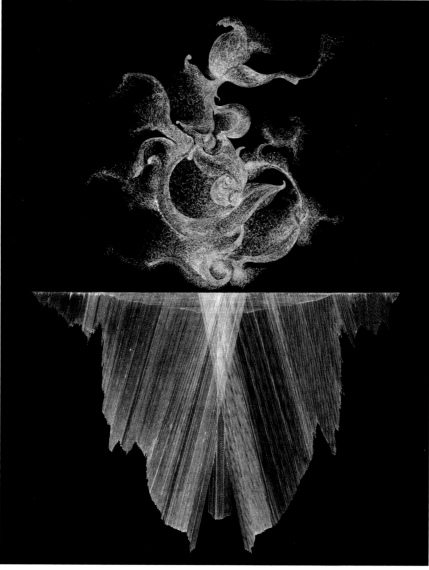

1

2 3

1 **The Ice Melts**
Size: 787mm × 1,092mm
Media/Materials: white pigment on black paper
Creative Purpose: fine art

2 **Unfold the Tenderness**
Size: 787mm × 1092mm
Media/Materials: white pigment on black paper
Creative Purpose: fine art

3 **Graceful Vines and Dainty Clouds**
Size: 787mm × 1,092mm
Media/Materials: ink on paper
Creative Purpose: fine art

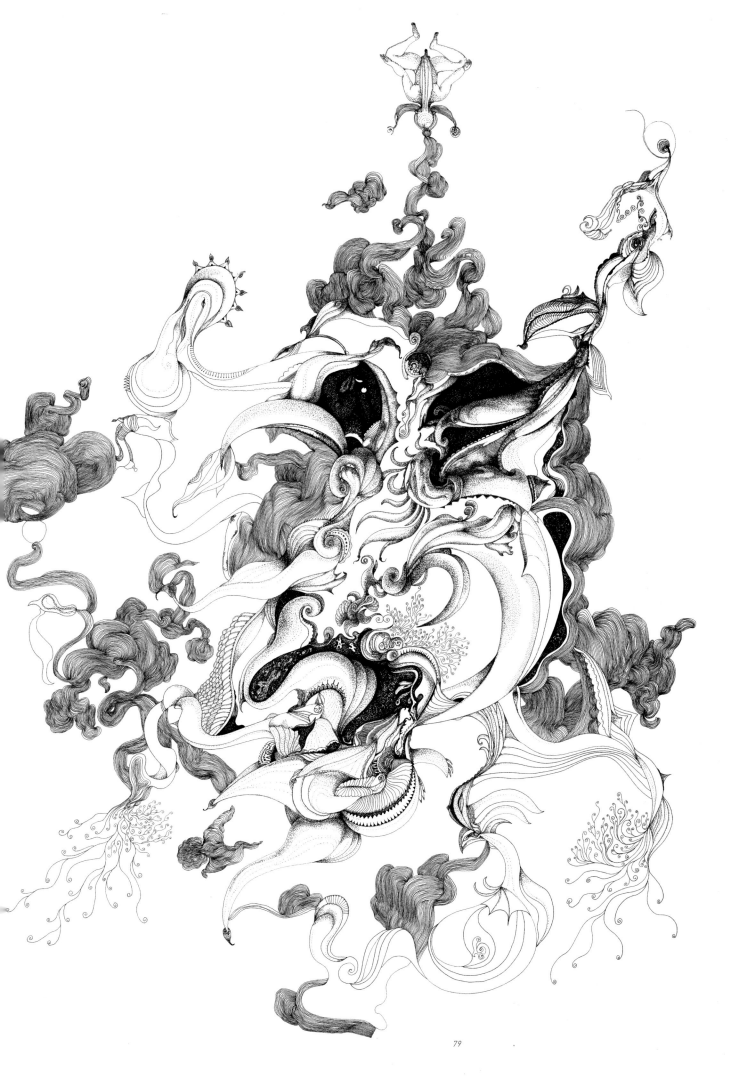

HUGUETTE DESPAULT MAY

Nationality: Canada
huguettemay.com

Huguette Despault May was born in Ottawa, Canada, but grew up and has lived mostly in the United States. Over the last 10 years she has focused on working in charcoal on paper, occasionally adding color with pastels. After finishing her "Hawser" series, she decided that nature would become her permanent inspiration and began working on the "Paper Nests" series. When she's not in the field photographing future subjects, Huguette is most often found in her studio in New Bedford, Massachusetts, housed in a former textile mill that is now called Hatch Street Studios.

Q: Why did you choose lines as the expressional tools for your artworks?

A: I've worked in nearly every painting and drawing medium as well as photography, but around 2005, because of an experience with an excellent mentor, I decided to focus entirely on drawing with charcoal. I had a strong sense of returning to my roots and wanted to pare my work life down to essentials. I consider myself a tonal artist making images with an illusion of depth created by attention to the direction and source of light and then juxtaposing lines in an almost architectural construction.

Q: Where do your inspirations come from? Can you tell us about some of your favorite artists?

A: It's become a cliché, but nature really is the ultimate inspiration. It took a long time to evolve my own creative view of the natural world because I care about it deeply.
My favorite artist is Albrecht Durer for his closely observed, meticulously rendered nature and animal studies. Another favorite is the American artist Georgia O Keefe for her simple but powerful compositions. I appreciate Leonard Baskin's highly expressive animal and plant drawings. There are many other artists I admire, especially the German school of etchers of the 19th century and a Russian etcher named Stanislav Nikireyev of the 20th century.

Q: Could you give us some tips on how to draw beautiful lines? Does it take much practice and patience?

A: I would say draw a lot! Explore the various line-making tools until you find one or two mediums that produce the effects that you like best. The time invested will reward you with confidence and freedom from technical struggle that will allow you to focus on what you want to express.

Q: How would you describe your works to the gallery, client, or potential buyers? How well do you think line art performs in the market, such as in galleries, and in the illustration market?

I routinely describe my work as "drawings in charcoal on archival paper." Paintings, especially in oil or acrylic, still seem to more easily command higher prices and greater public admiration. However, I believe that drawing, especially when large, is gaining ground. It's a matter of artists and gallerists educating collectors. Works on paper are often viewed as more fragile than works on canvas, but if the paper is archival and the work on it is in charcoal, graphite or permanent ink, it can last centuries with proper framing or storage. The skill and talent in producing high-quality works on paper is no less than that called upon for painting.

1　**Hawser series: Fuzzy Logic**
Size: 965mm × 1,270mm
Media/Materials: charcoal on paper
Creative Purpose: fine art

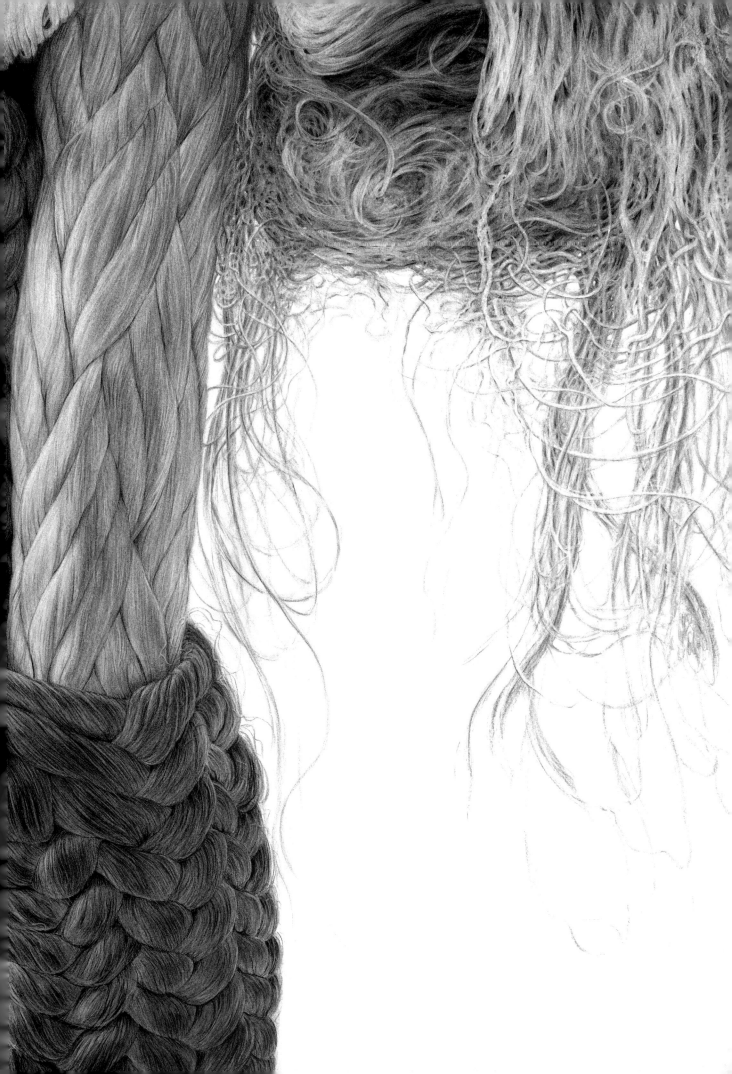

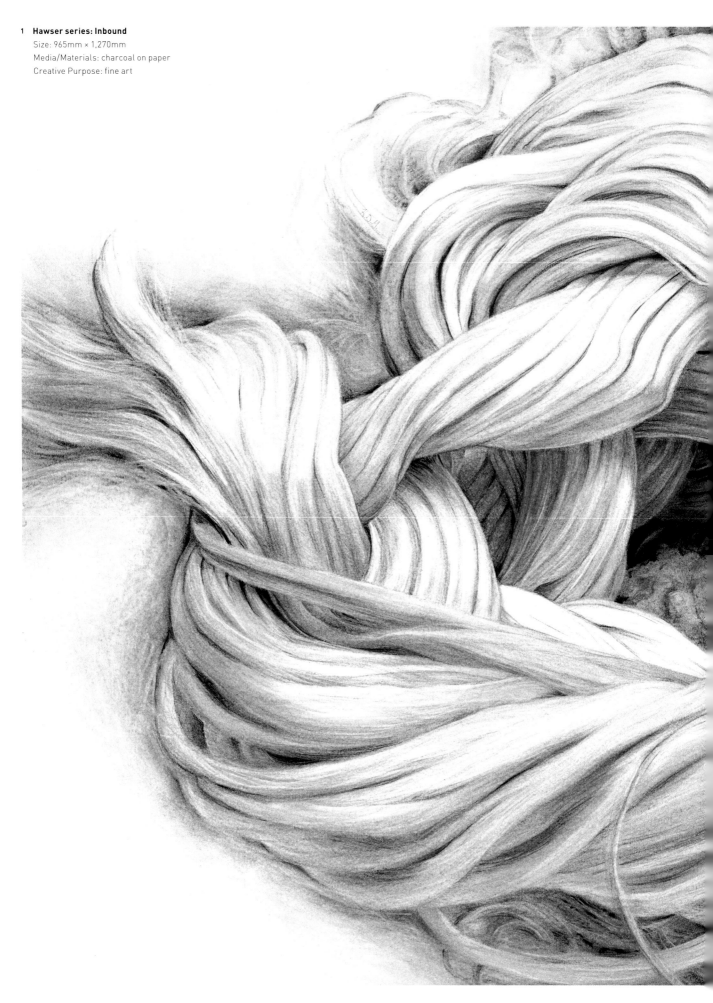

1 Hawser series: Inbound
Size: 965mm × 1,270mm
Media/Materials: charcoal on paper
Creative Purpose: fine art

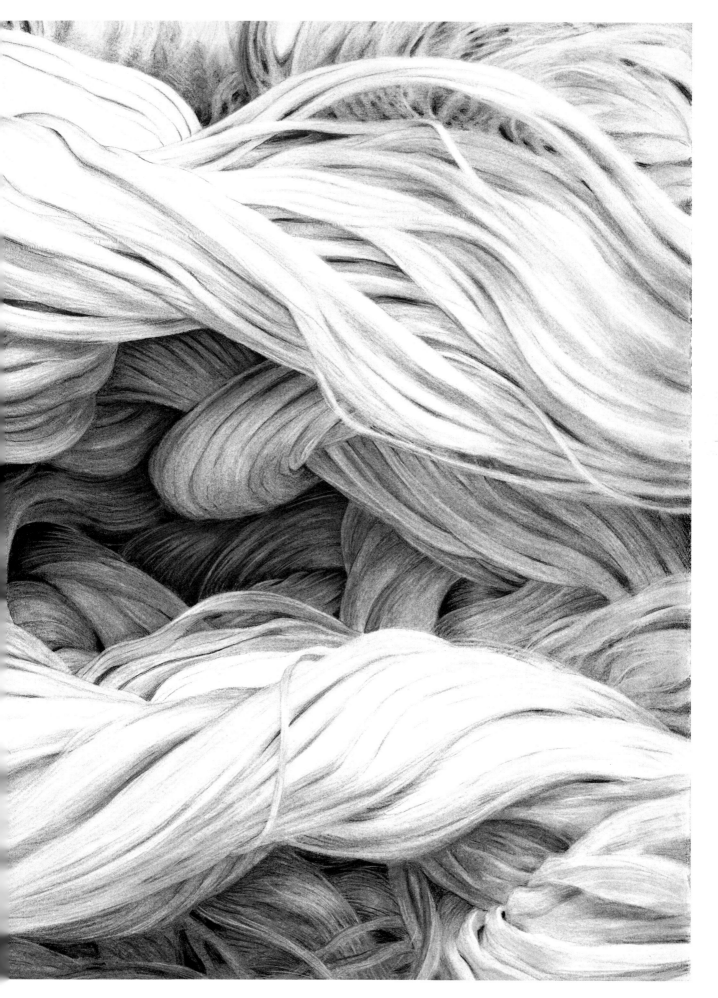

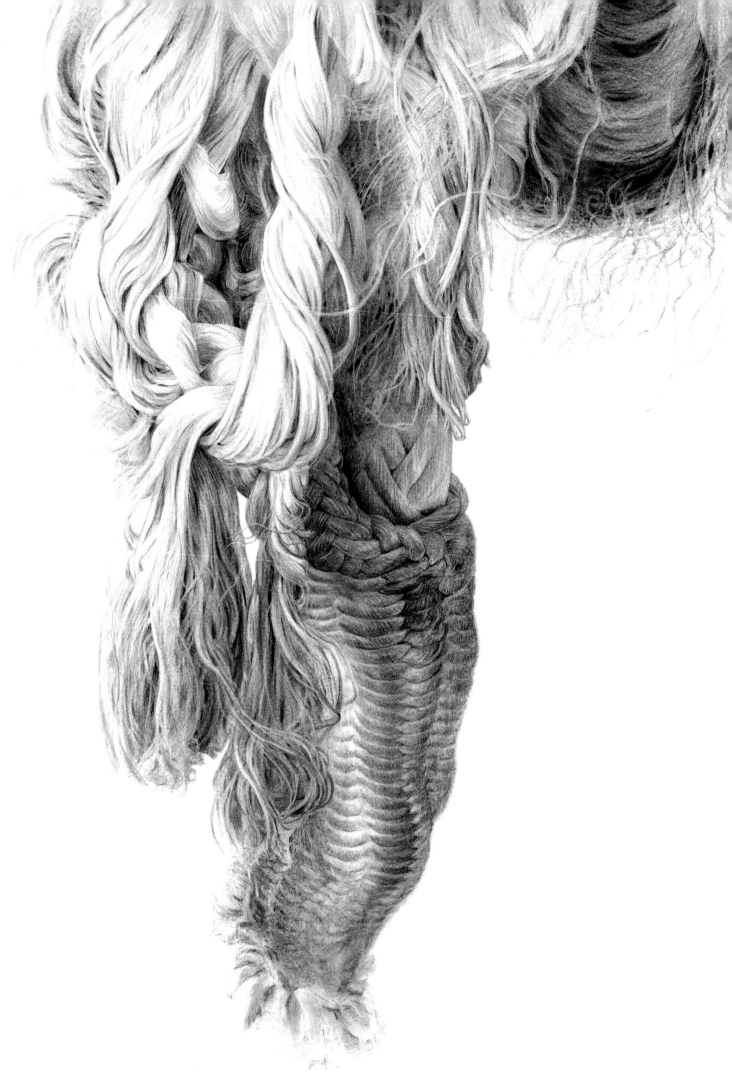

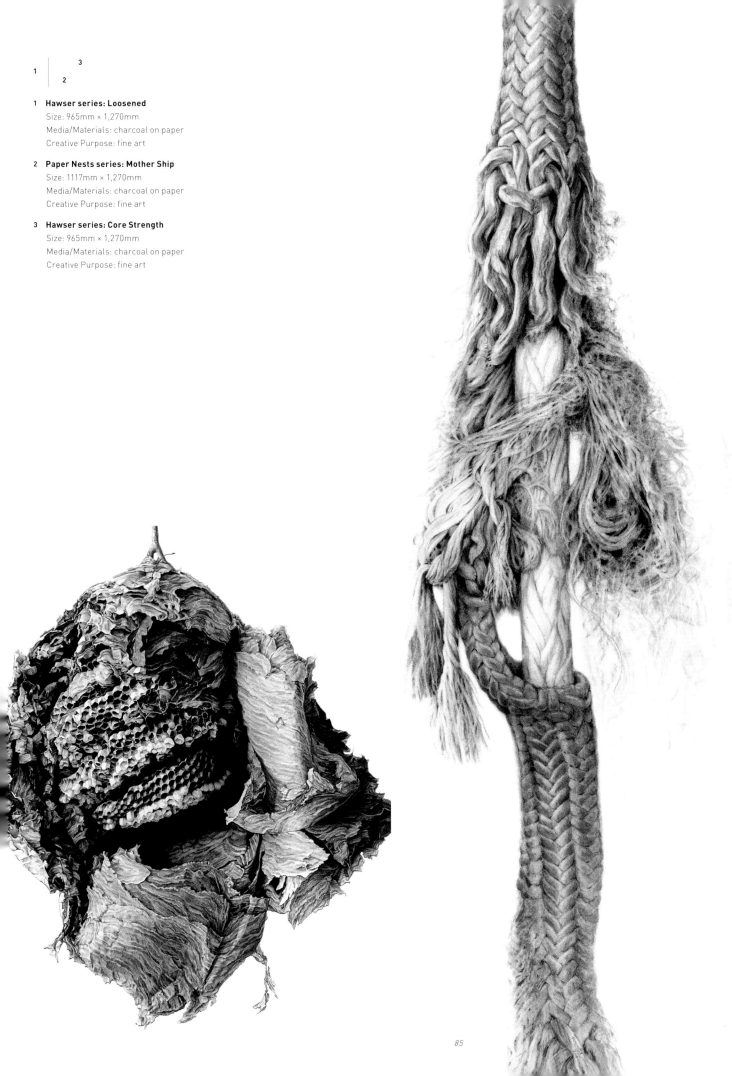

1 | 3
 | 2

1 **Hawser series: Loosened**
Size: 965mm × 1,270mm
Media/Materials: charcoal on paper
Creative Purpose: fine art

2 **Paper Nests series: Mother Ship**
Size: 1117mm × 1,270mm
Media/Materials: charcoal on paper
Creative Purpose: fine art

3 **Hawser series: Core Strength**
Size: 965mm × 1,270mm
Media/Materials: charcoal on paper
Creative Purpose: fine art

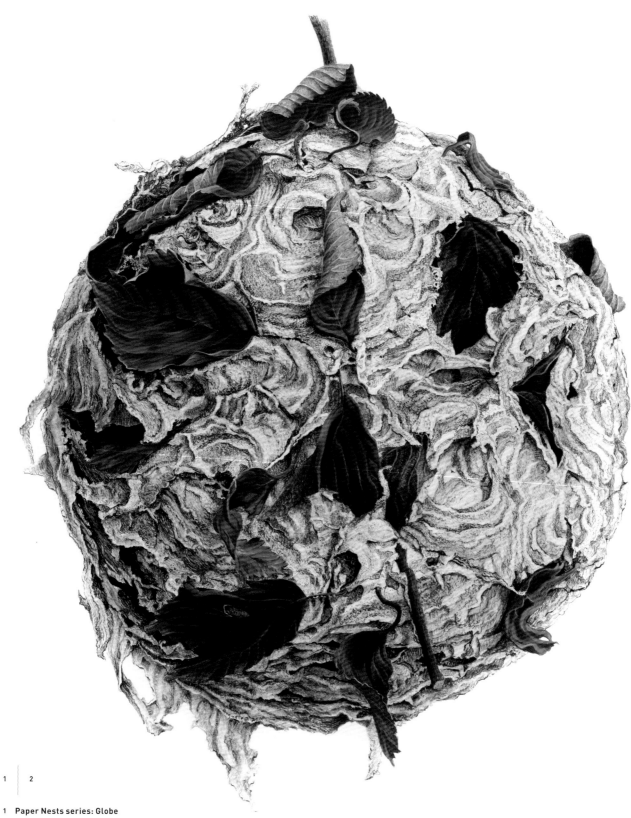

1 **Paper Nests series: Globe**
Size: 533mm × 533mm
Media/Materials: charcoal and pastel on paper
Creative Purpose: fine art

2 **Hawser series: Tempest**
Size: 965mm × 1,270mm
Media/Materials: charcoal on paper
Creative Purpose: fine art

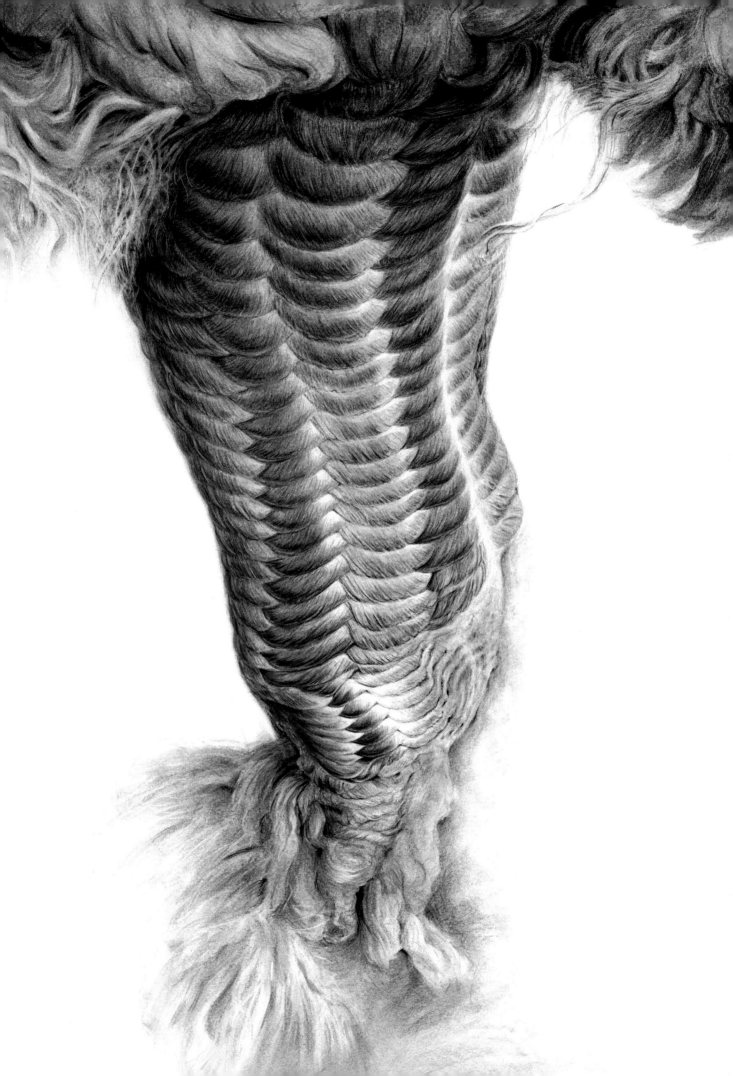

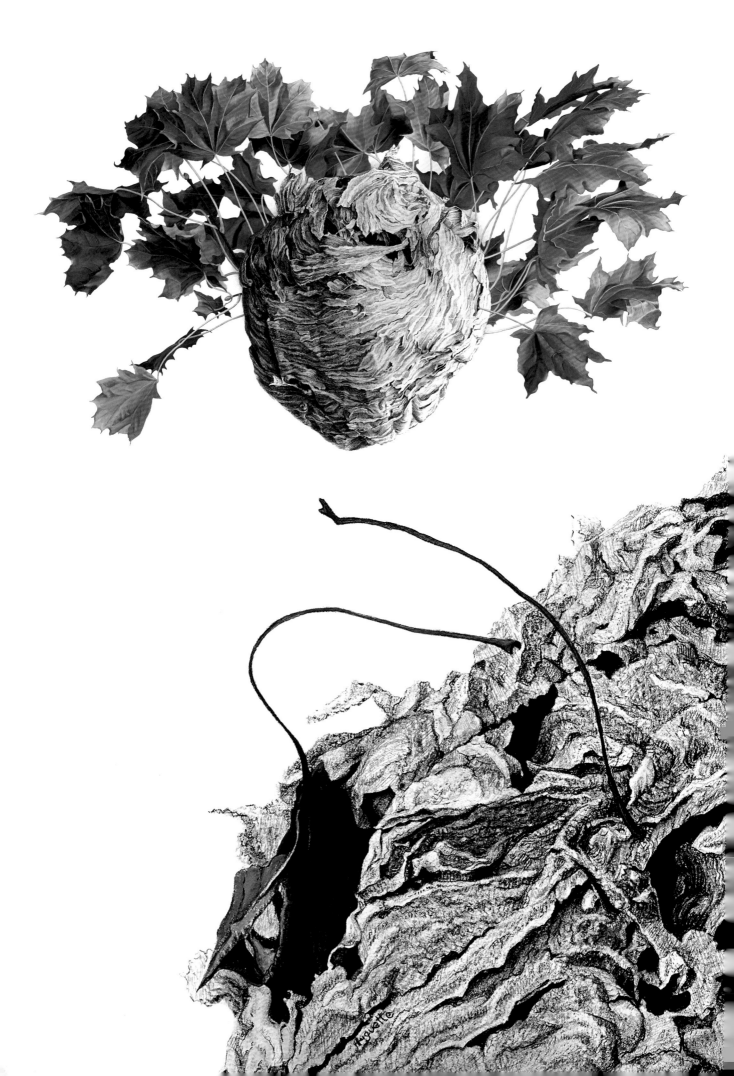

1 **Paper Nests series: Corona**
Size: 838mm × 1,270mm
Media/Materials: charcoal and pastel on paper
Creative Purpose: fine art

2 **Paper Nests series: Red Stems**
Size: 380mm × 533mm
Media/Materials: charcoal and pastel on paper
Creative Purpose: fine art

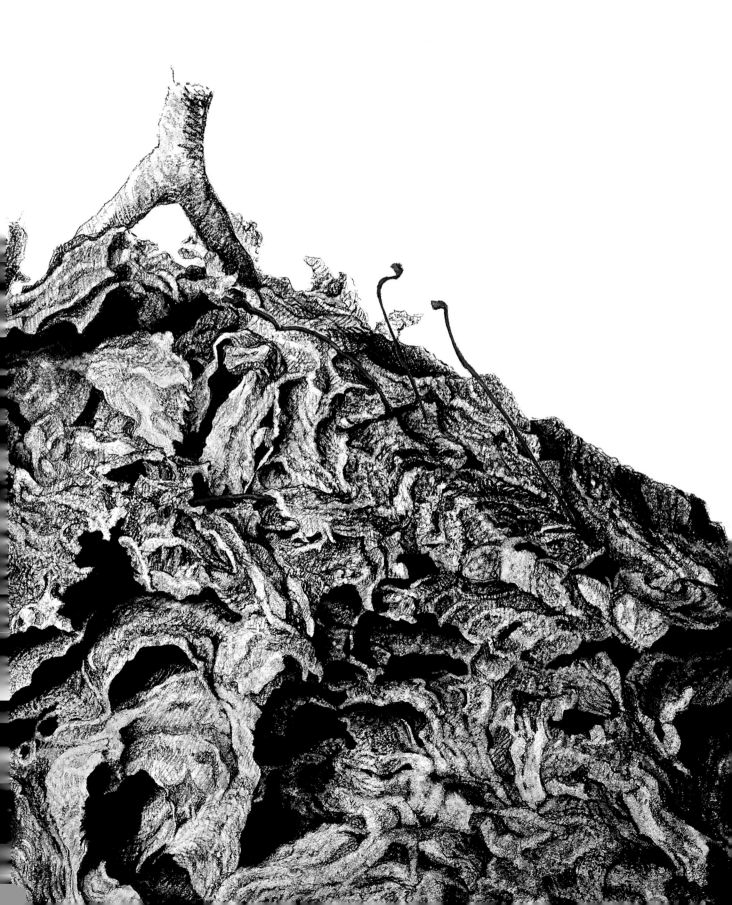

LITTLE E

Nationality: China
xiaoe.zcool.com.cn
weibo.com/suspection

Little E was born in Shandong province, China, and currently lives in Beijing. Most of her works are full of complex two-dimensional black-and-white decorative patterns, which make ideas out of the expression of lines and construction of patterns. By using new elements of illustration, Little E gives a fresh breath to decorative drawing.

Q: **Why did you choose lines as the expressional tools for your artworks?**

A: When I was studying in art school, I found drawing lines is what I'm good at. And by doing it for a long time, lines has become my main art language.

Q: **Where do your inspirations come from? Can you tell us about some of your favorite artists?**

A: Though not so directly, what I draw is still the product of what I saw. As examples, the chubby giant panda in Chengdu, the elfin squirrel in Dali, and the gorgeous peacock in Xishuangbanna. I drew them after I saw them.
My favorite artists? Too many of them! James Jean, Edward Hopper, Harry Clarke, Takato Yamamo and Yoshitaka Amano.

Q: **Could you give us some tips on how to draw beautiful lines? Does it take much practice and patience?**

A: Practice and patience can help you to better your techniques. But I think the ideas are more important, otherwise there would be a pile-up of lines, with no beauty in it.

Q: **How would you describe your works to the gallery, client, or potential buyers? How well do you think line art performs in the market, such as in galleries, and in the illustration market?**

A: Last year, when I participated in an exhibition in Beijing 798 Art Zone, I called my works "hard pen drawings." I tell other people that this is a brand new type of art that is similar to other well-known art types such as oil painting and watercolor. Though I rarely participate in, I see line art performs very well in the illustration market, and could be even better in the future.

1 **Memories Are Watching Me**
Size: 210mm × 297mm
Media/Materials: ink pen on paper
Creative Purpose: personal

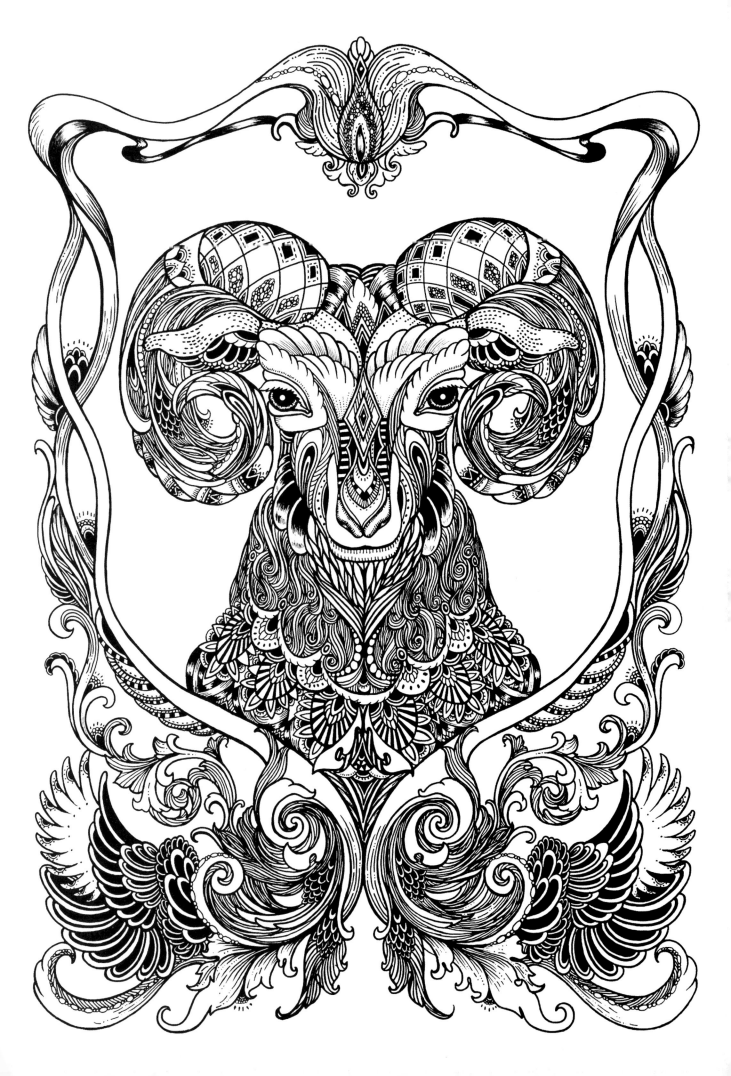

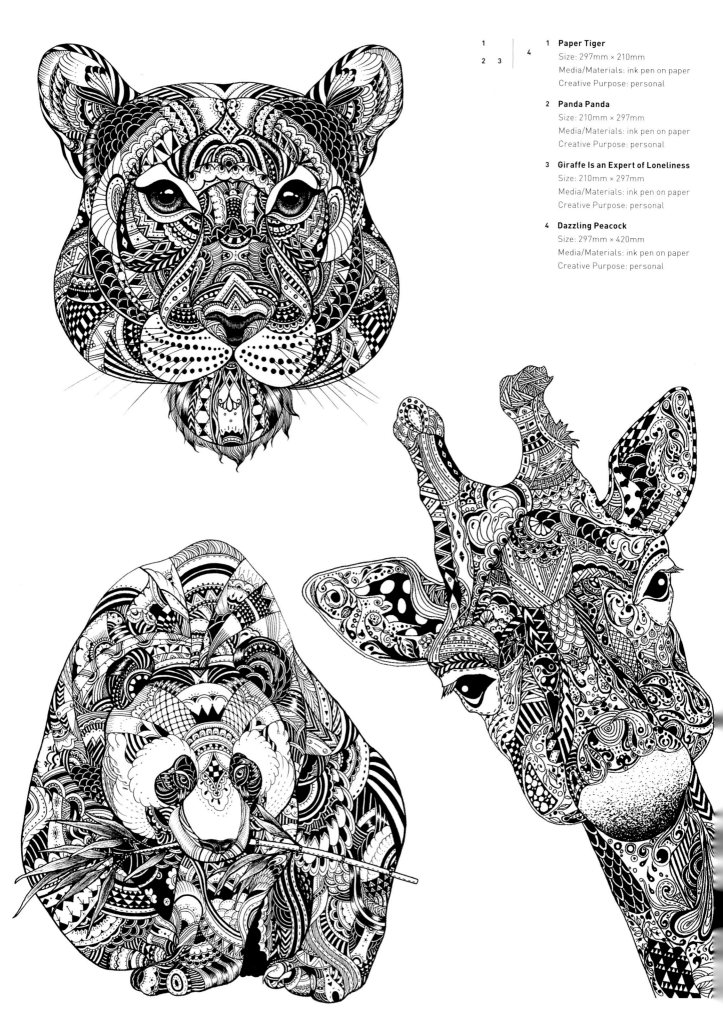

1 **Paper Tiger**
Size: 297mm × 210mm
Media/Materials: ink pen on paper
Creative Purpose: personal

2 **Panda Panda**
Size: 210mm × 297mm
Media/Materials: ink pen on paper
Creative Purpose: personal

3 **Giraffe Is an Expert of Loneliness**
Size: 210mm × 297mm
Media/Materials: ink pen on paper
Creative Purpose: personal

4 **Dazzling Peacock**
Size: 297mm × 420mm
Media/Materials: ink pen on paper
Creative Purpose: personal

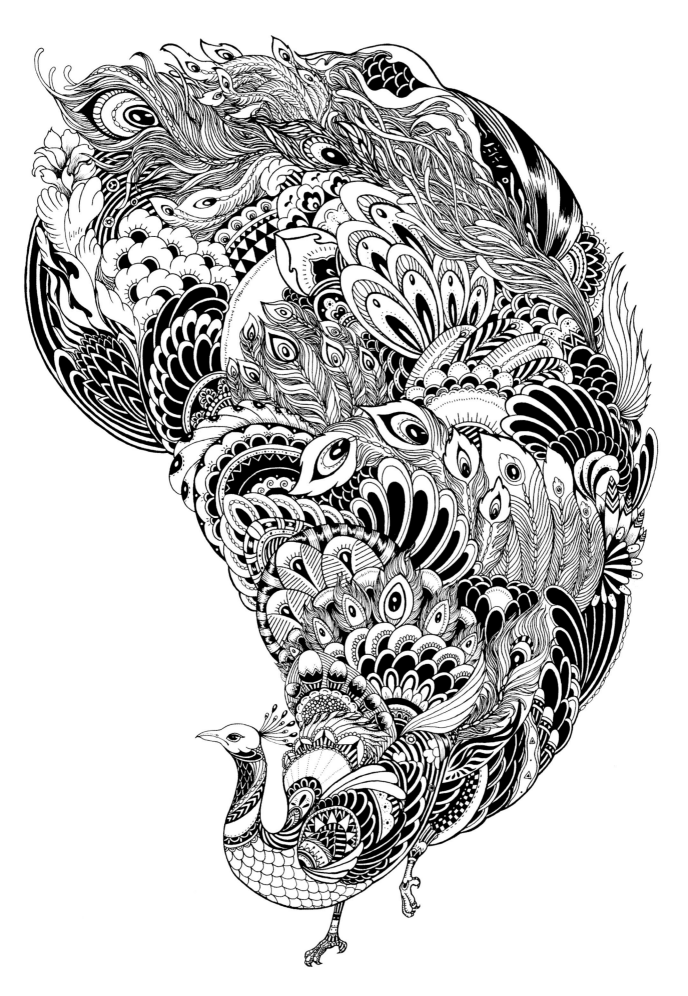

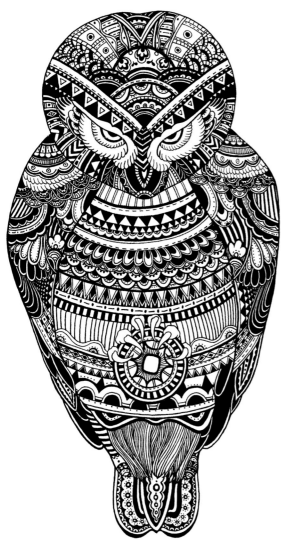

1 | 3
2

1 You Listen to a Person Changing Quietly
210mm × 297mm
Media/Materials: ink pen on paper
Creative Purpose: personal

2 Painted Feather
Size: 210mm × 297mm
Media/Materials: ink pen on paper
Creative Purpose: personal

3 Dragon
Size: 297mm × 420mm
Media/Materials: ink pen on paper
Creative Purpose: personal

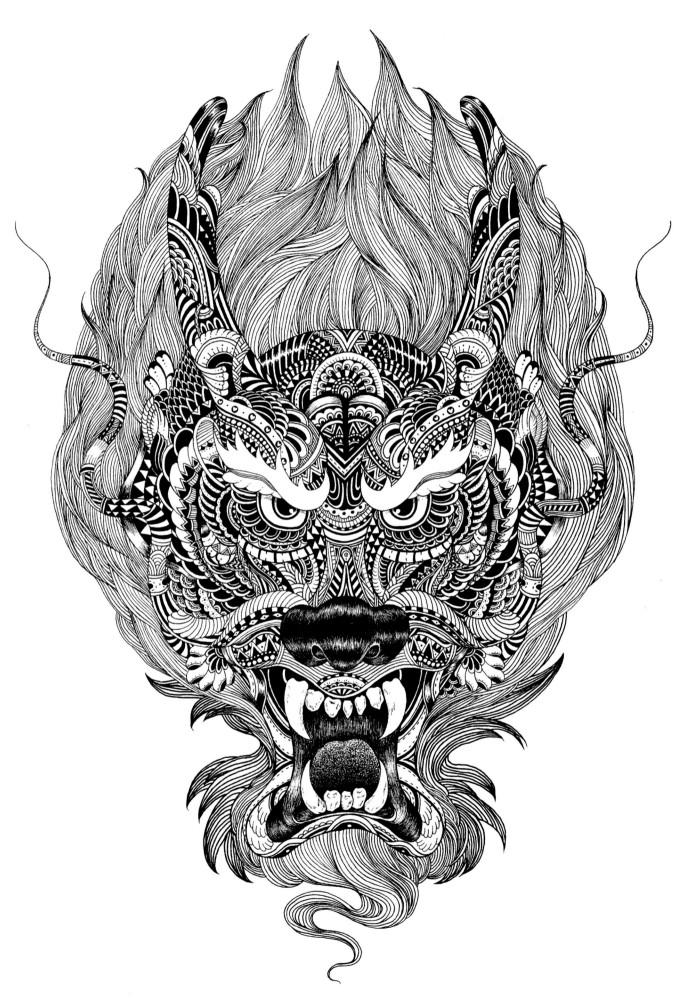

FUMI MINI NAKAMURA

Nationality: America
miniminiaturemouse.com
miniminiaturemouse.tumblr.com

Fumi Mini Nakamura was born in 1984 in Japan and currently lives and works in the New York City. She was born in a small town called Shimizu, Shizuoka, in Japan, and grew up surrounded by majestic mountains and endless ocean. She moved to the United States when she was 12 years old. She attended San Jose State University and studied fine arts in pictorial art concentrating on drawing. She began her drawing project/portfolio under the name of Miniminiaturemouse in 2004 and has worked with various clients including Puma, Gap, Urban Outfitters, NYLON Magazine, Bloomsbury, and published her works in various printed media.

Q: Why did you choose lines as the expressional tools for your artworks?

A: It's more meticulous and precise compared to other materials for me. It also fits my personality and I like detailed work. Using pencils to create lines is more satisfying than creating big splotches of colors. There is more information and more stories/emotions to it.

Q: Where do your inspirations come from? Can you tell us about some of your favorite artists?

A: I don't have any favorite artist at the moment. I'm inspired by fashion designers like Valentino because of all the small details he creates in each garment. I want to be able to draw/create something as minuscule and detailed as his garments.

Q: Could you give us some tips on how to drawing beautiful lines? Does it take much practice and patience?

A: Just patience.

O: How would you describe your works to the gallery, client, or potential buyers? How well do you think line art performs in the market, such as in galleries, and in the illustration market?

A: I usually don't tell much about my work to others. I would rather see/hear what they feel from it. Sometimes I see pictures of people staring into my work and getting lost in lines/details. I appreciate that more than talking about what to create. Also it all depends on how the marketing side plays! Having good clients and galleries are as important as having good work.

1 **Your Presence Only Remains Behind My Closed Eyes**
Size: 254mm × 254mm
Media/Materials: graphite on bristol paper
Creative Purpose: fine art

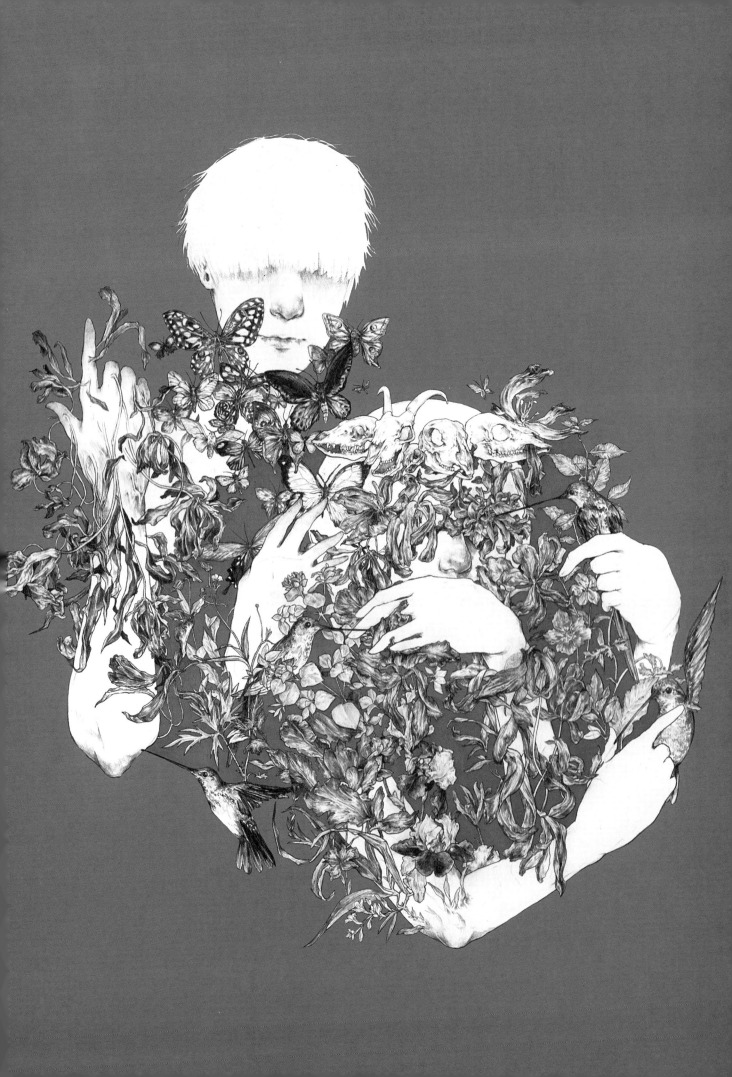

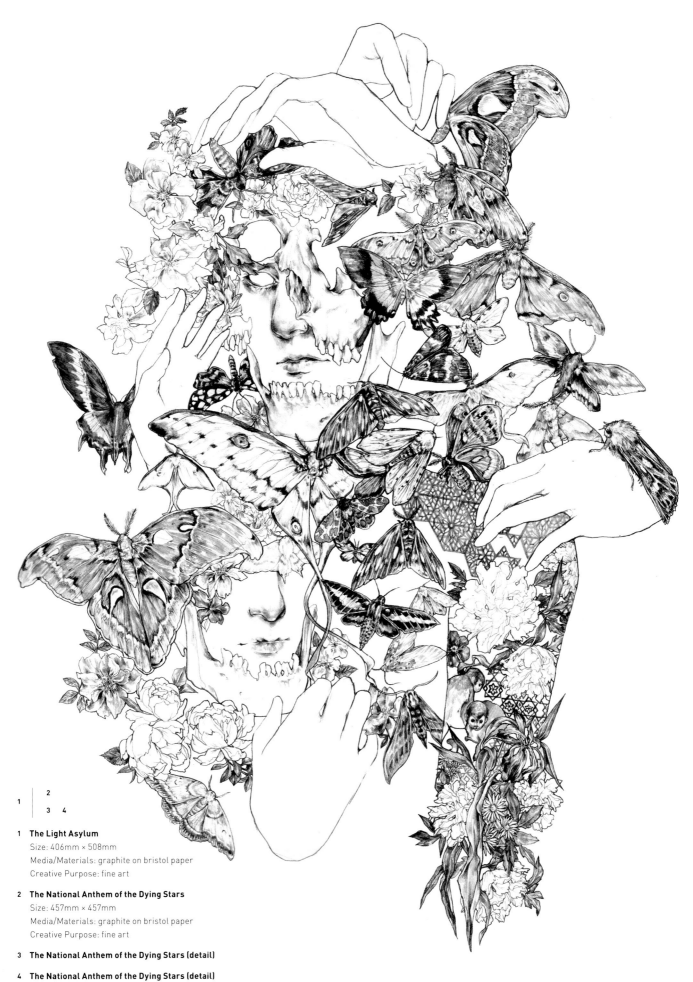

1 | 2
 | 3 4

1 **The Light Asylum**
 Size: 406mm × 508mm
 Media/Materials: graphite on bristol paper
 Creative Purpose: fine art

2 **The National Anthem of the Dying Stars**
 Size: 457mm × 457mm
 Media/Materials: graphite on bristol paper
 Creative Purpose: fine art

3 **The National Anthem of the Dying Stars (detail)**

4 **The National Anthem of the Dying Stars (detail)**

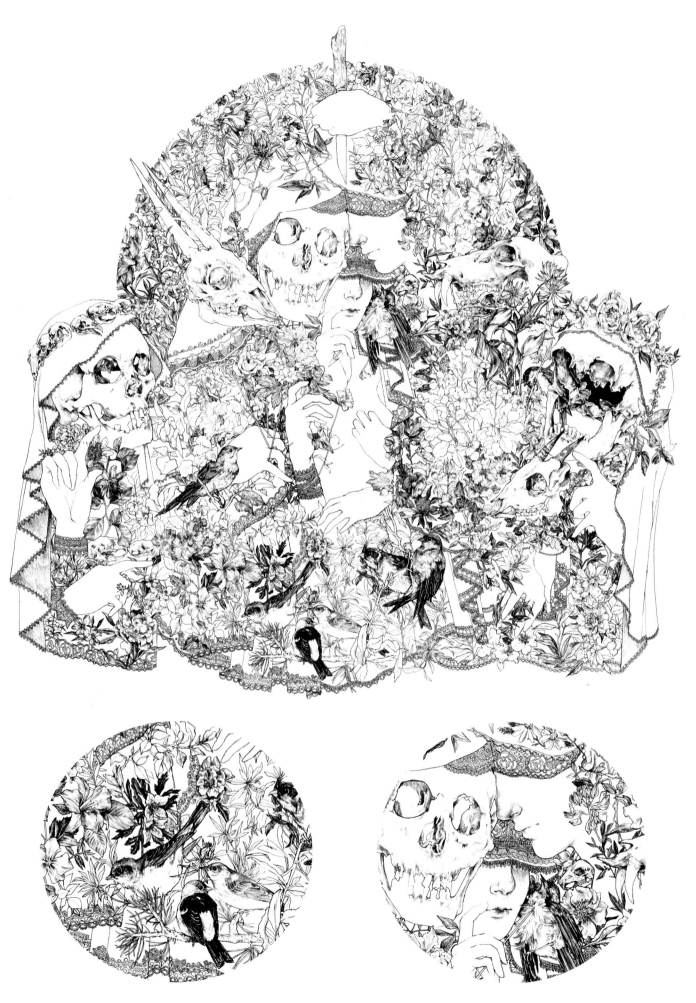

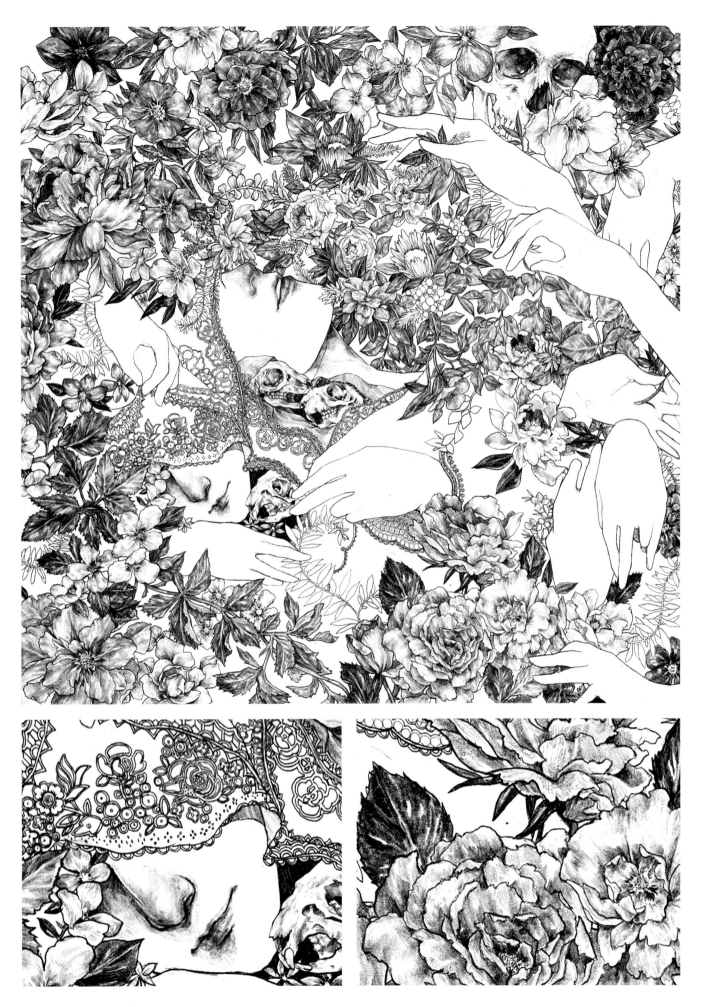

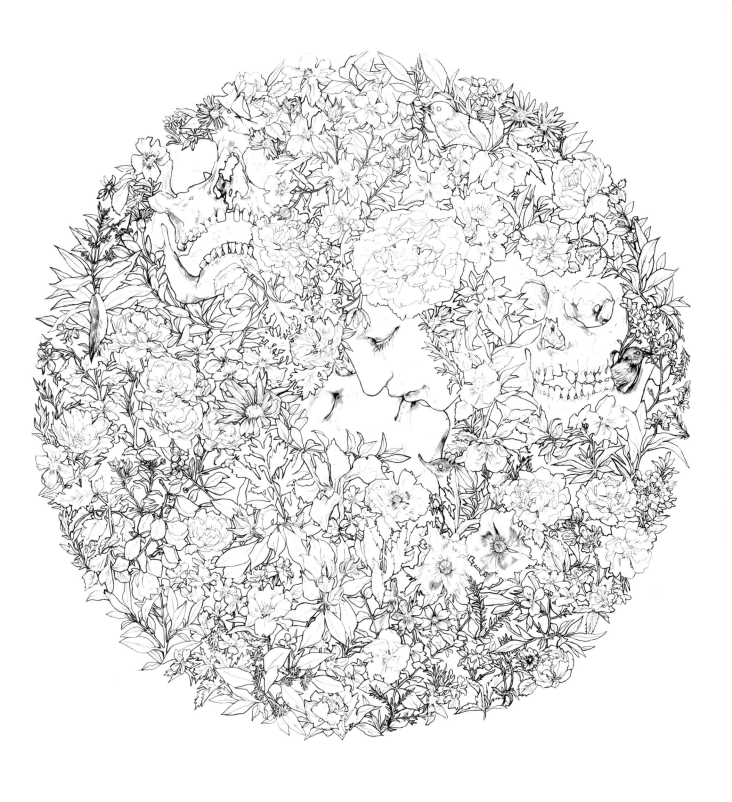

1 **Everyone Dead Wants Answers**
 Size: 254mm × 254mm
 Media/Materials: graphite on bristol paper
 Creative Purpose: fine art

2 **Everyone Dead Wants Answers (detail)**

3 **Everyone Dead Wants Answers (detail)**

4 **We Kissed Behind the Solar Eclipse**
 Size: 254mm × 254mm
 Media/Materials: graphite on bristol paper
 Creative Purpose: fine art

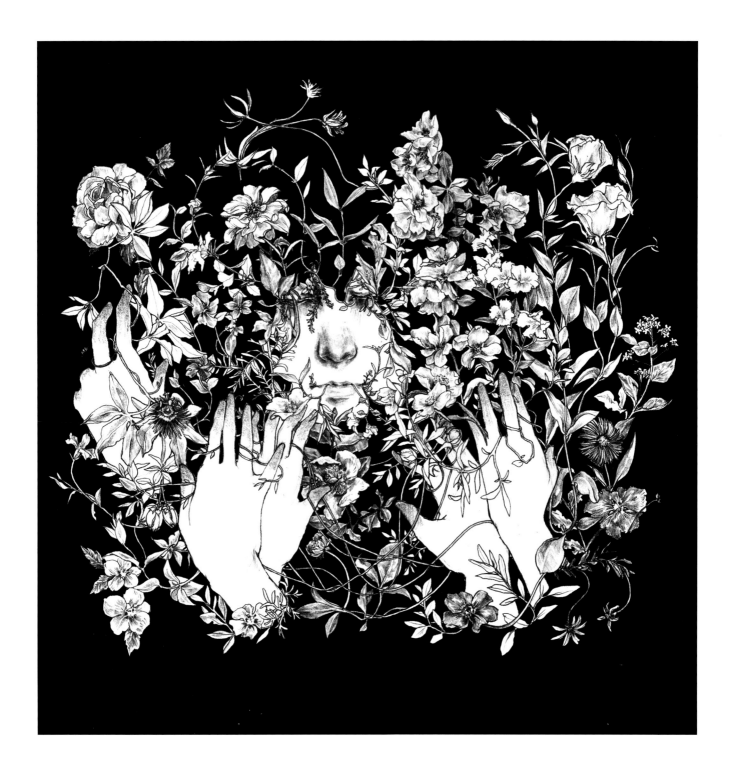

1 **The Slow Rising Smoke from Your Bedroom Window at 6:23AM**
 Size: 203mm × 203mm
 Media/Materials: graphite on bristol paper
 Creative Purpose: fine art

2 **Unexpected News to Be Delivered**
 Size: 203mm × 203mm
 Media/Materials: graphite on bristol paper
 Creative Purpose: fine art

3 **Unexpected News to Be Delivered (detail)**

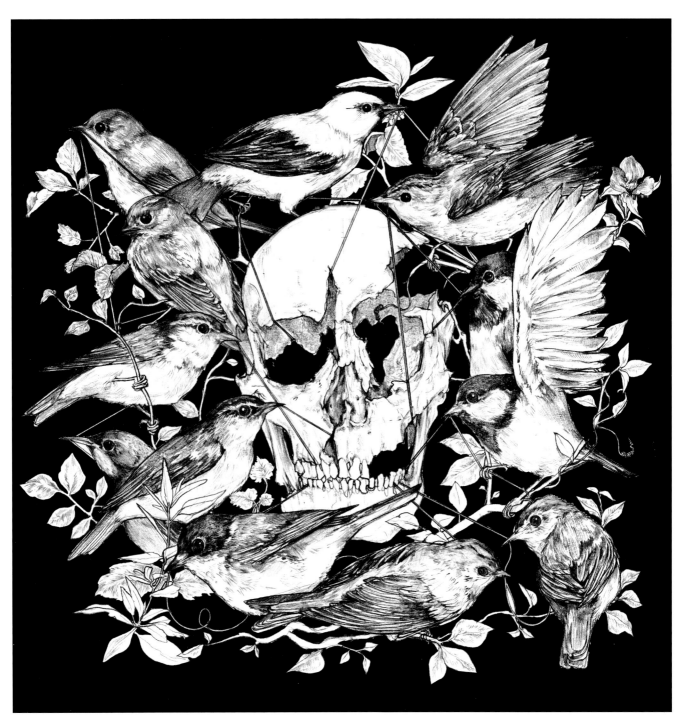

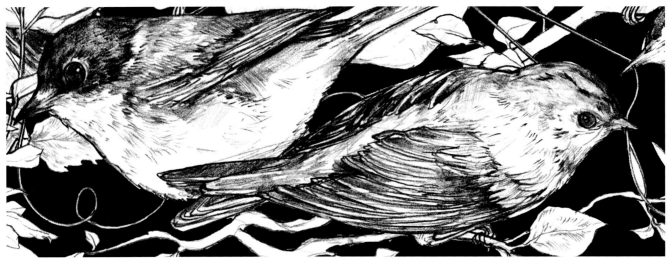

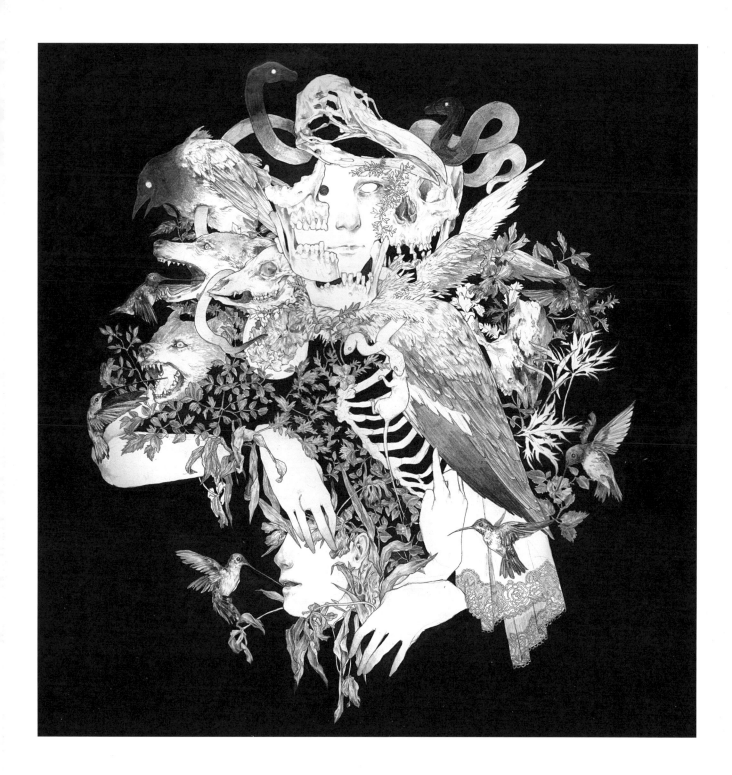

1 **When You Attempt to Remember Something, What Does It Look Like?**
 Size: 254mm × 254mm
 Media/Materials: graphite on bristol paper
 Creative Purpose: fine art

2 **Watch Me Burning/Hold Me While Crumbling/Catch Me As I'm Disappearing**
 Size: 355mm × 431mm
 Media/Materials: graphite on bristol paper
 Creative Purpose: fine art

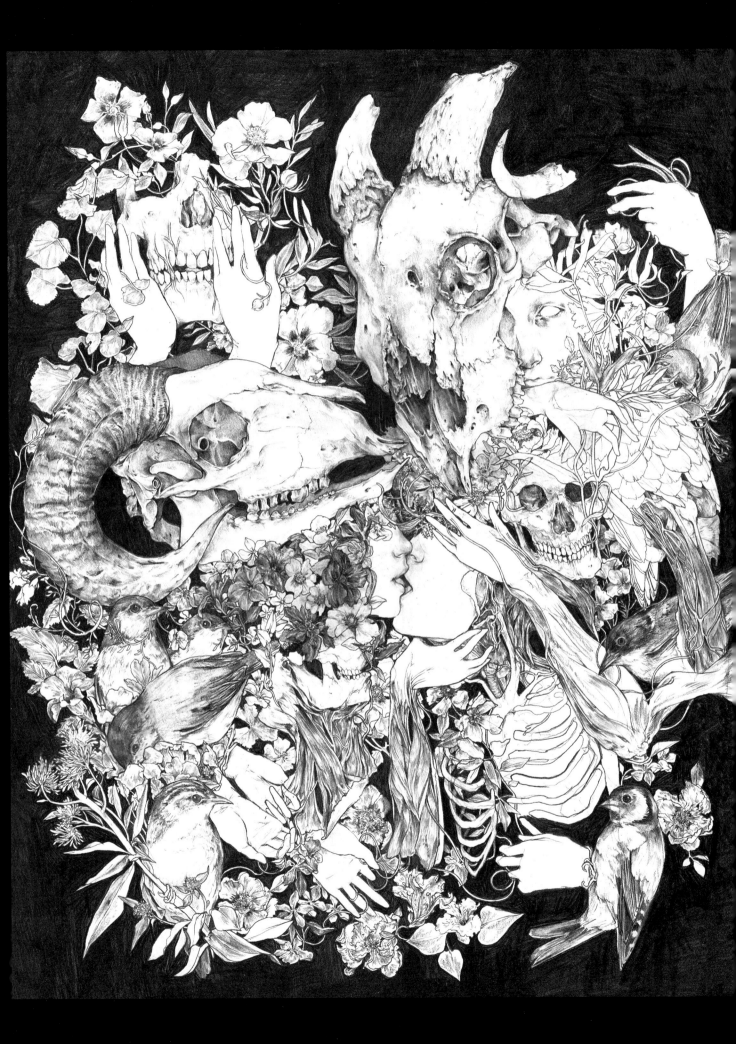

GOOD WIVES
AND WARRIORS

Nationality: United Kingdom
goodwivesandwarriors.co.uk
facebook.com/goodwiveswarriors

Becky Bolton and Louise Chappell are based in London, the United Kingdom, and have worked collaboratively as Good Wives and Warriors since 2007.

They began collaborating soon after graduating from the Painting Department at The Glasgow School of Art. They divide their time between designing large-scale installations for fine art settings and undertaking design commissions for companies in the UK and abroad, including Absolut Vodka, Tiger Beer, Swarovski, Adidas, Chevrolet and Swatch.

They have exhibited around the world, including shows in Berlin, Paris, Melbourne, Buenos Aires, San Francisco and Sao Paulo, and have been featured in a number of publications and books including *ICON* magazine, *Wired* magazine and *Illustration Now! 3* published by Taschen Books.

Q: Why did you choose lines as the expressional tools for your artworks?

A: We have worked together for the past 10 years, and our style has developed naturally over that time. We are intrinsically drawn to using a monochrome line as it works well when creating detailed drawings of interweaving imagery. Recent works for coloring in books have been entirely linear but a lot of our paintings mix line with areas of tone and shading too.

Q: Where do your inspirations come from? Can you tell us about some of your favorite artists?

A: We are inspired by imagery from the natural world and scientific world. We often take literal imagery and mix it with imaginative elements, patterns, strange juxtapositions and splicing. We love a number of artists who create detailed and fantastical artworks like Hieronymus Bosch and M. C. Escher, and also artists who create incredible technical artworks from the natural world like Ernst Haekel and Albrecht Durer.

Q: Could you give us some tips on how to draw beautiful lines? Does it take much practice and patience?

A: I don't know if we can give very much technical advice other than experimenting with different media to find the tools that you like best to draw with. We use different materials depending on our desired result such as a classic Bic Biro for soft delicate lines, 0.1 Staedtlers for clean graphic lines and black board paint for large scale flowing lines. Practice and patience are also beneficial!

Q: How would you describe your works to the gallery, client, or potential buyers? How well do you think line art performs in the market, such as in galleries, and in the illustration market?

A: Line art is definitely well suited to a commercial market as it is a strong visual tool for describing objects and ideas on a two-dimensional picture plain. I think line art also works very well as a fine art medium as contemporary artists such as Ross Nobel and Charles Avery demonstrate.

We describe our work as hand-drawn or painted, detailed, labor-intensive, collaborative and imaginative. As our work ranges in media, technique, format and content, this description can sometimes change depending on what we are describing.

1 **Living Mountain**
Media/Materials: paint on wall
Creative Purpose: commissioned work for Tor Art

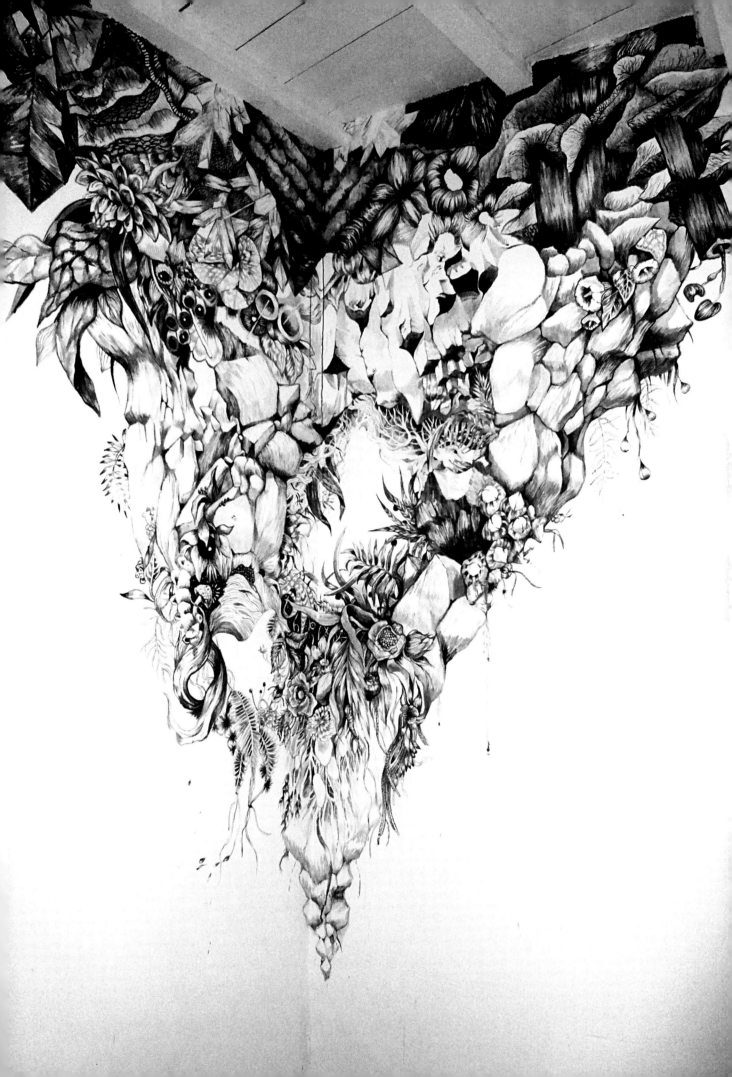

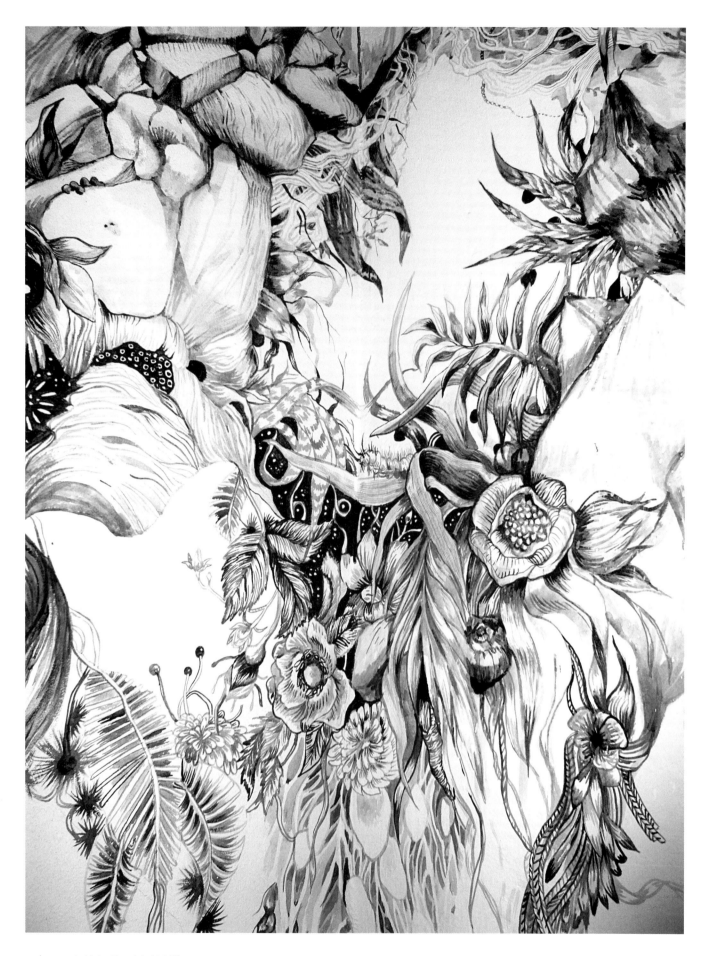

1 | 2

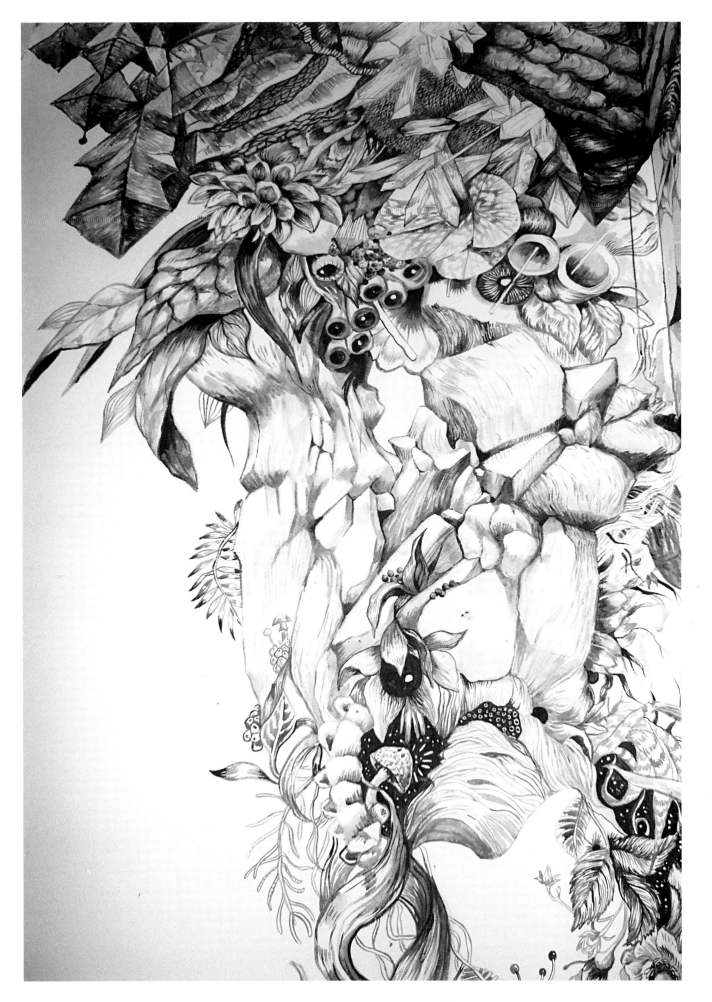

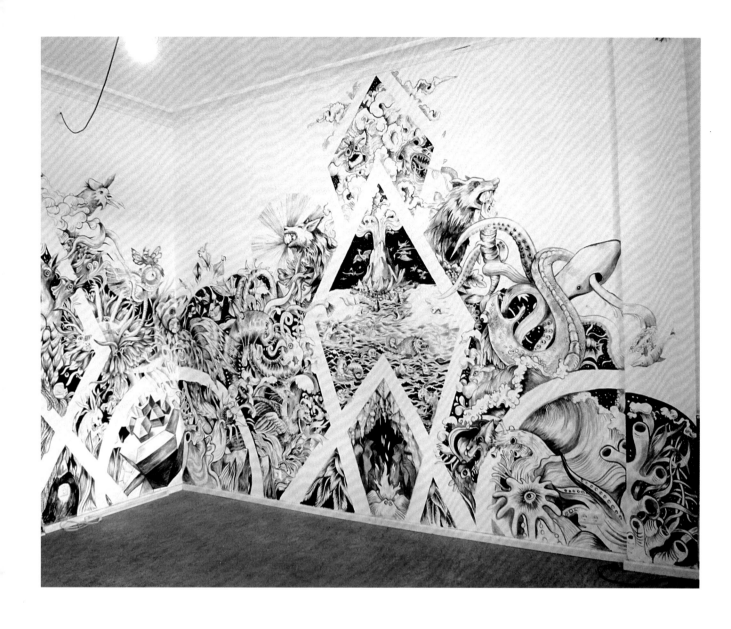

1 2

1 **Der Anfang des Endes (The Beginning of the End) (partial)**
 Media/Materials: paint on four walls
 Creative Purpose: commissioned work for Salon Renate

2 **Der Anfang des Endes (The Beginning of the End) (detail)**

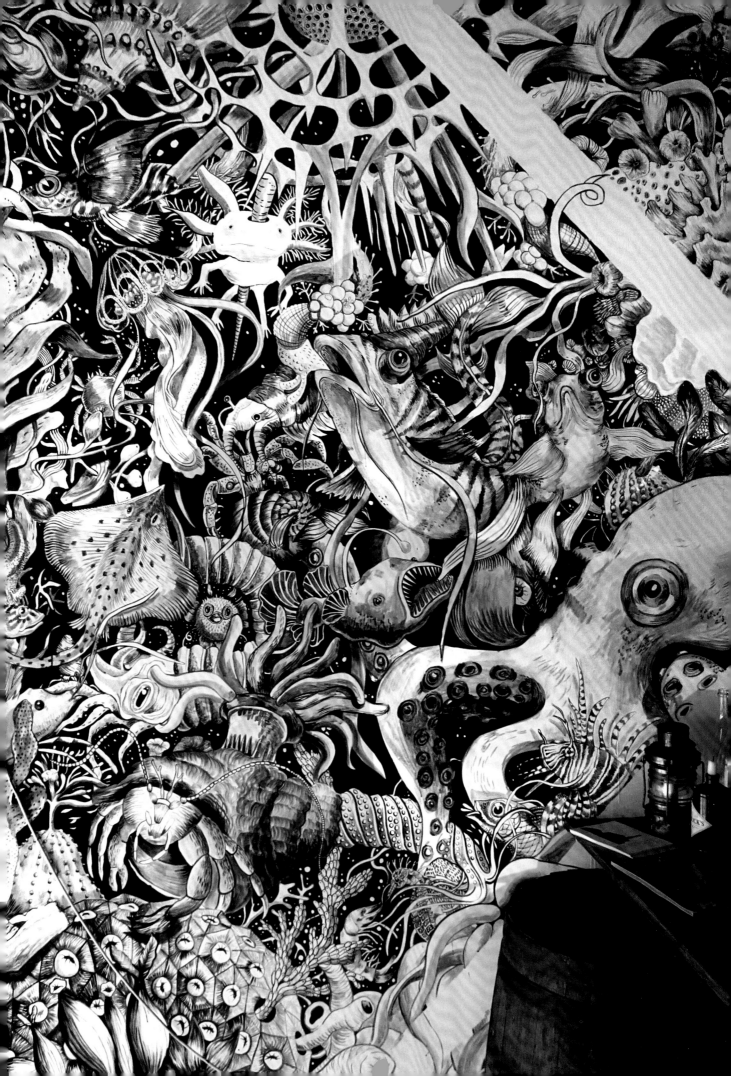

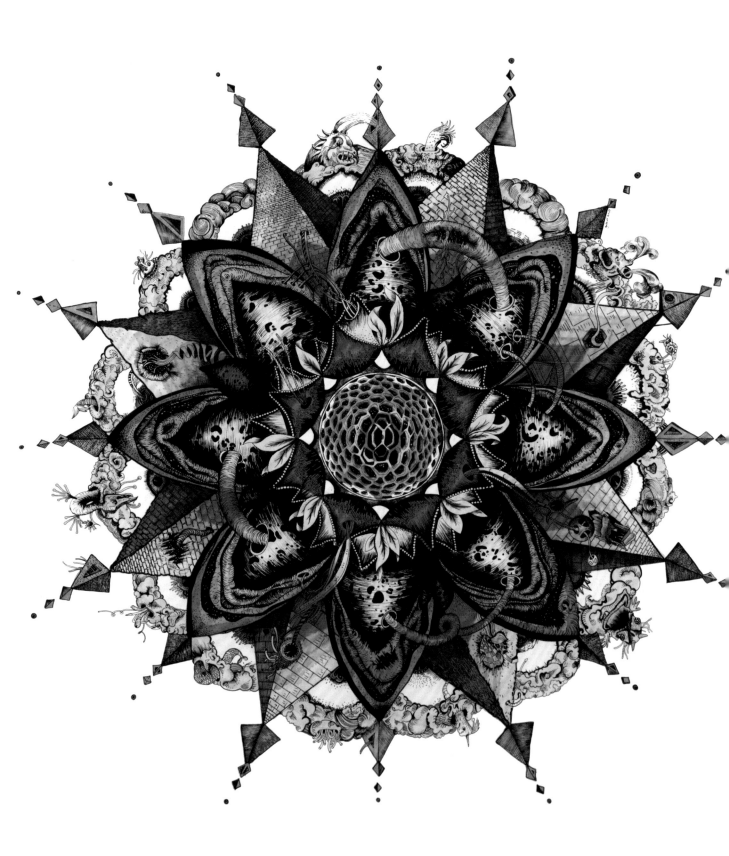

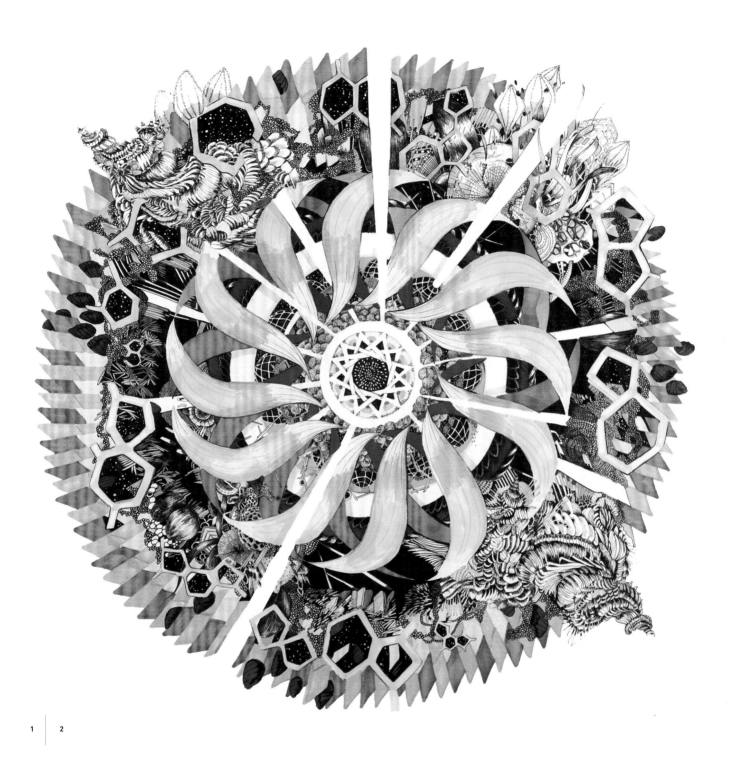

1 **Mandala 1**
 Size: 600mm × 600mm
 Media/Materials: biro, fineliner, posca pen on paper
 Creative Purpose: fine art

2 **Mandala 2**
 Size: 600mm × 600mm
 Media/Materials: biro, fineliner, posca pen on paper
 Creative Purpose: fine art

ANDIE DINKIN

Nationality: America
andiedinkin.com

Based in Brooklyn, Andie Dinkin is an American freelance artist/illustrator.

"My drawings are generally large-scale and obsessively detailed, depicting crowds of people interacting in a flattened party or restaurant scene," she said. "I tightly pack these slightly blank-faced yet elegant characters into intuitive and dream-like settings. As a daydreamer myself, I feel I can never truly immerse into the never-ending and bustling crowds of the New York City. And so I make drawings based upon my observations of these crowds, flattening them out as I see them."

Q: Why did you choose lines as the expressional tools for your artworks?

A: My goal is for my audience to be able to immerse themselves within my imagery and momentarily feel as if they have entered into another time and place. So on the technical side, I feel most in control when drawing lines. It's a slow and patient process, but that control means I am free to explore the depths of each line. Each single line provides so much information and importance. With lines, I have the ability to portray depth and light, simplicity and intricacy.

Q: Where do your inspirations come from? Can you tell us about some of your favorite artists?

A: In particular, I'm drawn to depicting costumes and social life from the 1920s to the 1950s. I am also inspired by the Decadent and Aesthetic Movement with the works of Aubrey Beardsley and Oscar Wilde.

Some of my favorite artists include: Dasha Shishkin, Toulouse Lautrec, Picasso, Egon Schiele, Gustav Klimt, Modigliani, Matisse, Chagal, Edward Gorey, Oscar Wilde, Aubrey Beardsley, James Ensor and Salvidor Dali.

Q: Could you give us some tips on how to draw beautiful lines? Does it take much practice and patience?

A: Drawing takes a lot of patience, dedication and practice. Figure drawing improved my drawing skills the most out of any other practice. I feel that it is something crucial to do in order to draw lines beautifully. In particular, gesture drawings taught me how to make lines quickly and to decipher between lines that are important and lines that are superfluous. It is equally important to learn which lines to include and which to leave out.

Q: How would you describe your works to the gallery, client, or potential buyers? How well do you think line art performs in the market, such as in galleries, and in the illustration market?

A: I'm inspired by the themes of the Aesthetic and Decadent Movement, an era of supposedly decadent art by Aubrey Beardsley and plays by Oscar Wilde. As a result, the figures turn into a series of two-dimensional and empty patterns, rather than individuals.

Driven by lines, my drawings are usually large-scale and obsessively detailed. My drawings could serve as open-ended narratives that I have with myself, and that I would like the viewer to continue. I feel that this shows that lines can serve to both the gallery and the illustration market, because it is a dialogue between the audience and me.

1 **Costume Party**
Size: 609mm × 457mm
Media/Materials: etching printmaking
Creative Purpose: fine art

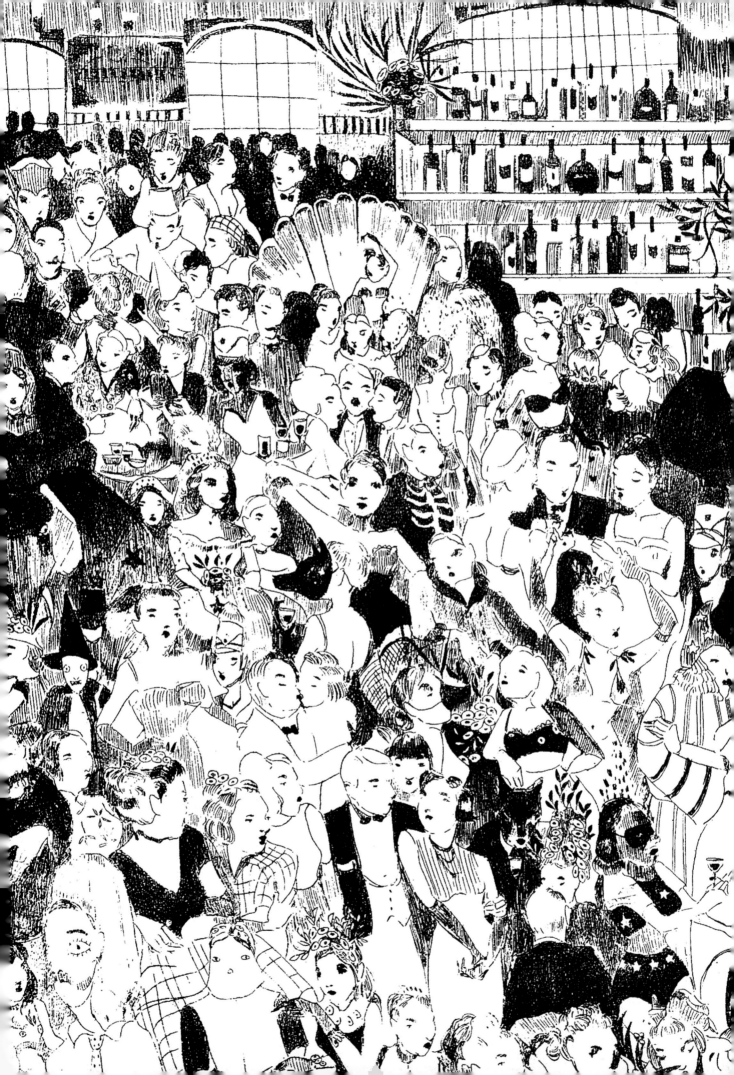

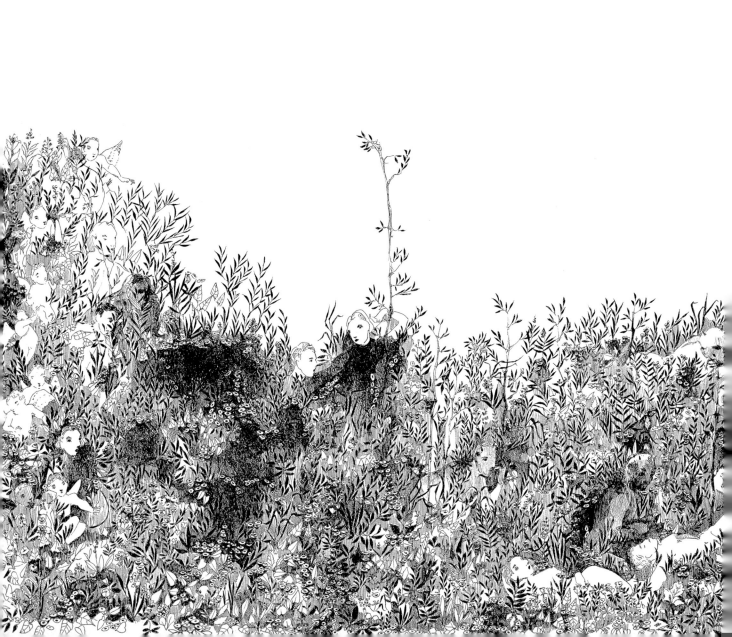

1 **A Midsummer Night's Dream**
Size: 1219mm × 457mm
Media/Materials: pen on paper
Creative Purpose: personal

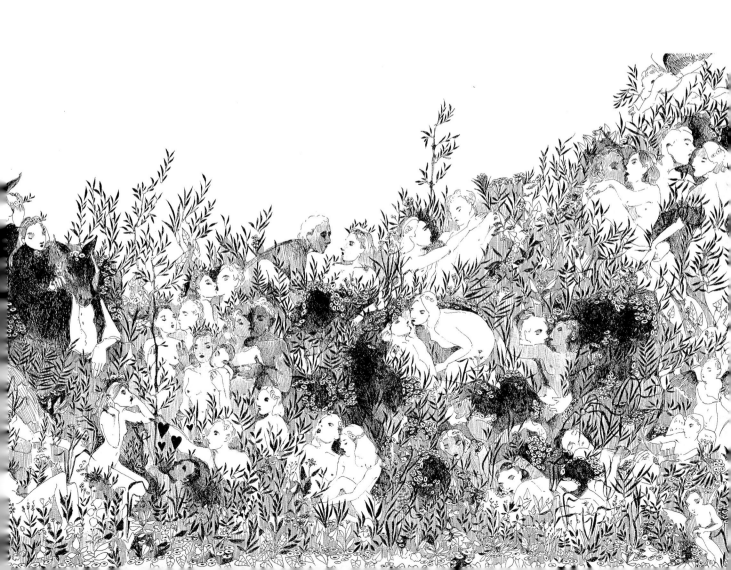

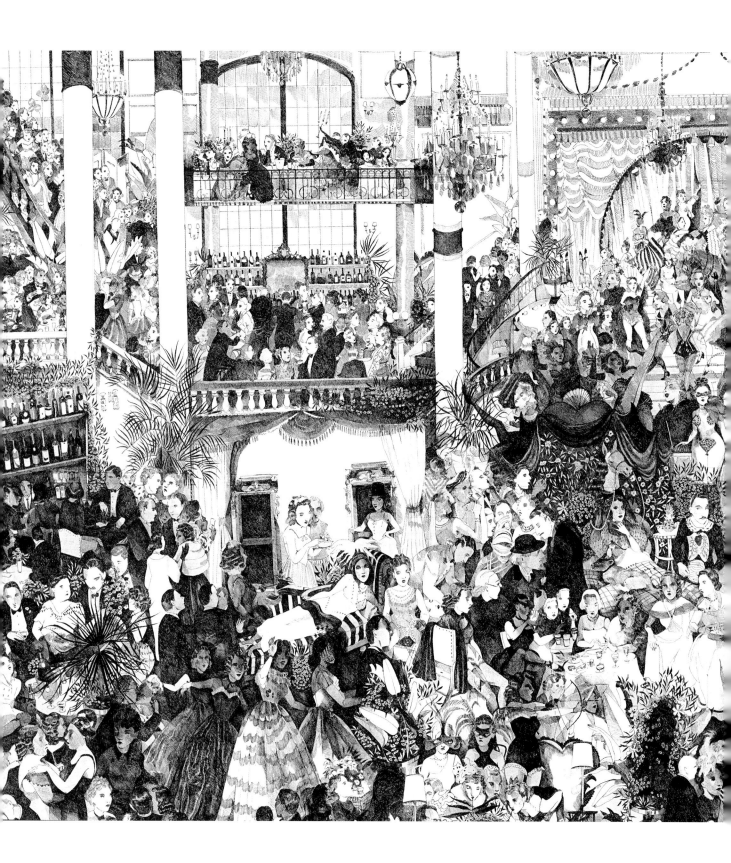

1 **New Year's Eve at Beverly Hills Hotel**
Size: 1,828mm × 914mm
Media/Materials: pen on paper
Creative Purpose: personal

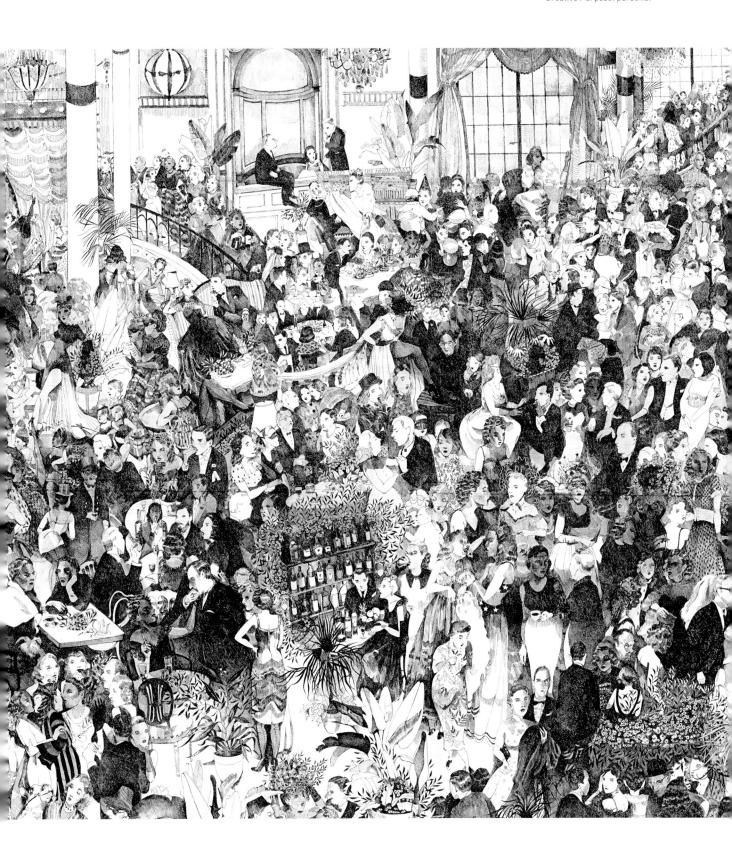

CHRISTINA NOVACHUK

Nationality: Ukraine
behance.net/Hardcookie

Christina Novachuk is an artist and illustrator based in Lviv, Ukraine.

"I'm an artist, although I can call myself illustrator more easily. I graduated with a major in art education, and I'm working as a professional artist, and sometimes a freelance illustrator. I have always admired drawing. My parents noticed it when I was a child and helped me to choose the right path. I am infinitely grateful to them. I think that to draw all the stories that formed in my head is a crazy gift that delights. Convey everything inside yourself on the paper, with great power of desire. Free yourself."

Q: Why did you choose lines as the expressional tools for your artworks?

A: I think that is a great delight when you are drawing with lines. It's some kind of a meditation. I feel calm when I'm drawing lines.

Q: Where do your inspirations come from? Can you tell us about some of your favorite artists?

A: I think my inspiration comes from my spiritual experience; the whole nature world, all the episodes and the moments of my life; and from people, their characters, hands, faces, bodies. But perhaps the greatest influence on me is nature and music and the contrasts in them. I love skulls especially.

And yes, I have some favorite artists. They are Luis Gabriel Pacheco, Burak Senturk, T-Wei, Pez Artwork, Andres Pallavicini, New Fren, 1001Day, Peter Donnelly, Vladimir Stankovic, Steve Simpson, Oleg, and many others.

Q: Could you give us some tips on how to draw beautiful lines? Does it take much practice and patience?

A: Only practice and patience. Sometimes it's hard but later you will be satisfied by the results!

Q: How would you describe your works to the gallery, client, or potential buyers? How well do you think line art performs in the market, such as in galleries, and in the illustration market?

A: I think that every work of art has buyers. Detailed figurative artwork attracts attention, just like the way jewelry work with many small details is expressive!

All the artists can choose their own technique of creative art and find their own market and buyer.

1 **Kitty**
Size: 180mm × 25mm
Media/Materials: liner on paper
Creative Purpose: personal

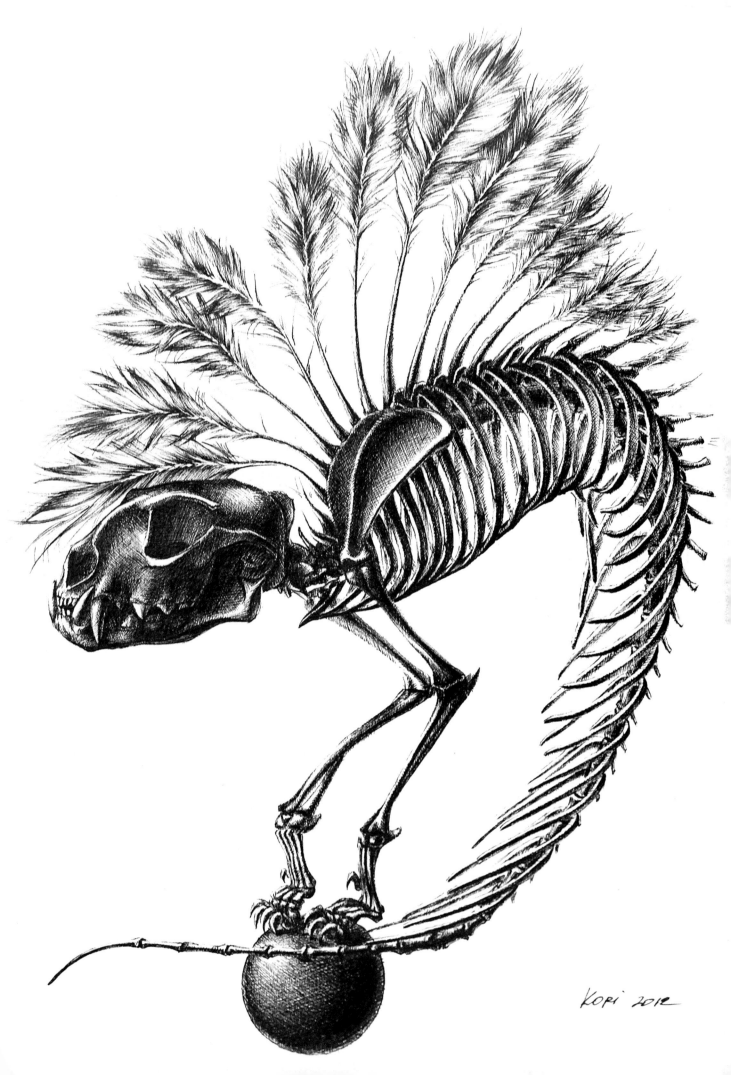

Kori 2012

1 Little Mermaid
Size: 310mm × 420mm
Media/Materials: liner on paper
Creative Purpose: personal

2 Kai and Gerda
Size: 300mm × 420mm
Media/Materials: liner on paper
Creative Purpose: personal

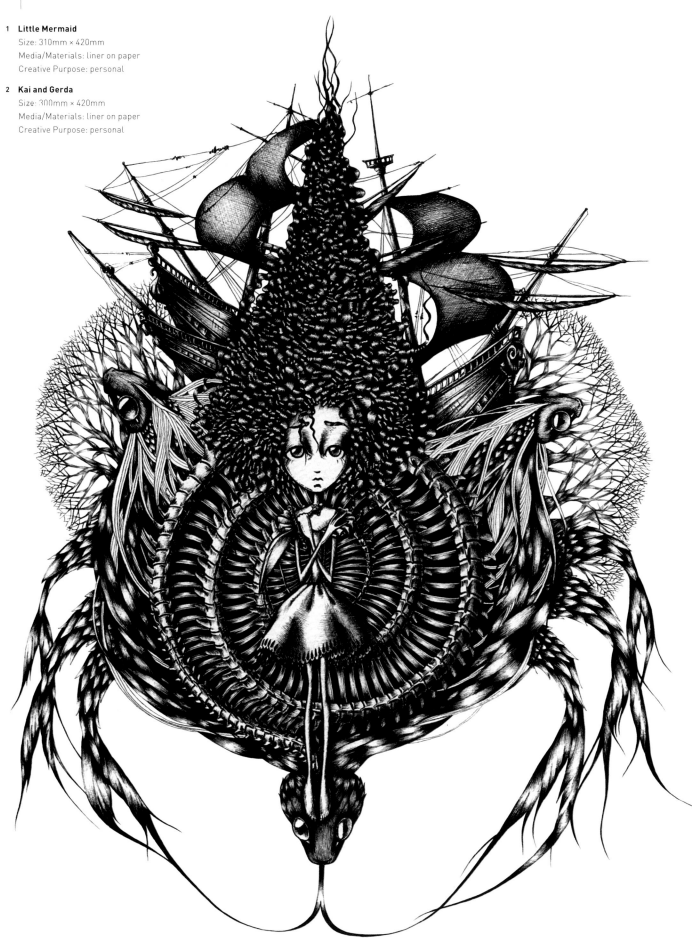

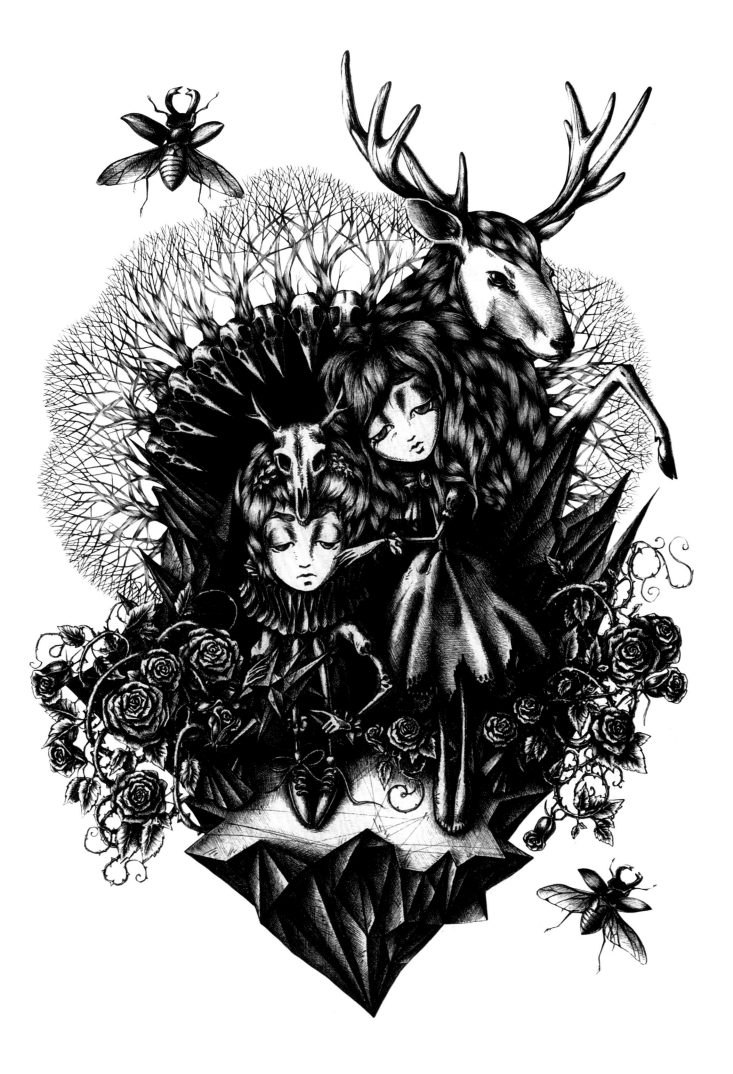

CARL KRULL

Nationality: Denmark

Carl Krull was born in 1975. He graduated from the Academy of Fine Arts in Cracow, Poland, in 1999 and has since contributed to a wide range of exhibitions in both Denmark and abroad.

Carl Krull is a consummate draftsman whose practice centers on drawing. Utilizing an almost sculptural approach in his drawings, the lines seem to protrude the paper in a way that resemble phenomena found in nature like the formations in stalactite caves or the growth rings found in trees. His latest works consist mainly of pencil-on-paper drawings, some of which were done from the passenger seat of a moving car while crossing the United States. On his road trip across the United States he worked on multiple scrolls, some of which were drawn in the car, and a larger one done on multiple locations throughout the whole country. The journey itself and the method used, drawing line after line almost like a writer brings to mind Jack Kerouac's novel *On the Road*, which was typed on a continuous, 120-foot scroll that Kerouac simply referred to as "the scroll."

Q: Why did you choose lines as the expressional tools for your artworks?

A: Like all children, I started as an abstract artist, then I found the pleasure of drawing symbols of the surrounding world. I drew my mom, my dad, myself, a house, a car, a plane, guns, and war and so on. The most crucial decision concerning what path my artistic expression would take was when I as a young teenager decided that I had to learn how to draw the human body from every angle and in any position I could imagine. I didn't want to look at photos as a reference; I wanted my drawings to be expressed and shaped through me solely.

Q: Where do your inspirations come from? Can you tell us about some of your favorite artists?

A: I'm inspired when I think about perception, how our eyes function and how sensory information becomes images in our minds when light strikes the retina. Playing with cameras and various photographic techniques inspires me. Conversations with friends about the mysteries of life, science, philosophy and all the things I don't understand inspire me.

Q: Could you give us some tips on how to draw beautiful lines? Does it take much practice and patience?

A: I had been working with linear hatching and cross-hatching as a technique for portraying depth for many years. The technique had a tendency of separating background from figure in an undesirable manner, and I was looking for a way of breaking these constraints. Instead of lines acting as borders, separating inside from outside, I started stacking lines one by one like a human printer. Every line has its own characteristic flow but still corresponds and relates to the previous line. In this way drawing has come a step closer to sculpting.

Q: How would you describe your works to the gallery, client, or potential buyers? How well do you think line art performs in the market, such as in galleries, and in the illustration market?

A: My work is figurative in nature and centers primarily on drawing. In almost all my drawings you will find the human form. All my life contour drawing has been my favorite form of expression, but in my most recent work I draw lines very differently than just to outline the shapes in my compositions. Rather than having contours that run along the outlines of a subject, an abundance of lines seems to protrude the subject. As if multiple cross sections have sliced the object and left their paths on its surface emphasizing the three-dimensional space in an almost topographical manner.

1 **Olmec 8**
Size: 1,180mm × 1,720mm
Media/Materials: graphite on paper
Creative Purpose: fine art

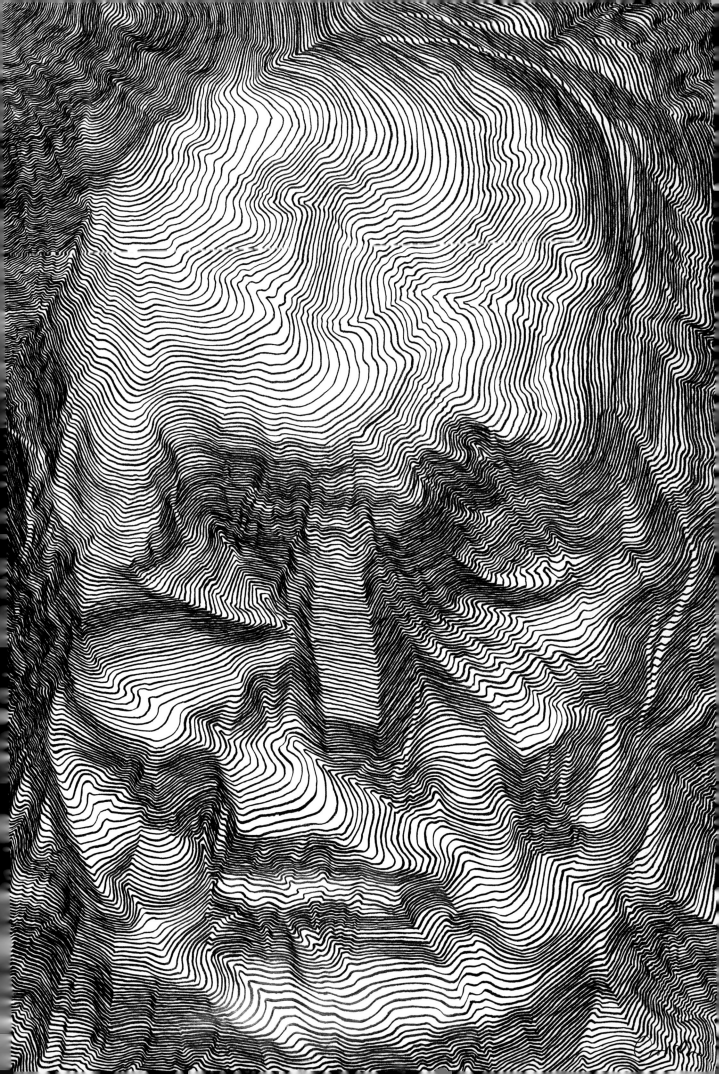

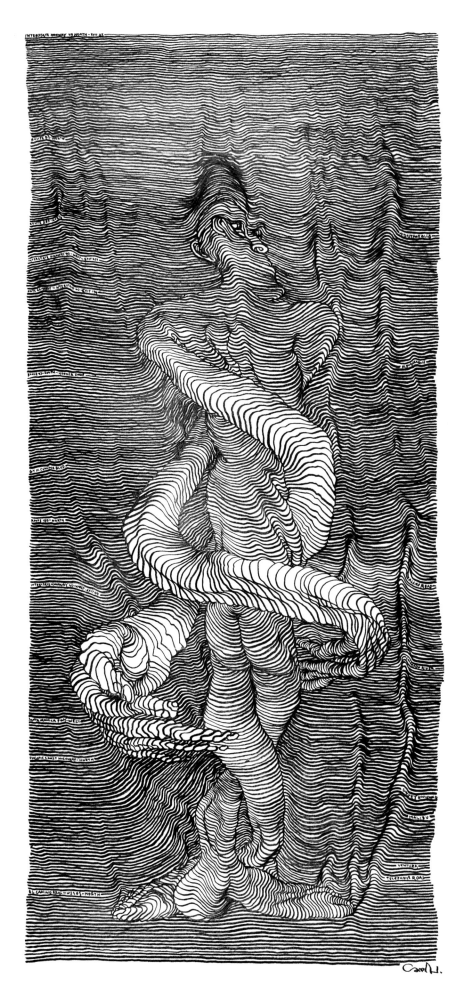

1

	2
1	3

1 Car Drawing 2
Size: 400mm × 1,000mm
Media/Materials: graphite on paper
Creative Purpose: fine art

2 Graphite 5
Size: 1,410mm × 1,000mm
Media/Materials: graphite on paper
Creative Purpose: fine art

3 Graphite 1
Size: 1,410mm × 1,000mm
Media/Materials: graphite on paper
Creative Purpose: fine art

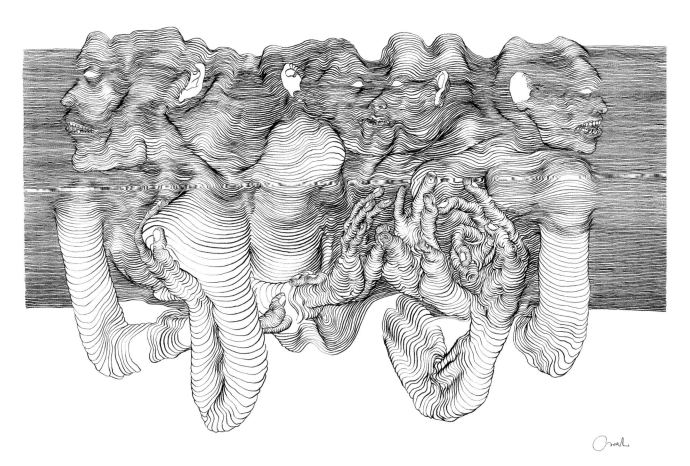

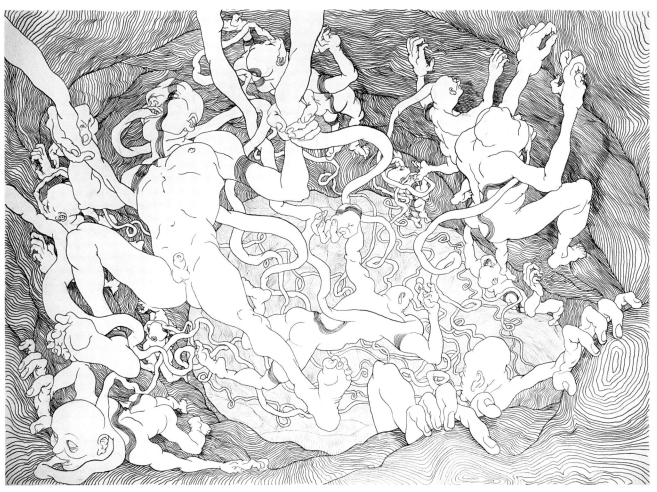

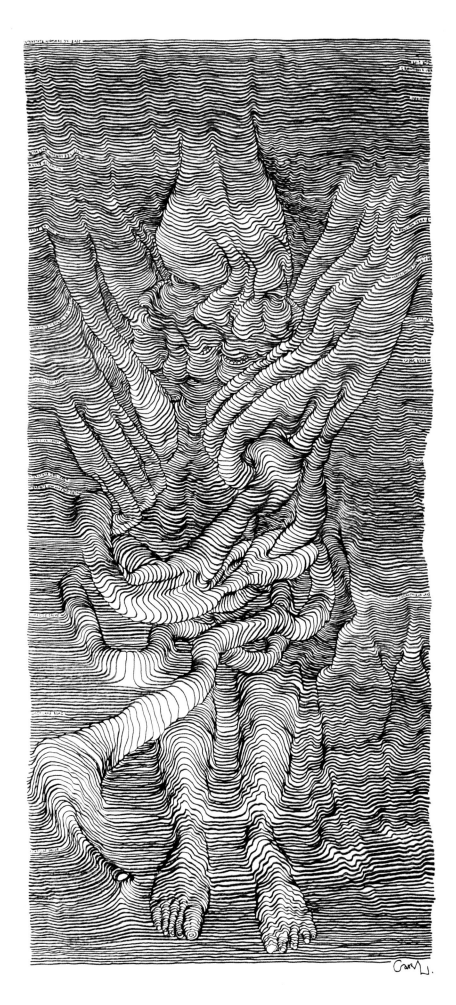

1 | 2
 | 3

1 Car Drawing 5
Size: 400mm × 1,000mm
Media/Materials: graphite on paper
Creative Purpose: fine art

2 Graphite 8
Size: 1,410mm × 1,000mm
Media/Materials: graphite on paper
Creative Purpose: fine art

3 Graphite 2
Size: 1,410mm × 1,000mm
Media/Materials: graphite on paper
Creative Purpose: fine art

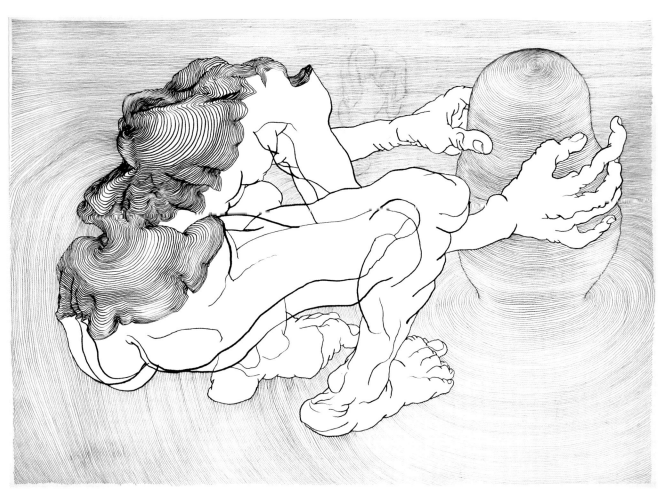

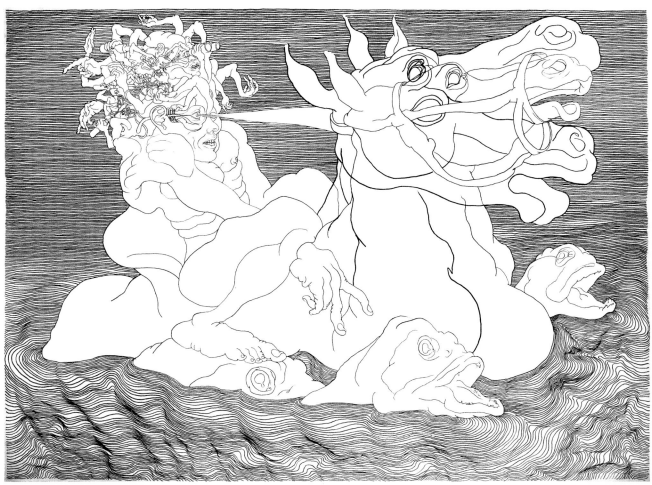

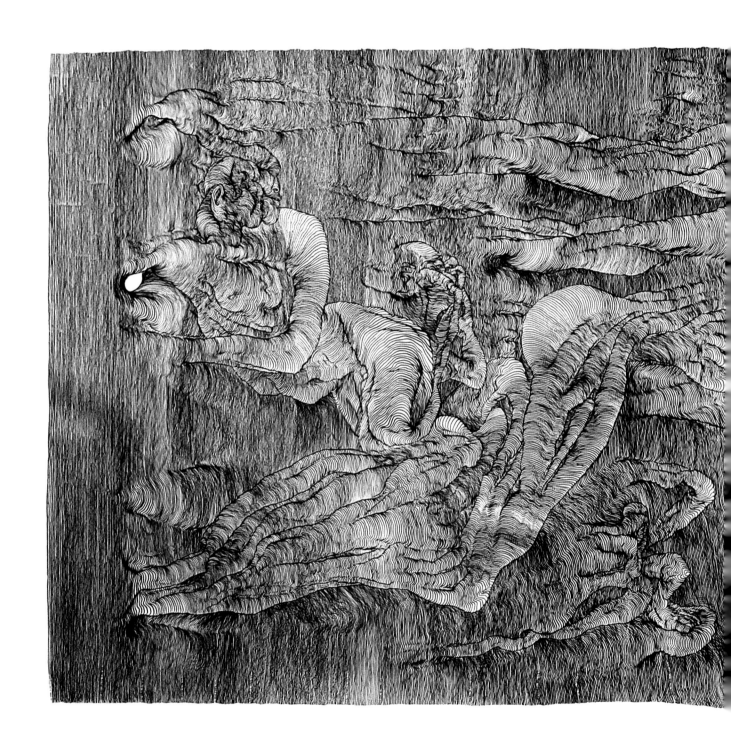

1 The Scroll
Size: 3,380mm × 1,520mm
Media/Materials: graphite on paper
Creative Purpose: fine art

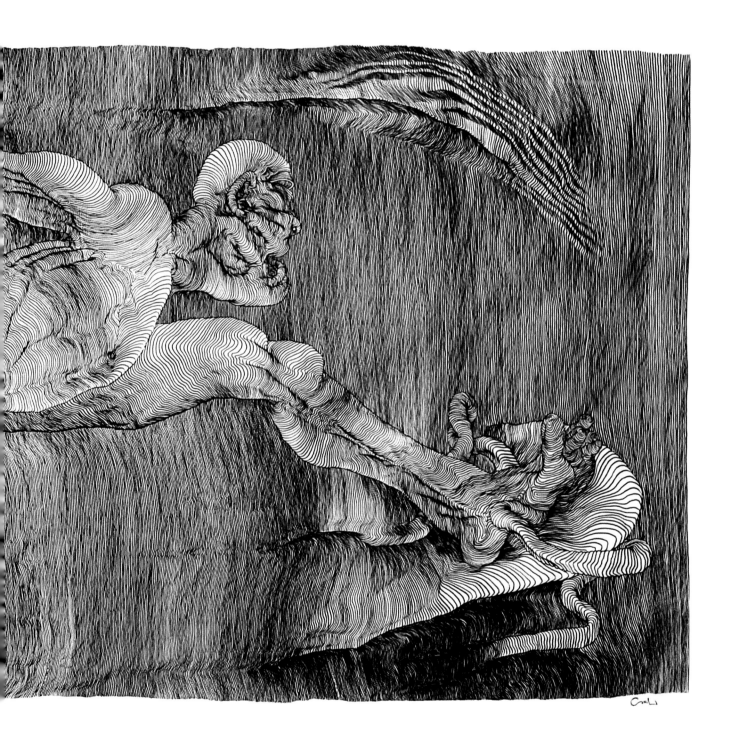

EVGENY KISELEV

Nationality: Russia
ekiselev.com

Evgeny Kiselev, Russian illustrator/graphic designer/artist.

"I have grown as a graphic designer ever since I was hired by a small advertising agency in 2001," Evgeny said. "I gained valuable experience and became a freelance digital artist and illustrator in 2004. I love to travel a lot and spend enough time in different places around the world. Therefore, my workplace is always changing. There is always a different view from the window, and always a lot of excitement and inspiration. Perhaps that is why I always want to develop different styles in my works."

Q: **Why did you choose lines as the expressional tools for your artworks?**

A: At the very beginning of my artistic career, I chose the development of new lines and shapes as my creation theme. I always wanted to come up with a completely different graphic language, new visual forms, and open a different meaning.
I confess this way because I am feeling energy and get a lot of positive emotions in the process.

Q: **Where do your inspirations come from? Can you tell us about some of your favorite artists?**

A: Most of the inspiration I get is from observations of the world. Creativity can express everything: watching wildlife, swimming in the sea, walking through an unknown city, meditation at sunset... We all live in a wonderfully complex and beautiful world, and each fragment of it is amazing, if you look closely.
As for the artists who affected me the most, I would select Moebius, Mucha, Escher, and Bilibin. They are the real masters of lines.

Q: **Could you give us some tips on how to draw beautiful lines? Does it take much practice and patience?**

A: All I can say is that it's necessary to draw boldly and confidently to charge your artworks with "energy." And then at least some viewers — if not all of them — would feel the same deep feeling of the artist by looking at the finished works.

Q: **How would you describe your works to the gallery, client, or potential buyers? How well do you think line art performs in the market, such as in galleries, and in the illustration market?**

A: I think that in the future people will be more attentive to this kind of work, because all the time people are searching for new things, and the line art is the new one. We can say that we are on the threshold of a new era rich in line art.

1 **Dancing Girl**
Media/Materials: vector illustration
Creative Purpose: personal

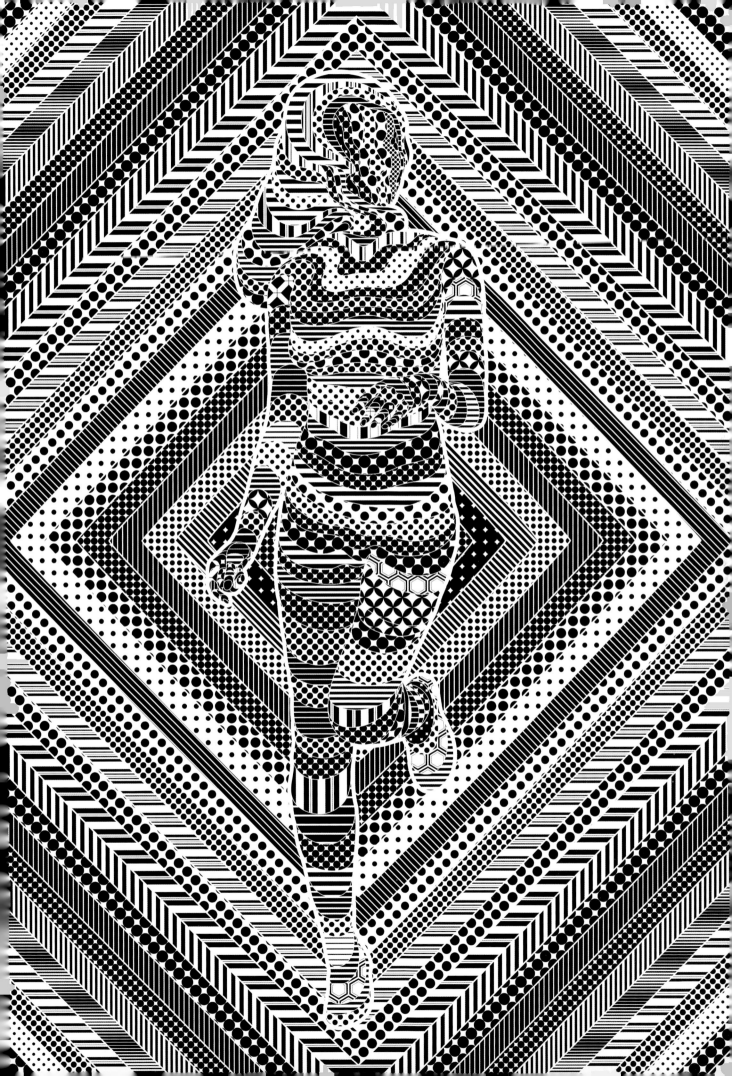

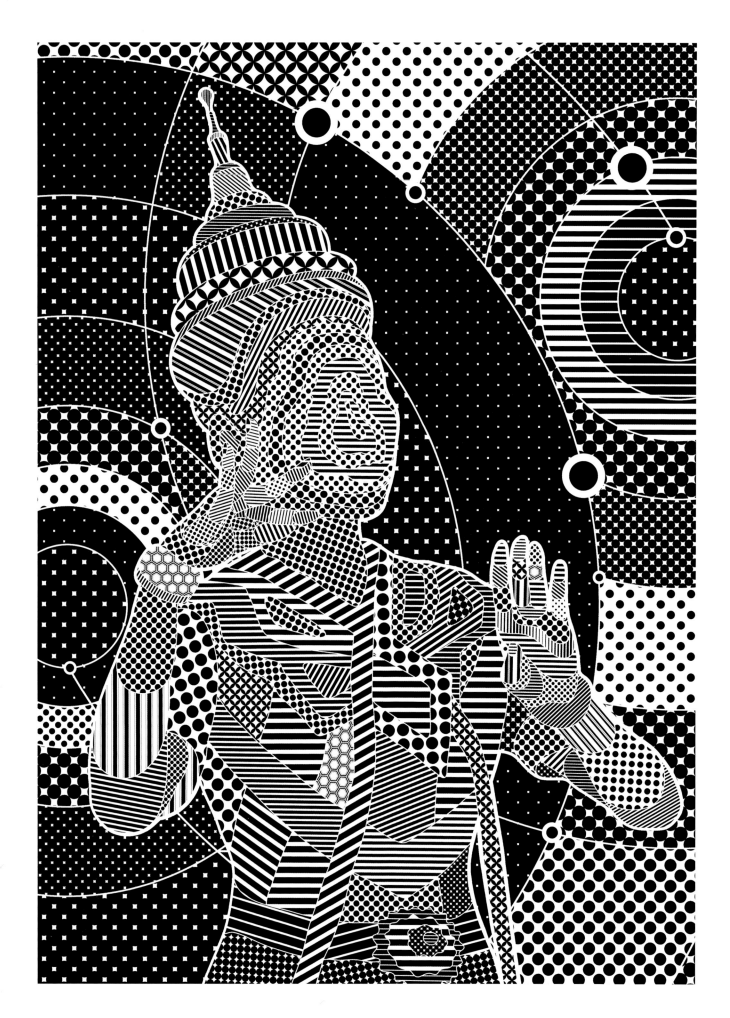

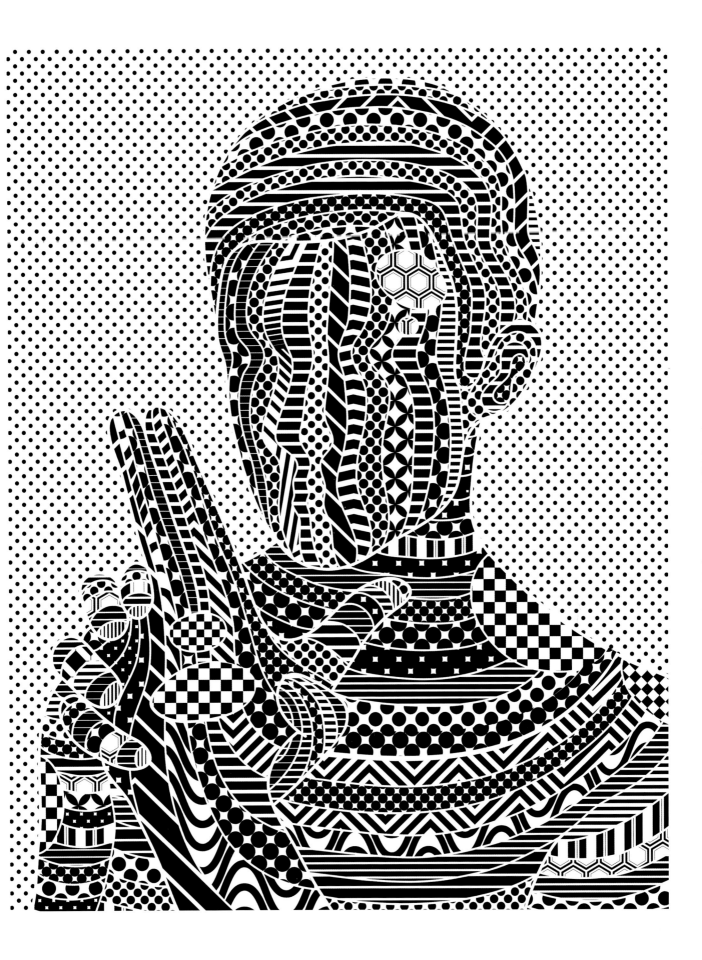

1 **Cosmodance**
Media/Materials: vector illustration
Creative Purpose: personal

2 **Selfportrait**
Media/Materials: vector illustration
Creative Purpose: personal

1 | 2

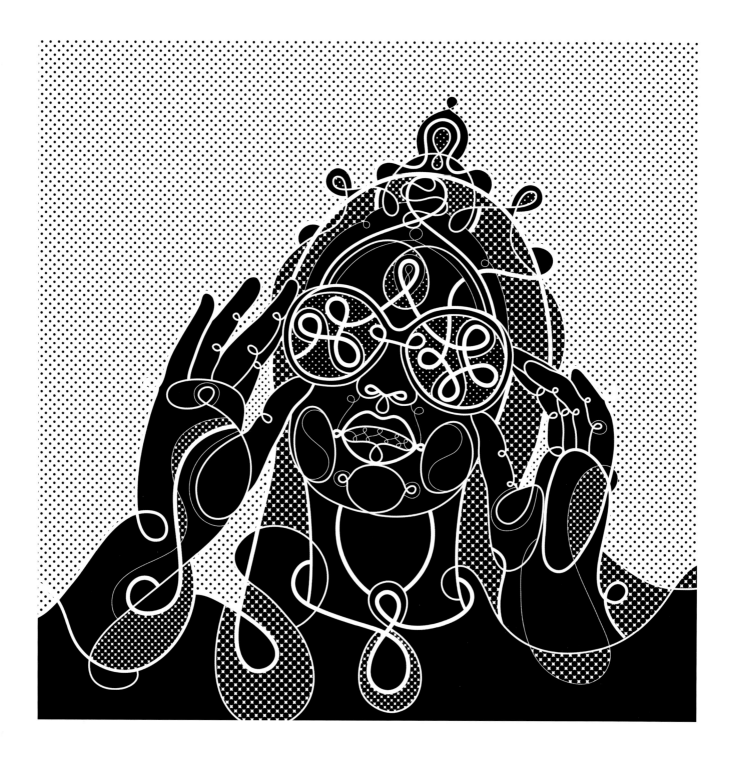

	2
1	
	3

1 **Party Girl**
Media/Materials: vector illustration
Creative Purpose: personal

2 **Oikoumene 1**
Media/Materials: vector illustration
Creative Purpose: personal

3 **Oikoumene 2**
Media/Materials: vector illustration
Creative Purpose: personal

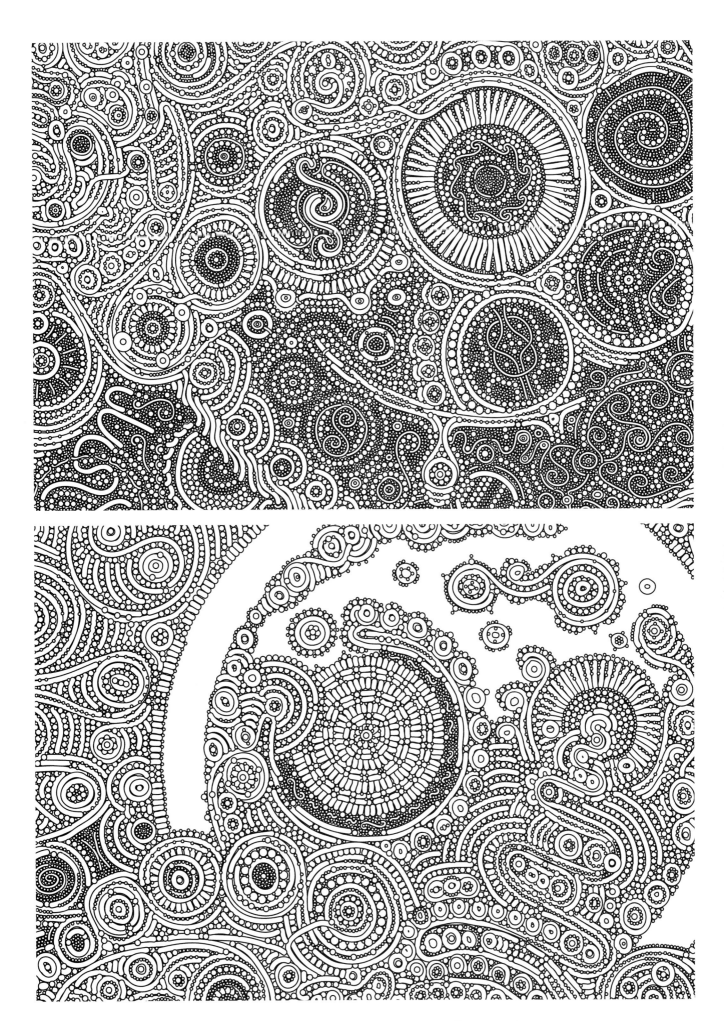

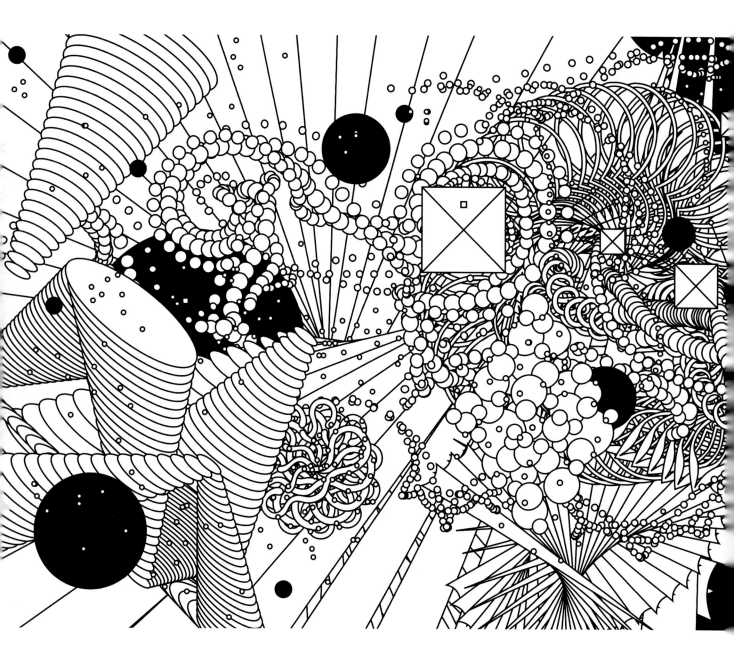

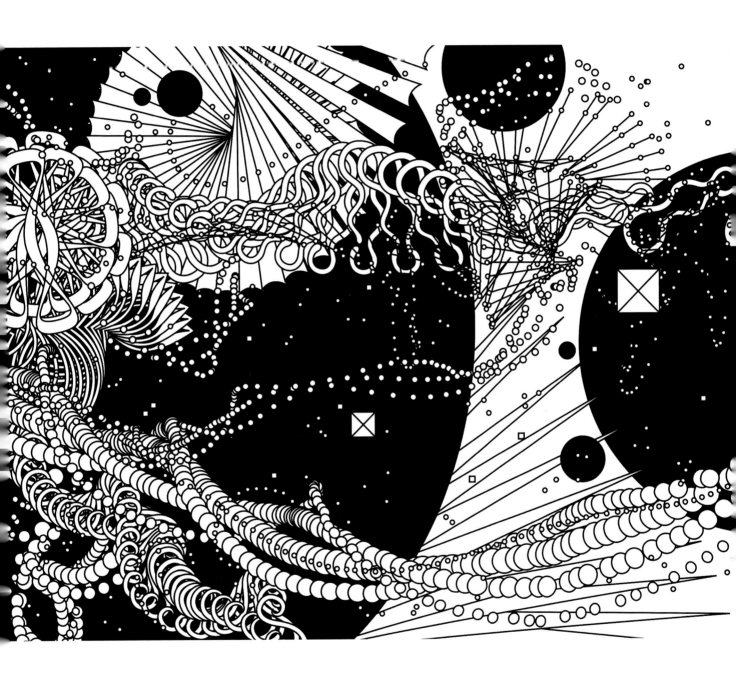

TAKAO MIURA

Nationality: Japan
noahs-art-gallery.com/en/
behance.net/NoahsARTGallery
instagram.com/noahsartgallery/

Takao Miura, aka Noah's ART, is a Japanese freelance artist and illustrator.

"I was born and raised in Sapporo, and currently live in Tokyo, Japan," Takao said. "I started drawing at the age of 24, during travel in New Zealand for one year; I got inspired by Maori's tribal design (such as tattoos) and beautiful nature. My drawings mostly consist of 'botanical design,' 'animal' and 'tribal design.' I'm working with apparel companies and sports/outdoor brands for design work."

Q: Why did you choose lines as the expressional tools for your artworks?

A: Usually, I don't have any complete image in mind while I'm drawing. I really like to see my art spreading on paper with minimum units, such as line and dot. It's like meditation. When I draw lines and dots, I can empty my mind. I like that moment.

Q: Where do your inspirations come from? Can you tell us about some of your favorite artists?

A: Mostly, I got inspired by artists all over the world. It's not only painters and illustrators, but also musicians. I'm influenced by song lyrics and famous proverbs. I tend to see artists who have their own views of the world, or beautiful lines in their artwork. My favorite artists are Junaida, Jon Burgerman, Amaia Arrazola, Hina Aoyama and Johanna Basford. They have different styles, but I like all of the lines they make.

Q: Could you give us some tips on how to draw beautiful lines? Does it take much practice and patience?

A: I always try not to rush even if I wanted to complete my artwork. If I focus my attention on trying to complete my artwork, I would probably set up a deadline, then I would need to take efforts in keeping myself patient and hope time flies. Therefore, I don't give myself a deadline; I just concentrate on filling in the blank space and having fun to draw; this way I don't need think about patience any more.

Furthermore, from a technical perspective, by varying the pace of moving my hand, I can draw different lines with the same pen. I always pay attention not to make distorted lines.

Q: How would you describe your works to the gallery, client, or potential buyers? How well do you think line art performs in the market, such as in galleries, and in the illustration market?

A: I have been asked to make tattoo designs, and also I have got offers to draw for coloring books for adult women. I believe my artworks are accepted by a wide range of age groups. I think line art is really simple and everyone can start if they want. So line art is attractive to many people.

Especially, here in Japan, zentangle and coloring books are getting popular among women these days. As I'm being offered to draw for coloring books, line art could be a very suitable form of art.

1 **Botancial Peacock**
Size: 297mm × 420mm
Media/Materials: ball-point pen and drawing pen on paper
Creative Purpose: personal

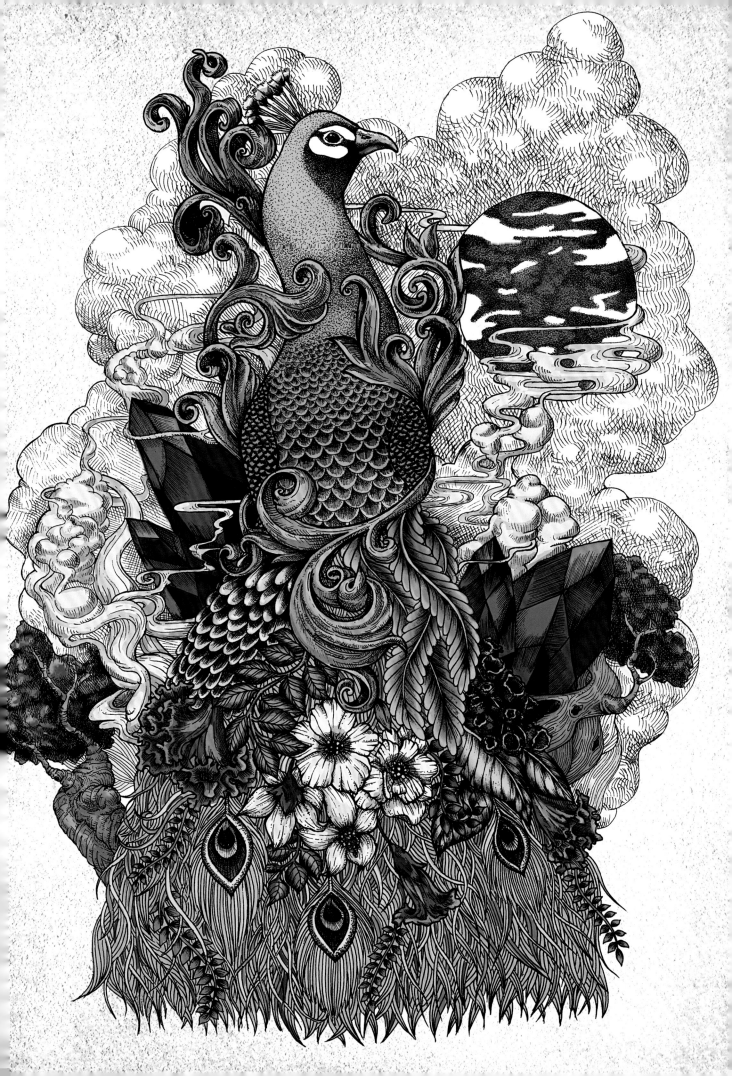

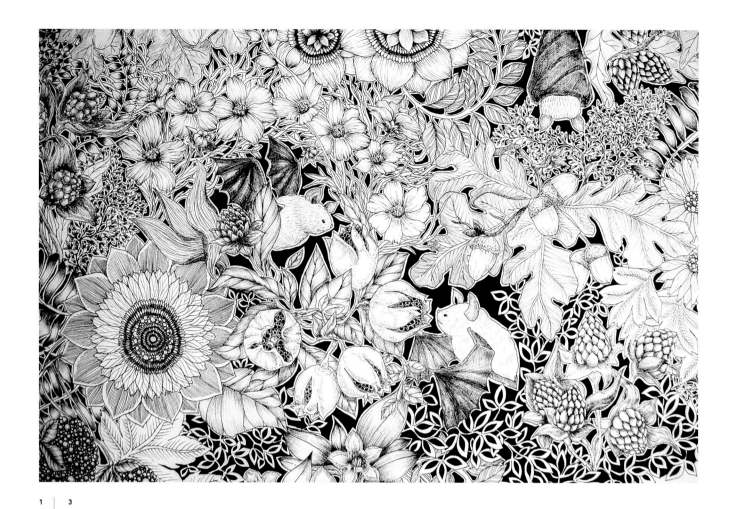

1	3
2	

1 Botanical Wave × Bat (detail)

2 Botanical Wave × Bat
Size: A1 (594mm × 841mm) × 5 panels
Media/Materials: ball-point pen and drawing pen on paper
Creative Purpose: fine art

3 Botanical Wave × Bat (detail)

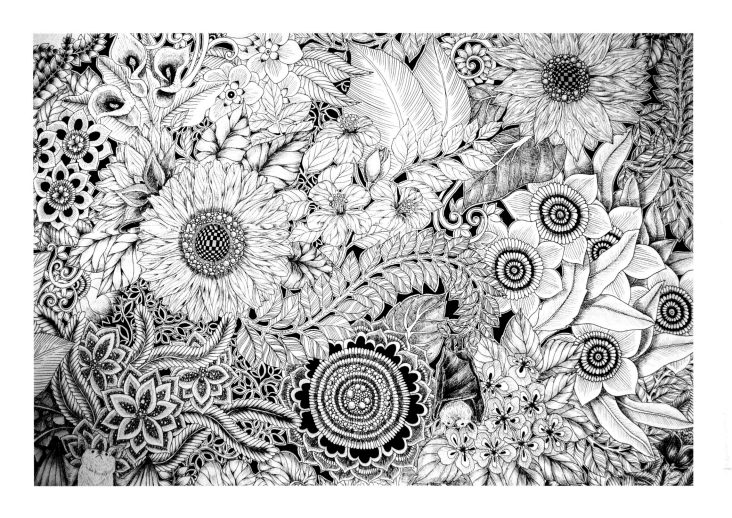

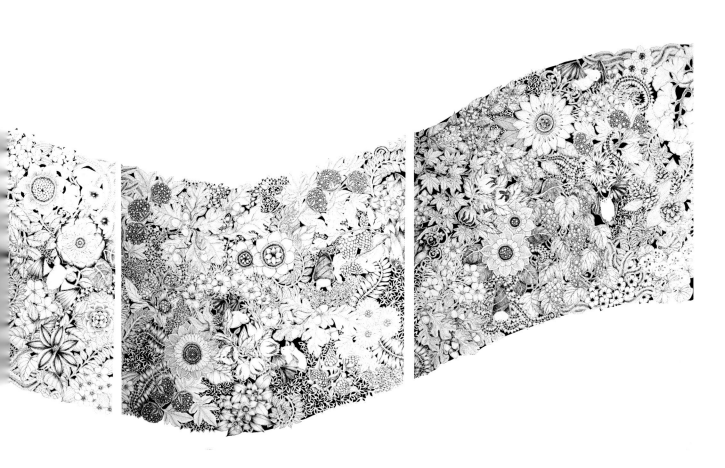

ILLUSTRANESIA

Nationality: Indonesia
behance.net/illustranesia
instagram.com/illustranesia

Illustranesia (pseudonym of Septian Fajrianto) has been a full-time freelance illustrator for five years. Based in Indonesia, he is inspired by the country's beautiful islands. He captures all kinds of natural phenomena and rearrange them into his artwork. He enjoys documentaries on heavy metal bands, and he likes to discuss the topic of death in his artworks. He has done a lot of art projects with heavy metal bands, and they in turn also inspire him with their works and stories. He loves to illustrate a metamorphosed character figure that he created based on his personality, which tends to tell people that everyone is living and would be always live in their dream in their own way.

Q: **Why did you choose lines as the expressional tools for your artworks?**

A: I've tried quite a few materials and tools to get the best characteristics that could represent my mind best. Lines are the best tool I've got, especially with the use of technical pen. They work so wild on paper, full of uncontrollable distortions, which is just the aspect I like.

Q: **Where do your inspirations come from? Can you tell us about some of your favorite artists?**

A: Many things inspire me, such as poems, instrumental music (it's fun to make a visual art based from that kind of music), any social phenomena and issues.
Favorite artists? Godmachine is my biggest inspiration these days. Vania Zouravliov, Aaron Horkey, and Richey Beckett are also daily inspirations. Beksiński, Zbigniew M. Bielak, and Gustave Doré's artworks show me how dark an artwork can be.

Q: **Could you give us some tips on how to draw beautiful lines? Does it take much practice and patience?**

A: I create artworks mostly with lines and dots. Most of them are completed in around three to four weeks. Practice and patience are the keys to creating my best character. And I believe that each artist has to create their own private therapy to train their technique and sharpen their analytical tools for anything around them. Just do your most enjoyable things, and keep working on it.

Q: **How would you describe your works to the gallery, client, or potential buyers? How well do you think line art performs in the market, such as in galleries, and in the illustration market?**

A: I'm usually exposing a dark atmosphere in my works, and trying to represent my personality in figurative works. And I'm still exploring printing methods and doing experiments to create the most beautiful forms based on my drawings with quite a few materials. It may not perform well enough in my country, but I believe that it will transform line illustrations into another unique form.

1 **Astral – Altar**
Size: 350mm × 350mm
Media/Materials: pen on paper
Creative Purpose: for Astral Collective Independent Project (Indonesia)

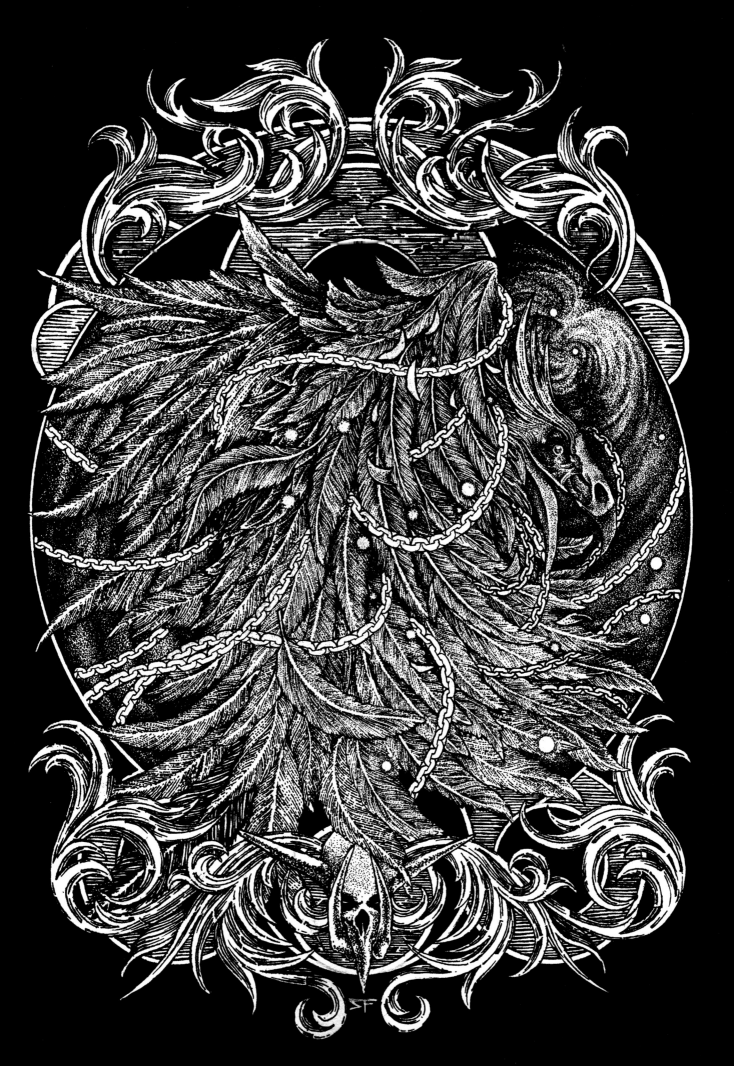

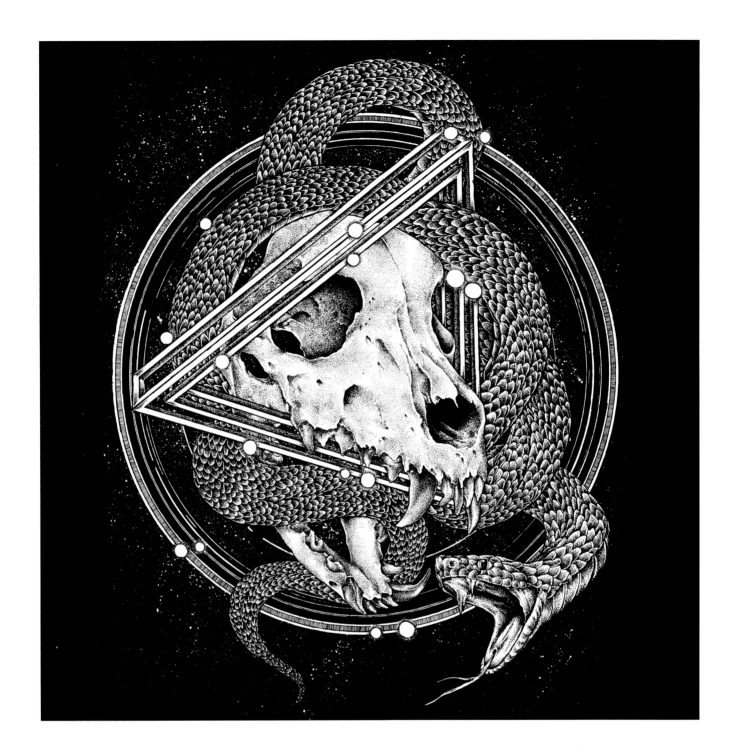

1 Killer Instinct
Size: 350mm × 350mm
Media/Materials: pen on paper
Creative Purpose: personal

2 Symphony of Death
Size: 350mm × 350mm
Media/Materials: pen on paper
Creative Purpose: a worldwide collaboration project

3 Symphony of Death (detail)

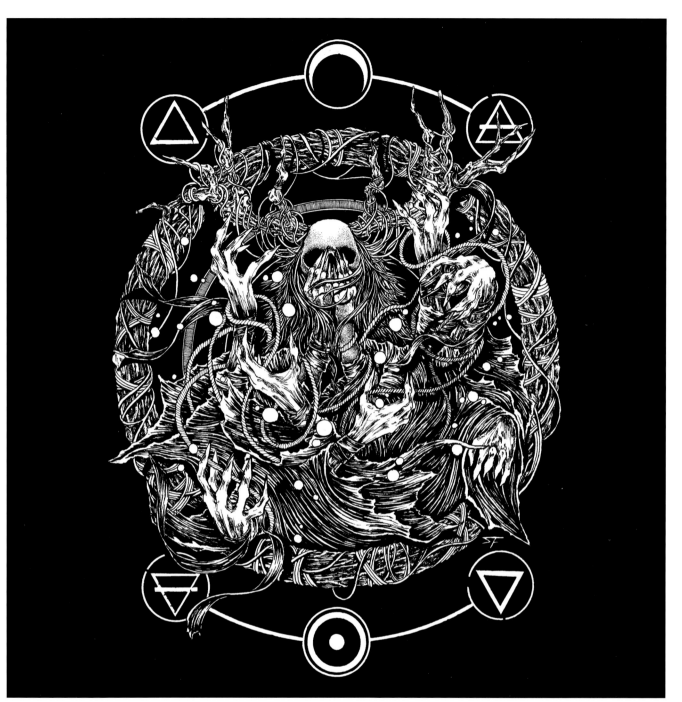

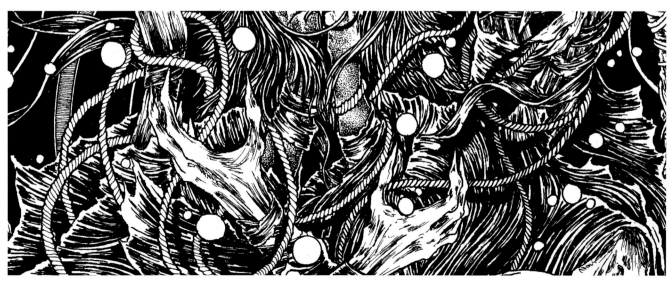

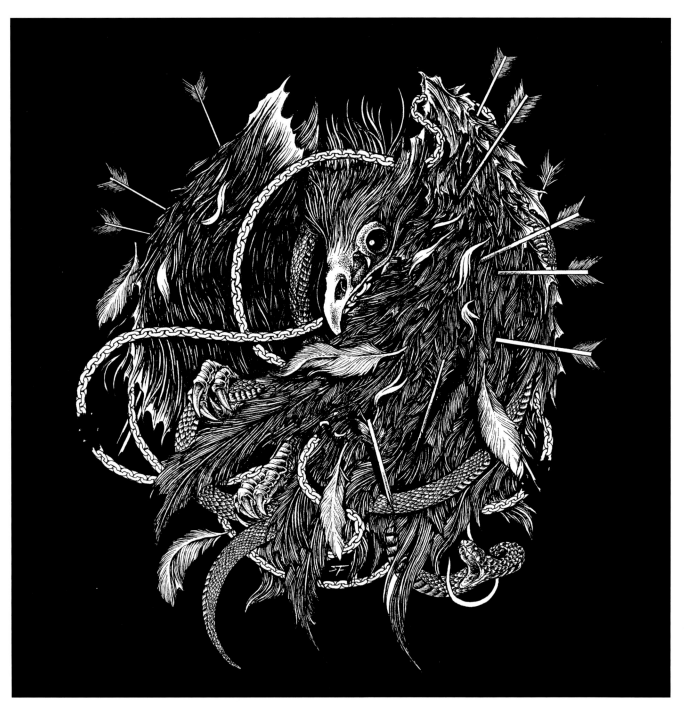

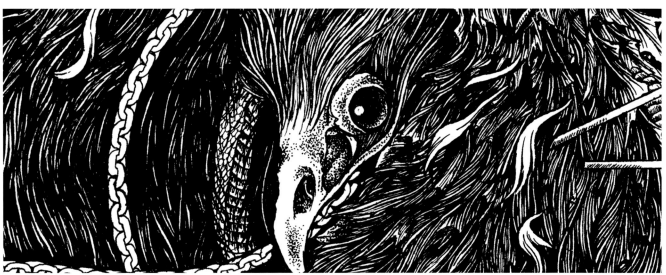

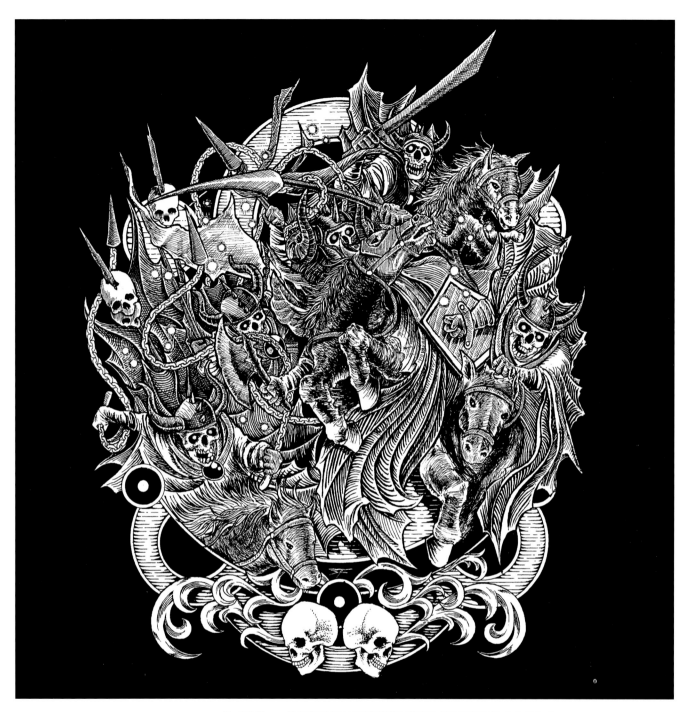

1 Snake and Arrow
 Size: 350mm × 350mm
 Media/Materials: pen on paper
 Creative Purpose: for Seringai (Indonesia-based metal band)

2 Snake and Arrow (detail)

3 Counter Attack
 Size: 350mm × 350mm
 Media/Materials: pen on paper
 Creative Purpose: cover art for Down for Life (Indonesia-based metal band)

4 Counter Attack (detail)

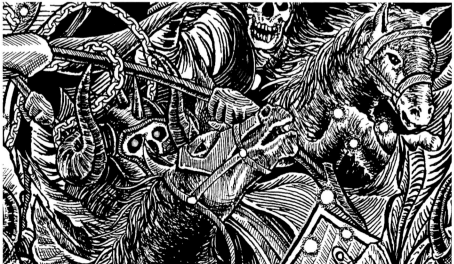

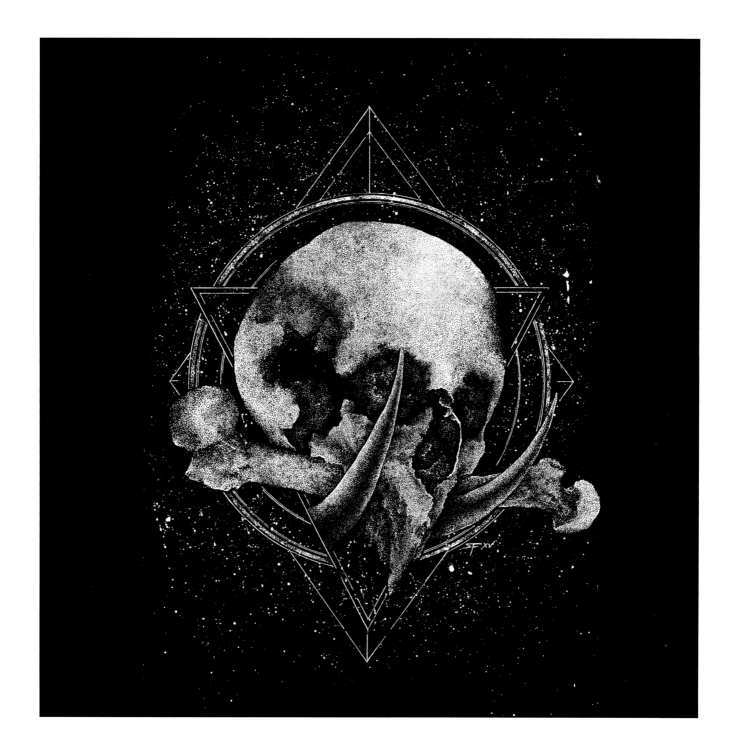

1 | 2
 | 3

1 **Metamorph**
 Size: 350mm × 350mm
 Media/Materials: pen on paper
 Creative Purpose: for Heaven the Axe (Australia-based rock band)

2 **Enslaved**
 Size: 350mm × 350mm
 Media/Materials: pen on paper
 Creative Purpose: personal

3 **Enslaved (detail)**

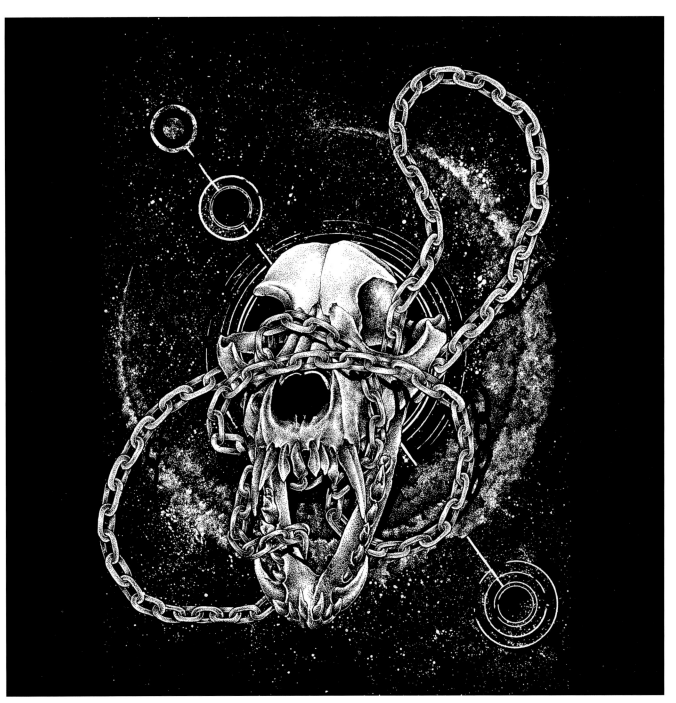

JULIEN BROGARD

Nationality: France
julien.brogard.com (graphic design)
behance.net/julienbrogard (illustration)

Julien Brogard is a 24-year-old graphic designer and freelance illustrator. He likes to mix mystical, death and sexual symbols in his work and often hide some parts of his life behind the illustrations.

Q: Why did you choose lines as the expressional tools for your artworks?

A: I don't know why but as a child, I used to fill pages and pages with abstract lines. When I was old enough to draw some characters, I just kept using lines to create illustrations.

I'm not a big fan of minimalism. I like generosity and movement in a picture, and using lines is a good way to express those feelings.

Q: Where do your inspirations come from? Can you tell us about some of your favorite artists?

A: My inspiration comes from many things. I really appreciate etching from the Middle Age, but I also like the symbolism movement. Lately, I love artists such as Gustave Moreau, Gaston Bussière and Edgard Maxence, who inspired me by their metaphorical and beautiful compositions.

Q: Could you give us some tips on how to draw beautiful lines? Does it take much practice and patience?

A: I think you need to be relaxed when you are drawing lines. You have to let your pencil slip on the paper. Of course some people draw beautiful lines with a shaky hand. It depends on what style you want, I assume.

It certainly needs practice and patience. Drawing is like learning to play an instrument, you can't be good on the first try.

Q: How would you describe your works to the gallery, client, or potential buyers? How well do you think line art performs in the market, such as in galleries, and in the illustration market?

A: These questions are a bit tricky for me because I'm very new in the illustration world. Actually, I began to draw for myself since last year with no intention of selling my illustrations.

1 **Pyrrha**
Size: 300mm × 420mm
Media/Materials: digital
Creative Purpose: personal

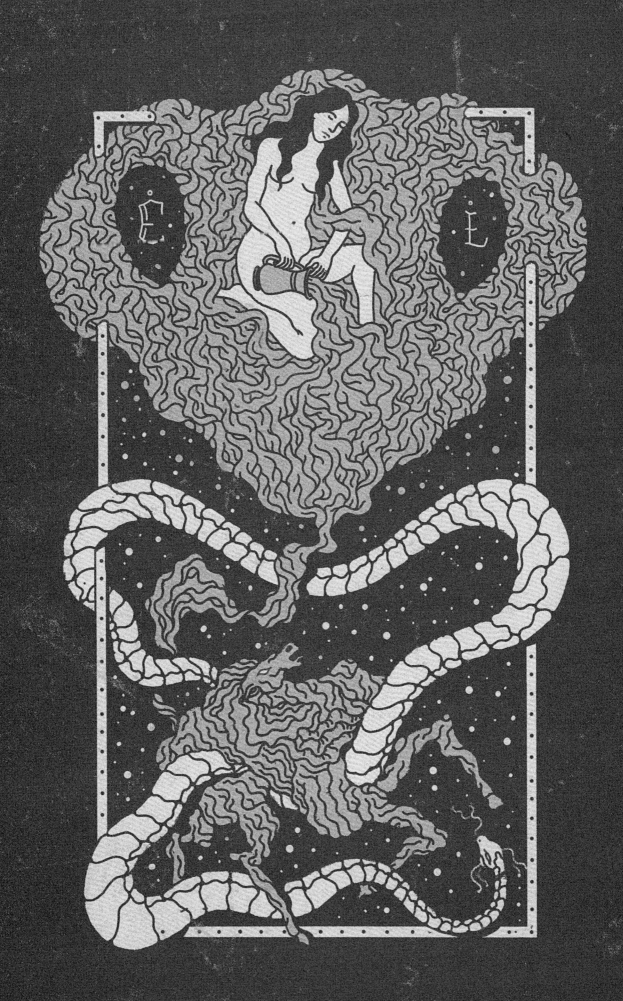

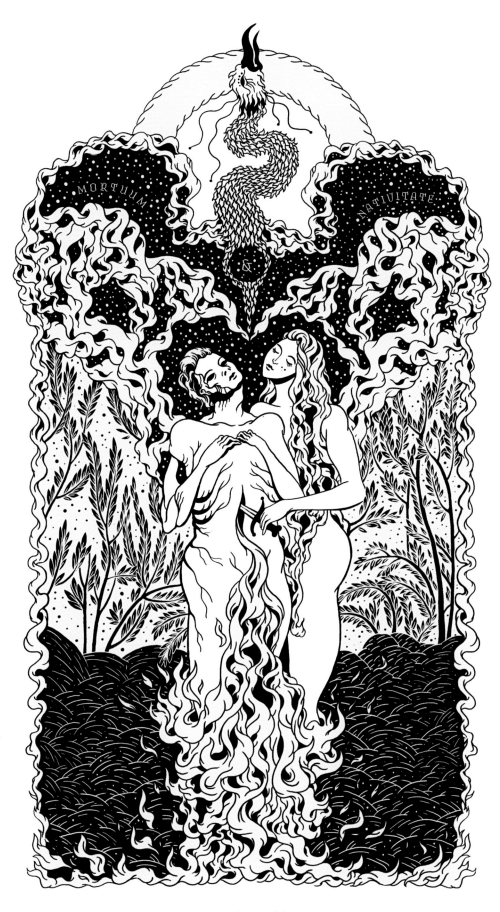

Death is our friend,
especially because it bring us into absolute
and passionate presence with all that is here,
that is natural, that is love.

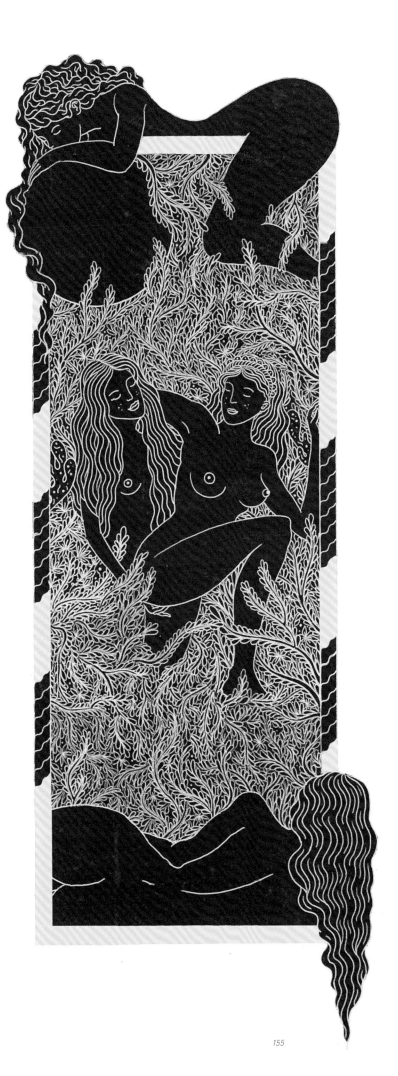

1 | 2

1 Mortuum & Nativitate
Size: 300mm × 420mm
Media/Materials: digital
Creative Purpose: personal

2 The Clearing
Size: 300mm × 420mm
Media/Materials: digital
Creative Purpose: personal

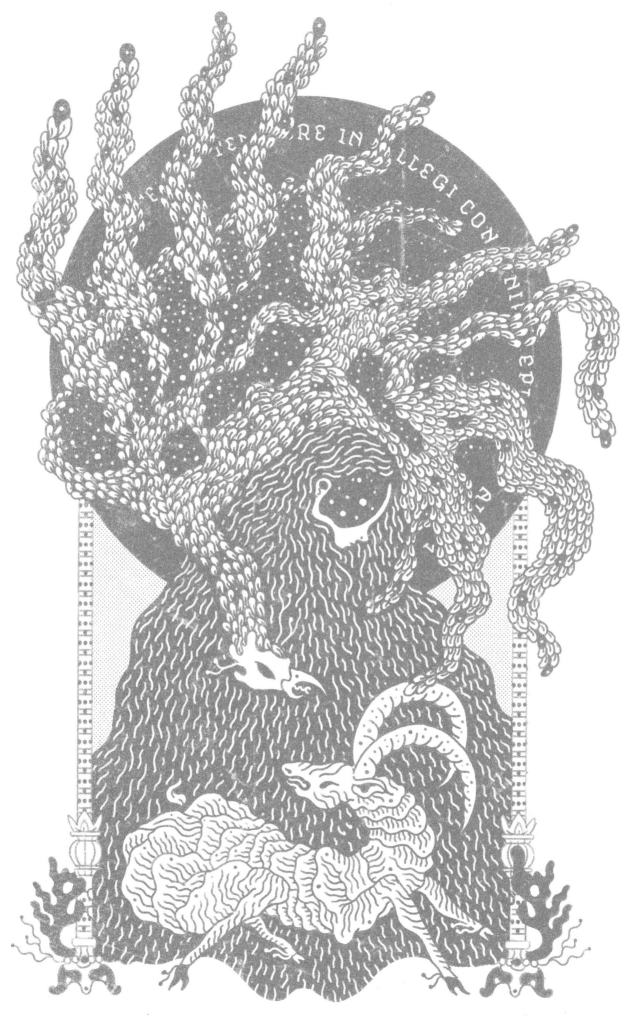

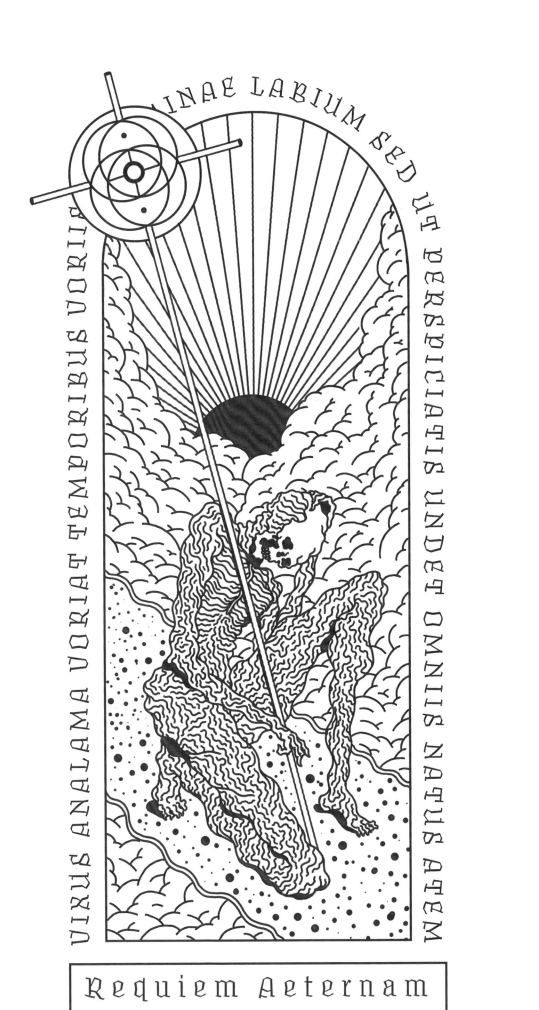

1 **The Sleeping Shepherdess**
Size: 300mm × 420mm
Media/Materials: digital
Creative Purpose: personal

2 **Requiem Aeternam**
Size: 300mm × 420mm
Media/Materials: digital
Creative Purpose: personal

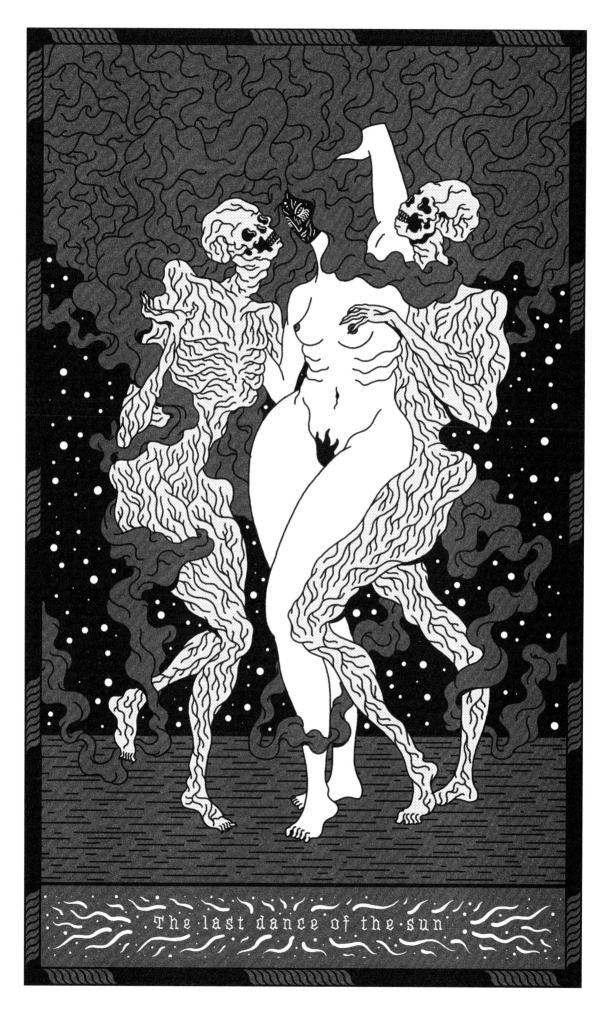

The last dance of the sun

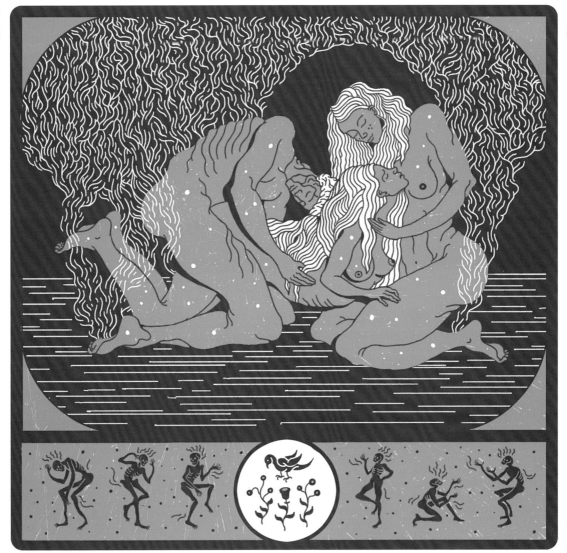

1 | 2

1 The Last Dance of the Sun
Size: 300mm × 420mm
Media/Materials: digital
Creative Purpose: personal

1 The Love of Absinthe
Size: 270mm × 300mm
Media/Materials: digital
Creative Purpose: personal

THEORETICAL
PART

Nationality: Russia
theoreticalpart.com

Theoretical Part is the creative union of two illustrators, Boris and Daria Sokolovsky, based in Rostov-on-Don, Russia. They talked about their artwork and creative processes.

"Our inspiration is in the cultural heritage of the past epochs, which come to the present times through the portals of antique shops, libraries, ruins and museums. Our aesthetics are woven of images, symbols and arcane knowledge, which are stretched like thin threads from the depths of hoary antiquity. By passing the sands of time through the millstones of the creative mill and refracting the reality by the prism of imagination, we are building the tiny worlds of dust and light and fix it on paper."

Q: **Why did you choose lines as the expressional tools for your artworks?**

A: We have experience in drawing and in classical and digital painting, but ultimately we came to the lines and it's alchemical, maybe sacramental in nature. The drawing process itself is a very meditative practice: you can dive into the subject of your artwork as well as into yourself. And it's really a magical act of creating the complex patterns from the various lines.

Q: **Where do your inspirations come from? Can you tell us about some of your favorite artists?**

A: Our inspiration comes from the cultural heritage of mankind, the forces of nature and the attractive power of arcane knowledge. We love works of Albrecht Durer, Hieronymus Bosch, Pieter Bruegel, Gustave Dore, Zdzislaw Beksinski, Michael Parkes and other talented artists of past and present days.

Q: **Could you give us some tips on how to draw beautiful lines? Does it take much practice and patience?**

A: Patience is the seed of the drawing process. But beautiful drawing includes not only technical aspects. Erudition, aesthetics and maybe some psychological skills are also important. And reading books, generating your own observation and analysis of the world around and the other artworks are just as effective as practice and patience.

Q: **How would you describe your works to the gallery, client, or potential buyers? How well do you think line art performs in the market, such as in galleries, and in the illustration market?**

A: Our works? Nothing new, just the little pieces extracted from the depths of time. Mental archeology in action. It's hard to describe your works for commercial purposes. We think that this is a task mostly for an art manager, rather than for the artist. But yes, that's an important aspect of art and illustration.

For the second question, in our region we don't feel any uncontrollable demand on line art and ink drawings. But in the whole world this direction is still popular as we can observe, and there are many fans of ink drawings from all the corners of the world, and we can interact and cooperate thanks to the worldwide web!

1 **Mournful Chronicles**
Size: 800mm × 600mm
Media/Materials: ink on paper
Creative Purpose: fine art

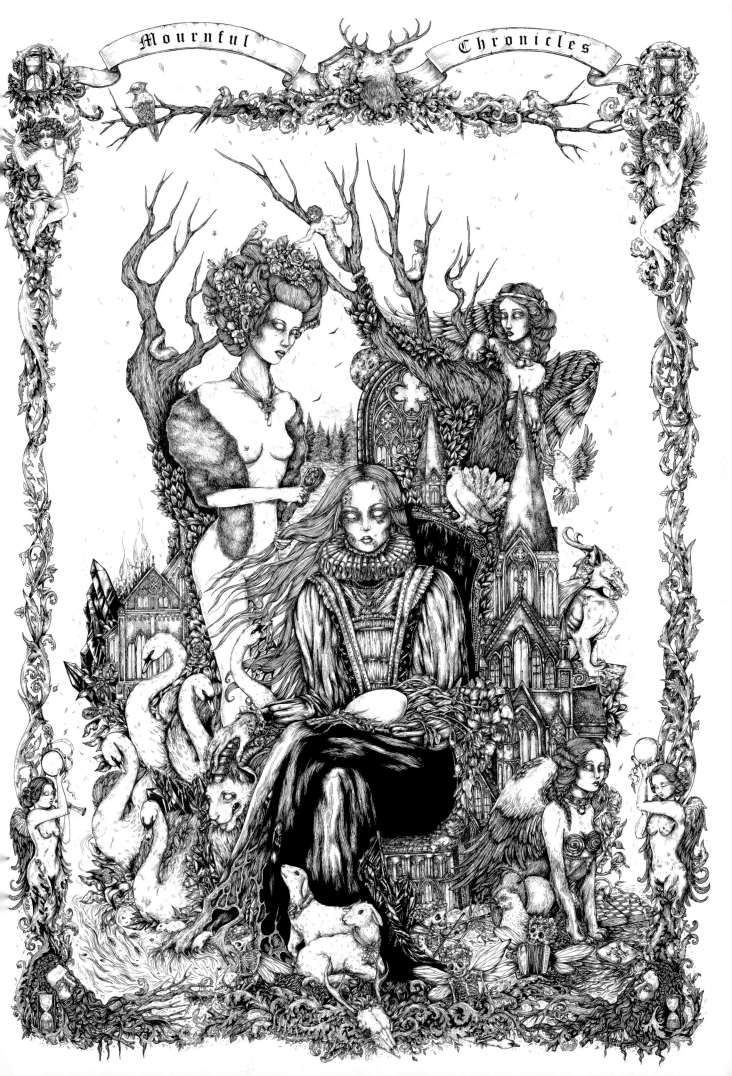

Mournful Chronicles

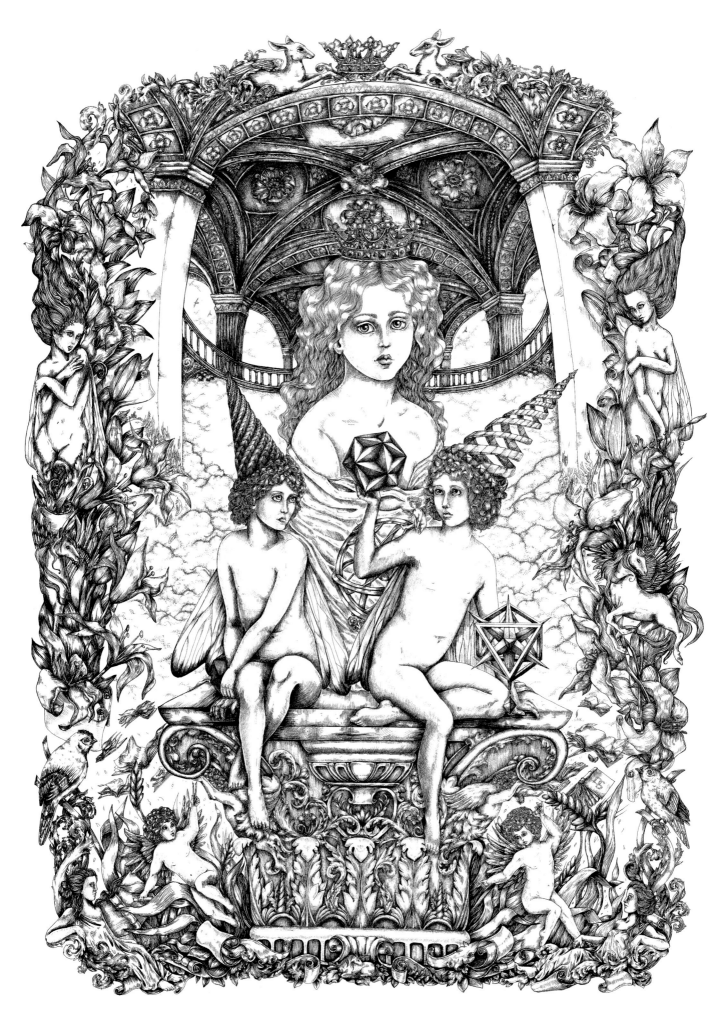

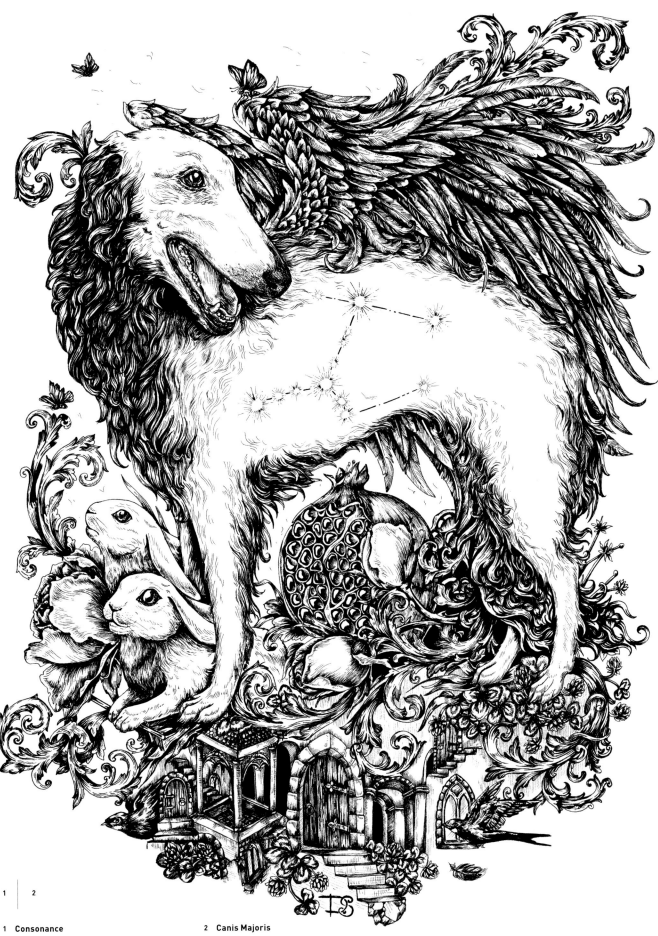

1 **Consonance**
Size: 800mm × 600mm
Media/Materials: ink on paper
Creative Purpose: fine art

2 **Canis Majoris**
Size: 420mm × 297mm
Media/Materials: ink on paper
Creative Purpose: personal

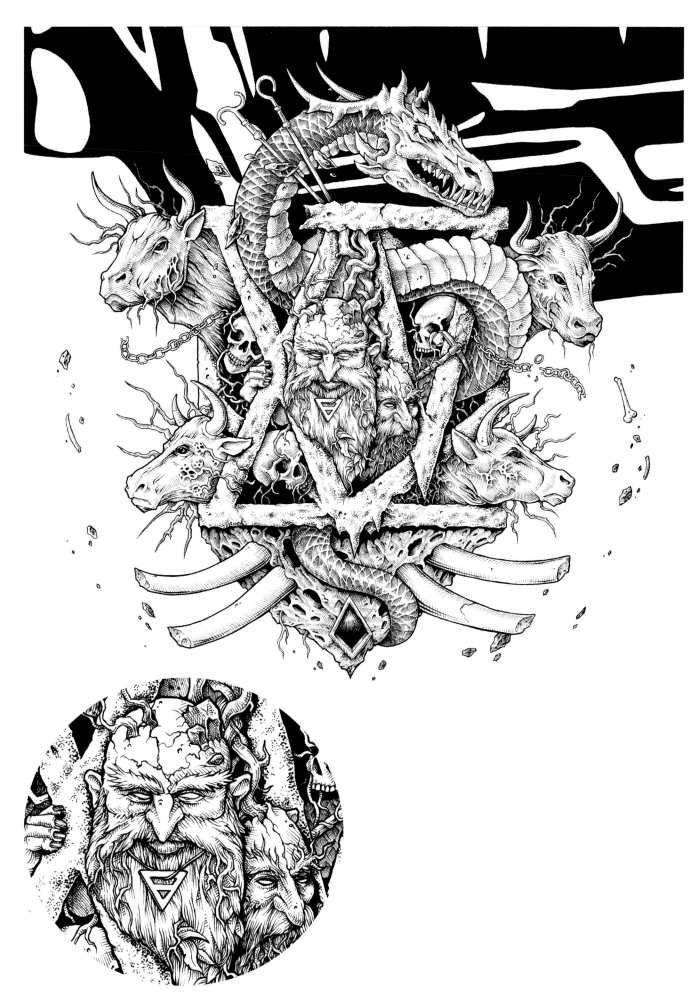

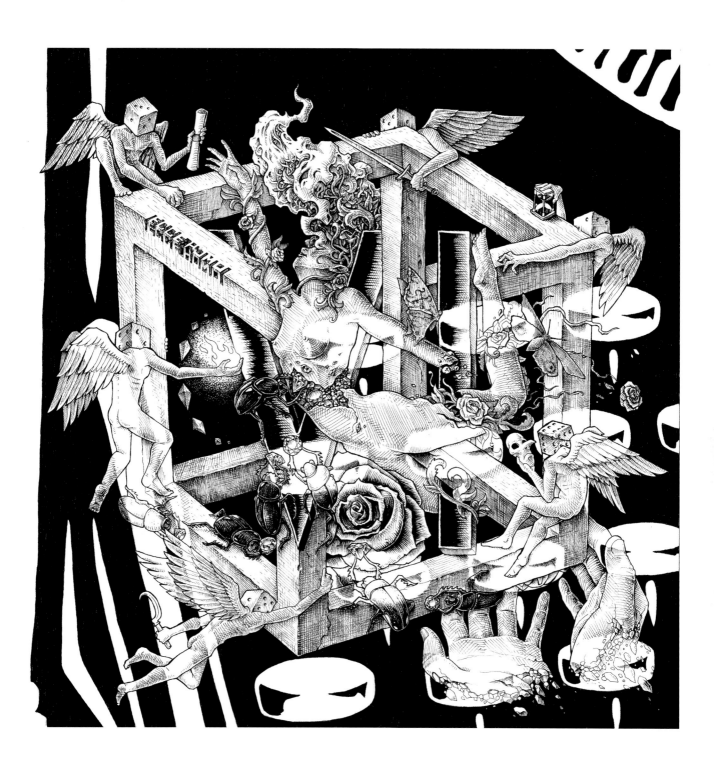

1 3

2

1 XV. Terra Mater
Size: 297mm × 297mm
Media/Materials: ink on paper
Creative Purpose: fine art, part of the Machina Mundi polyptych

2 XV. Terra Mater (detail)

3 VI. Ecce Homo
Size: 297mm × 297mm
Media/Materials: ink on paper
Creative Purpose: fine art, part of the Machina Mundi polyptych

GREG COULTON

Nationality: United Kingdom
gregcoulton.com

Greg Coulton is a British illustrator, designer and typographer. Whether he's creating brand stories or album covers, packaging or portraits, the art of storytelling is at the heart of his works.

His illustration philosophy — "The devil is in the detail" — pretty much defines everything he does. Intricate and multilayered, his hand-drawn illustrations are driven by the principles of good communication design, honed during his 12 years of designing in London Ad agencies. Combined with his traditional draftsmanship skills and love of exuberant, Baroque-inspired flourishes, the end result is Greg's unique works of meticulous detail and enchanting narratives.

Q: Why did you choose lines as the expressional tools for your artworks?

A: I feel very fortunate that drawing, and the way I draw, seems to come naturally to me. Often the lines on the paper seem to draw themselves — they are as much a surprise to me as to anyone else when they evolve on the page!

Drawing through lines gives me the freedom to create expansive expressions of movement, but also areas of intense detail, depth and structure.

Q: Where do your inspirations come from? Can you tell us about some of your favorite artists?

A: Many of my illustrations feature animals and plants, so I would have to say my biggest influence is probably nature. Nature is responsible for so many incredible expressions of shape and form — far more creative than anything we humans could design!

As for other artists, in the digital age I stumble upon new, incredibly talented people almost on a daily basis. In terms of style, execution and being an all-around master of his craft, David A. Smith of Torquay, England, has to be my idol. His work is utterly extraordinary, no one else is anywhere near his level of expertise.

Q: Could you give us some tips on how to draw beautiful lines? Does it take much practice and patience?

A: Personally, I don't practice that often; I work when I need to and when it feels right. When I try to force it, I almost always make mistakes. I would however say yes, it takes a lot of patience and persistence to get it right.

Q: How would you describe your works to the gallery, client, or potential buyers? How well do you think line art performs in the market, such as in galleries, and in the illustration market?

A: I feel that linework illustration is still relevant and in demand, across many different markets and sectors. Line art I believe is timeless — it can communicate a concept or idea in a much more direct and immediate way than many other forms of expression, be it digital or otherwise. If you ask any creative person how they first express their ideas, they will all say, "With pencil and paper."

1 **Guy Clark**
Size: 210mm × 297mm
Media/Materials: pens on paper
Creative Purpose: magazine

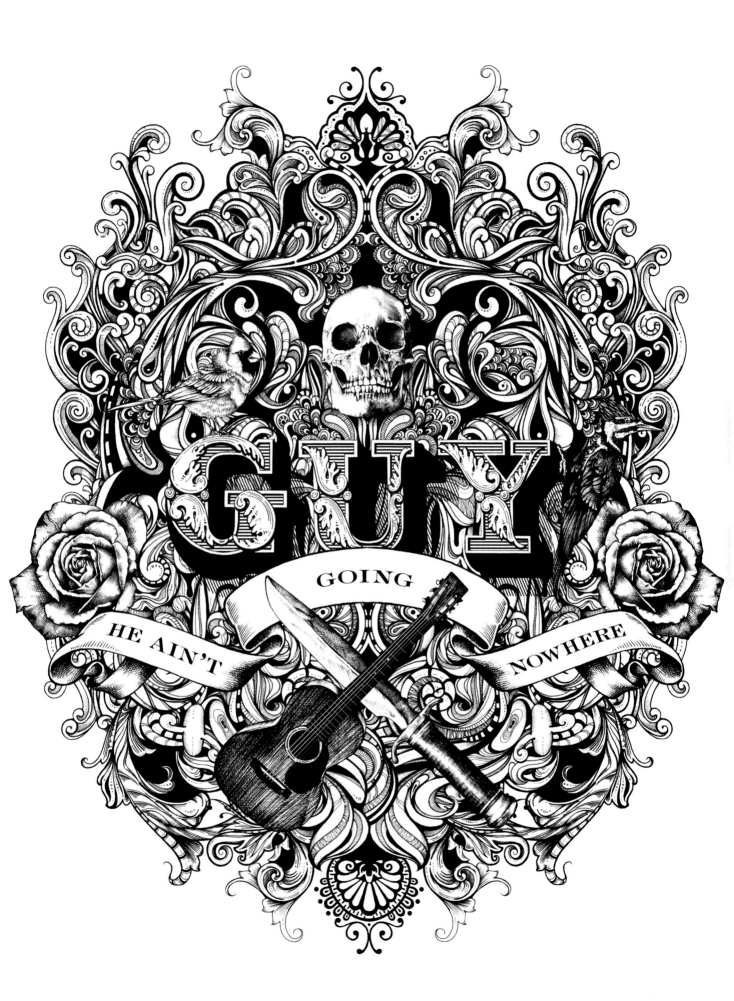

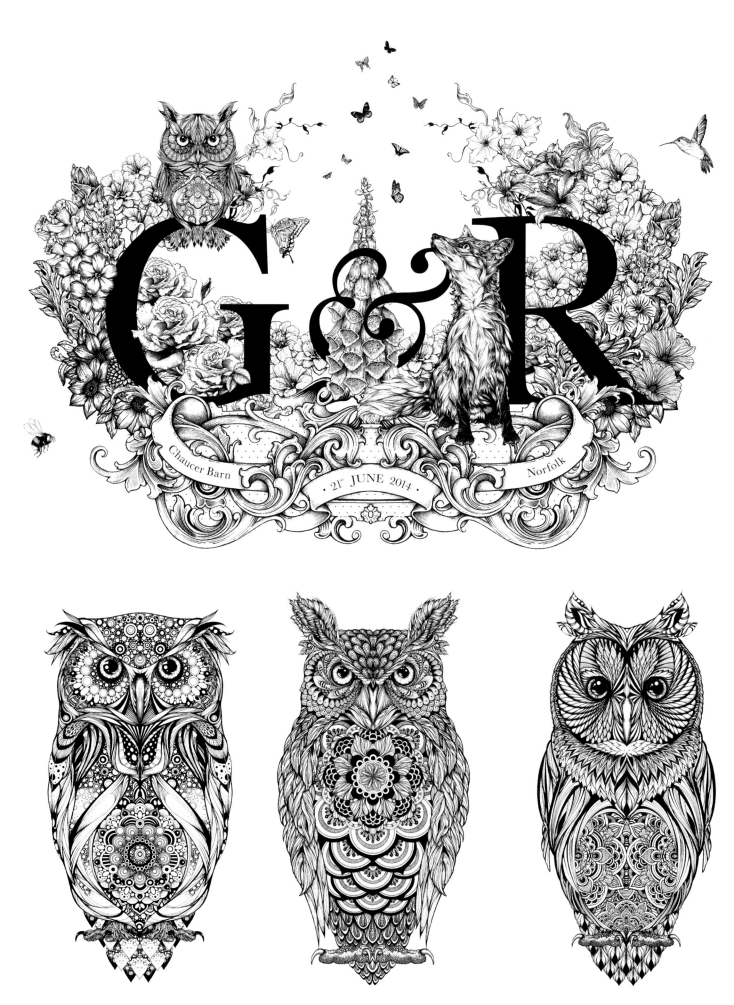

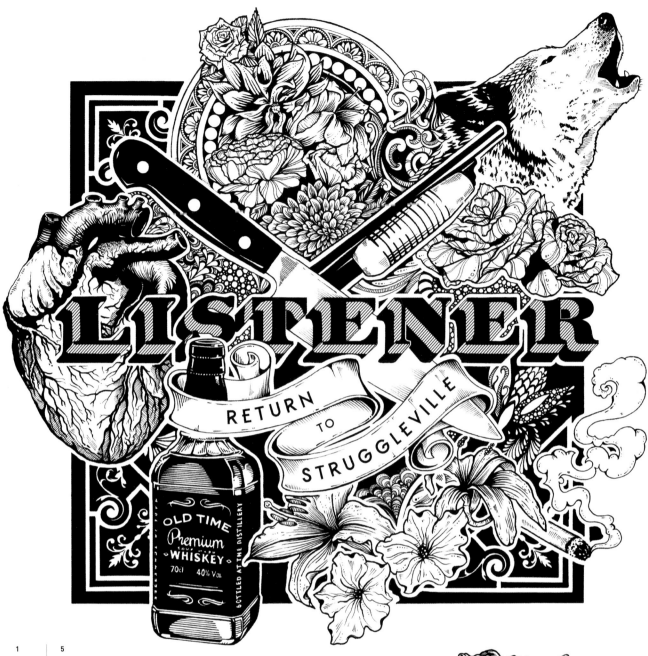

1 | 5
2 3 4 | 6

1 **G&R Wedding Branding**
Size: 594mm × 420mm
Media/Materials: pens on paper
Creative Purpose: wedding invitation,
stationary, signage and decoration

2 **Hoot Owls: Spotted Eagle Owl**
Size: 210mm × 297mm
Media/Materials: pens on paper
Creative Purpose: branding and packaging
for exhibition

3 **Hoot Owls: Great Horned Owl**
Size: 210mm × 297mm
Media/Materials: pens on paper
Creative Purpose: branding and packaging
for exhibition

4 **Hoot Owls: Long Eared Owl**
Size: 210mm × 297mm
Media/Materials: pens on paper
Creative Purpose: branding and packaging
for exhibition

5 **Return to Struggleville**
Size: 297mm × 297mm
Media/Materials: pens on paper
Creative Purpose: album sleeve

6 **Oak Devil**
Size: 210mm × 297mm
Media/Materials: pens on paper
Creative Purpose: packaging

THOMKE MEYER

Nationality: Germany

Thomke Meyer is an illustrator based in Hamburg, Germany. She focuses on traditional pencil drawings in combination with digital colors. The lines are the foundation of all of her artworks.

Q: **Why did you choose lines as the expressional tools for your artworks?**

A: It's the technique I feel most comfortable with. It is the way I can express myself the best and put my feelings in.

Q: **Where do your inspirations come from? Can you tell us about some of your favorite artists?**

A: It changes very often. At the moment I read a lot of graphic novels and get inspired by Manule Fior, Cyril Pedrosa or Gipi, but there are lots of artists out there who influence my work.

Q: **Could you give us some tips on how to draw beautiful lines? Does it take much practice and patience?**

A: I think it takes much practice to get confident with lines and not to be scared to draw something "wrong." I don't think there is a right way in drawing lines "beautiful." It's an individual way of the artist.

Q: **How would you describe your works to the gallery, client, or potential buyers? How well do you think line art performs in the market, such as in galleries, and in the illustration market?**

A: I'd rather not answer this question.

1 **The Hunt-4**
Media/Materials: pencil drawing and Photoshop
Creative Purpose: personal

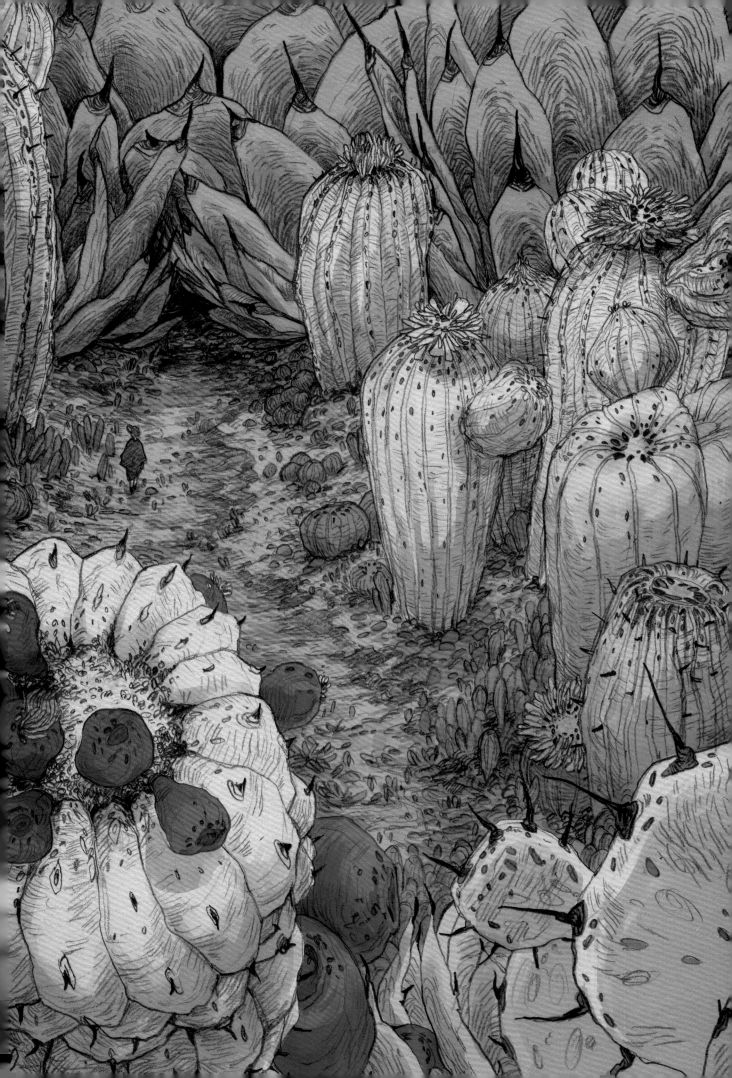

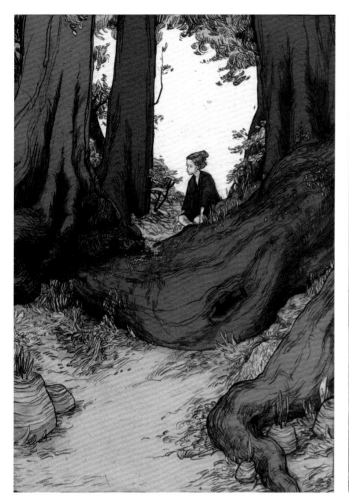

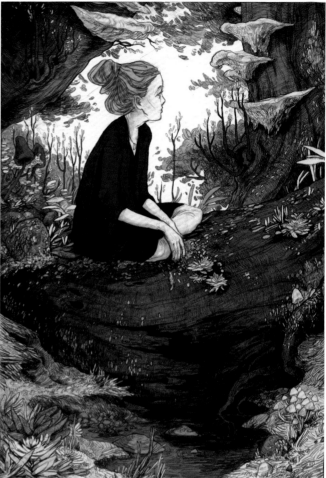

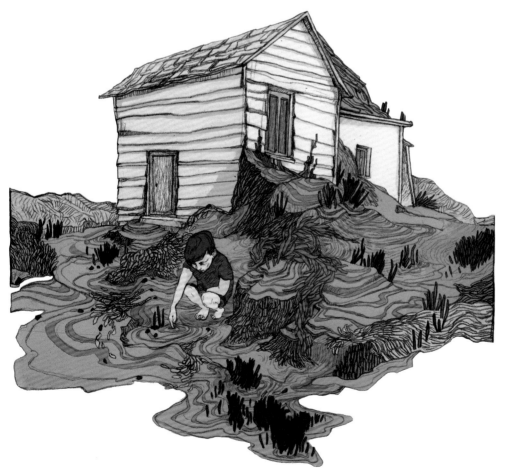

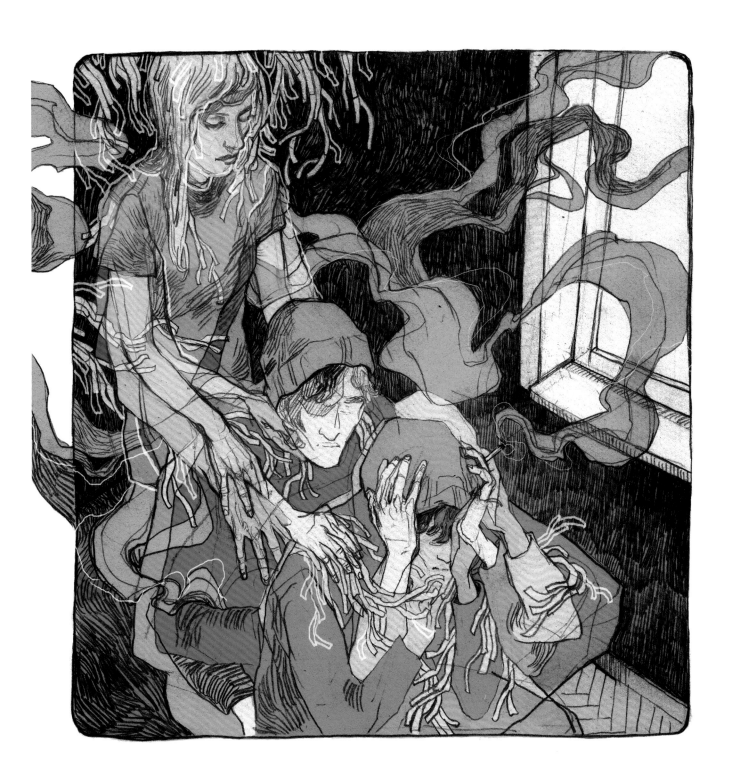

NIKITA KAUN

Nationality: Russia
sunturnsintowater.tumblr.com/

Nikita Kaun was born in 1993 in Saint-Petersburg, Russia. She is an illustrator and artist.

She began working in her present style in 2013. She has already worked with many streetwear brands, bands, and participated in multiple local and international exhibitions.

Q: **Why did you choose lines as the expressional tools for your artworks?**

A: For me it's easier to work with lines to express shapes, and then add halftones and textures. It reminds me how comics are made.

Q: **Where do your inspirations come from? Can you tell us about some of your favorite artists?**

A: I gain inspiration from Internet and music. I often browse sites such as Tumblr and Pinterest. My favorite artists include James Jean, Vania Zouravliov, David Choe, Paul Pope and Pat Perry.

Q: **Could you give us some tips on how to draw beautiful lines? Does it take much practice and patience?**

A: Try to variate the thickness of lines; it makes your works look smarter.

Q: **How would you describe your works to the gallery, client, or potential buyers? How well do you think line art performs in the market, such as in galleries, and in the illustration market?**

A: Line art works are often more understandable and easier to perceive than fine-art works. The style of the artist can be seen better, which is important to make your portfolio impressive to customers.

1 **In View**
Size: 457mm × 609mm
Media/Materials: digital
Creative Purpose: for a clothing brand "BREATHE OUT"

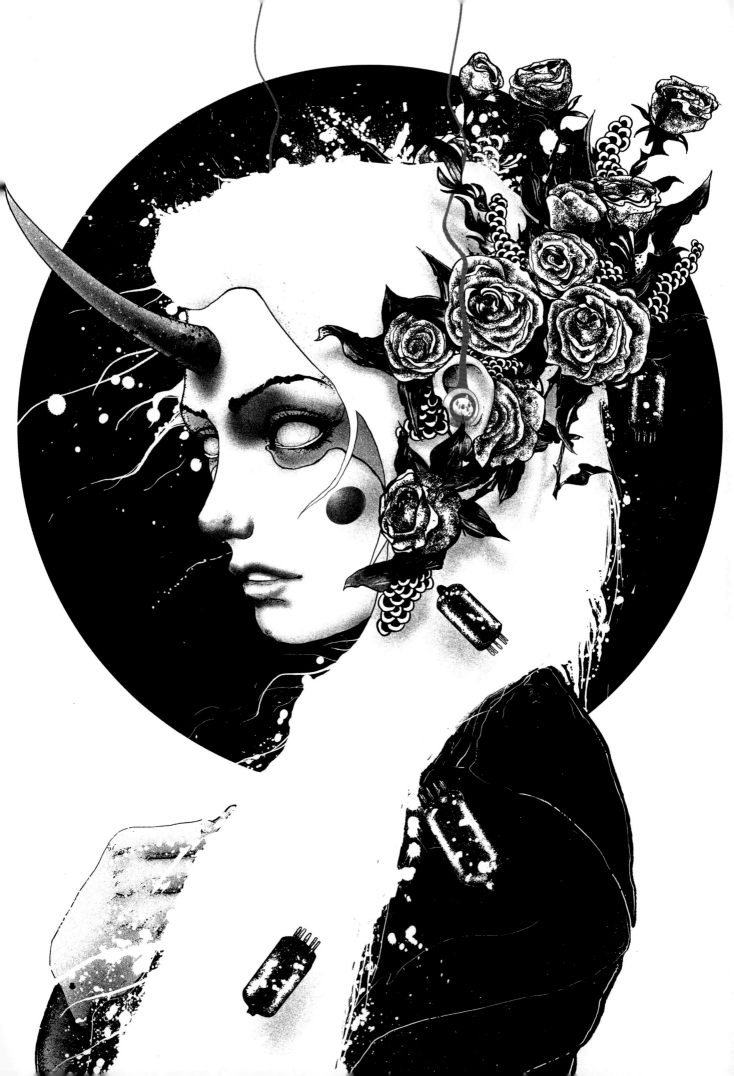

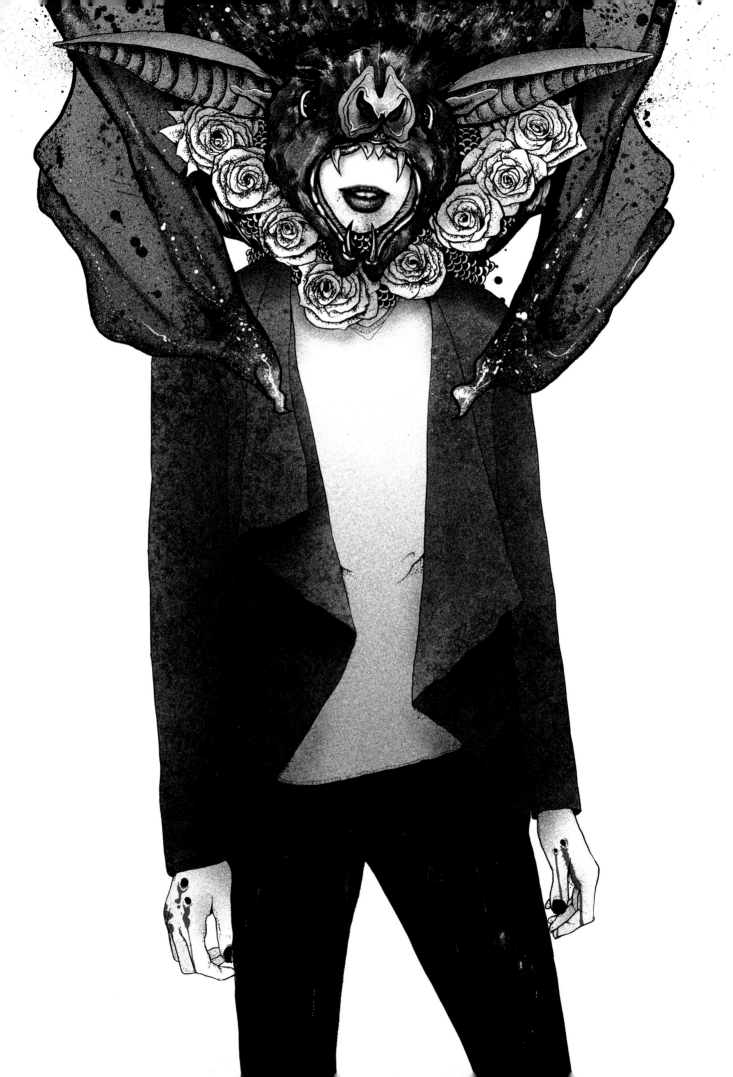

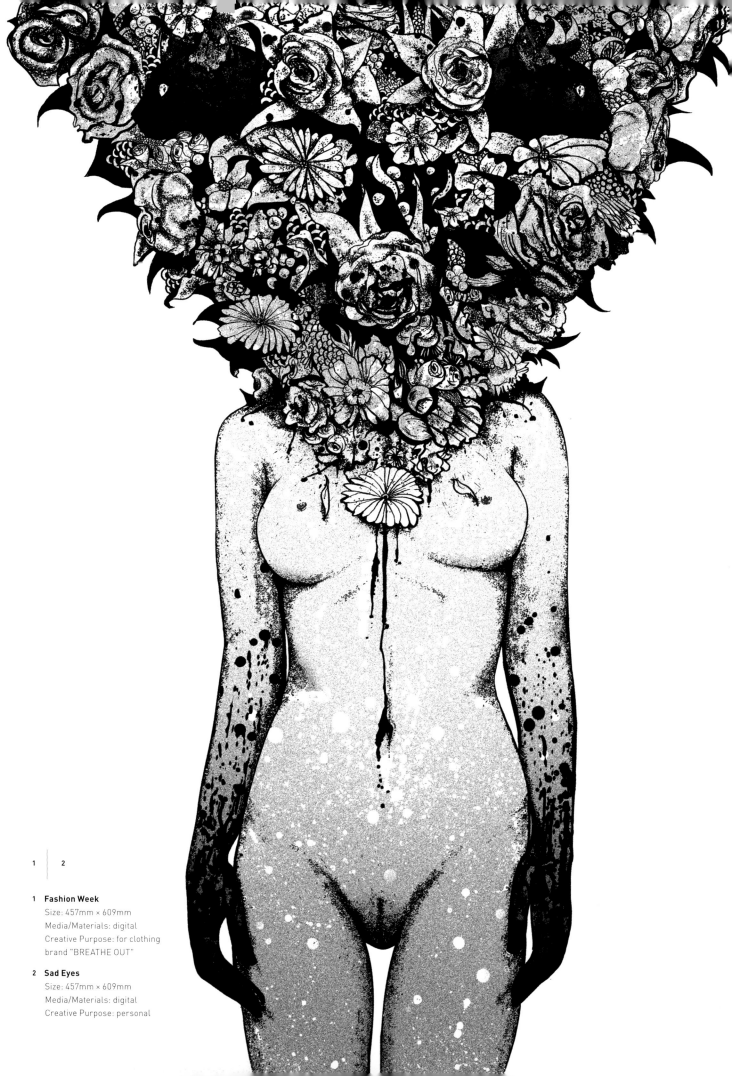

1 2

1 Fashion Week
Size: 457mm × 609mm
Media/Materials: digital
Creative Purpose: for clothing
brand "BREATHE OUT"

2 Sad Eyes
Size: 457mm × 609mm
Media/Materials: digital
Creative Purpose: personal

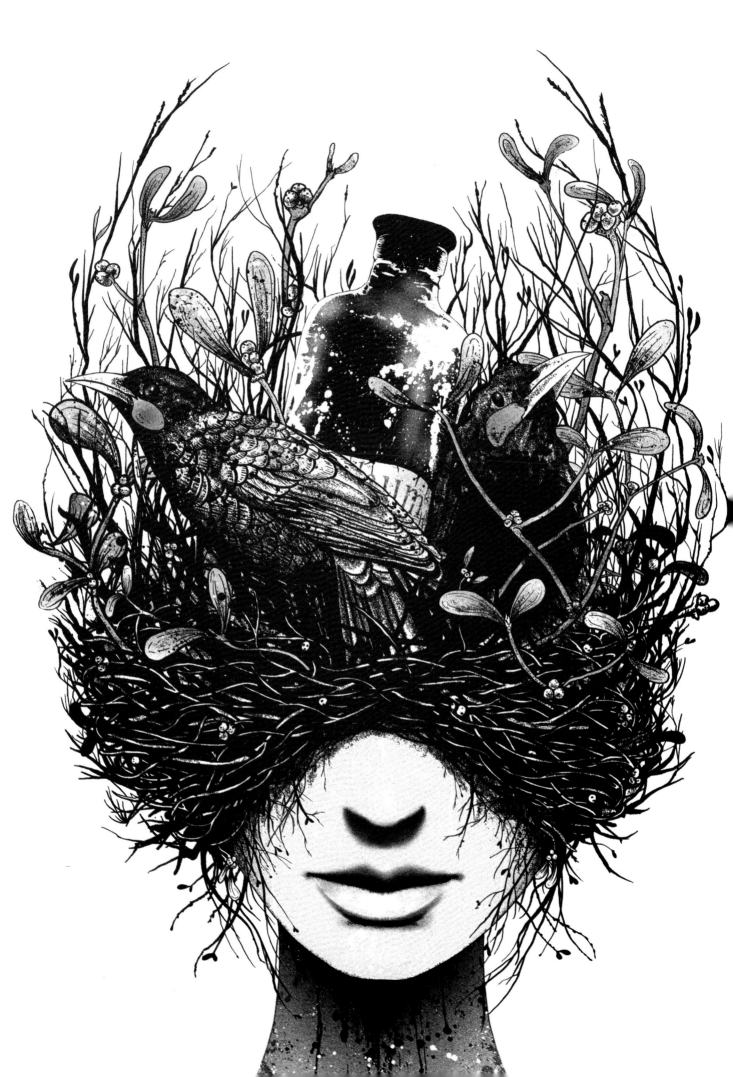

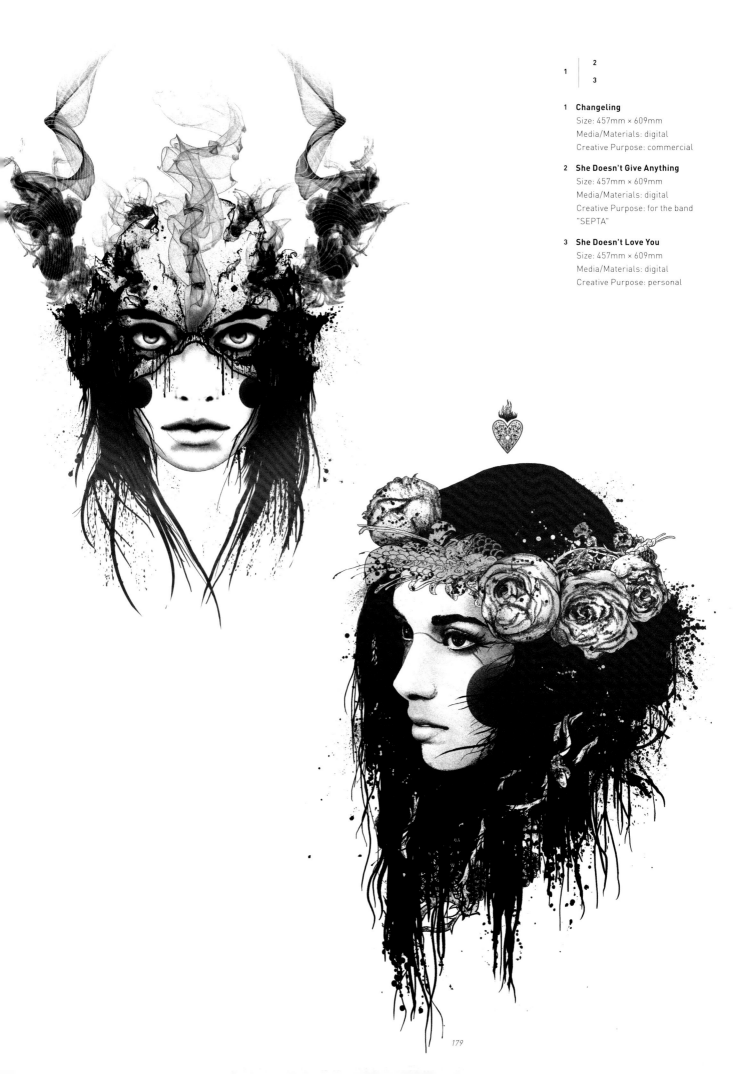

1 Changeling
Size: 457mm × 609mm
Media/Materials: digital
Creative Purpose: commercial

2 She Doesn't Give Anything
Size: 457mm × 609mm
Media/Materials: digital
Creative Purpose: for the band
"SEPTA"

3 She Doesn't Love You
Size: 457mm × 609mm
Media/Materials: digital
Creative Purpose: personal

MARK DEAN VECA

Nationality: America
markdeanveca.com

Mark Dean Veca lives and works in Los Angeles. He graduated with a BFA from the Otis Art Institute in Los Angeles in 1985. Veca has exhibited extensively in solo and group exhibitions both nationally and internationally. He received fellowships from The New York Foundation for the Arts in 1998, 2002 and 2008, The Pollock-Krasner Foundation in 2006, and a City of Los Angeles (C.O.L.A.) Grant in 2011. His work has been reviewed in numerous publications including *The New York Times*, *The Los Angeles Times*, *Time Out New York*, *Artforum*, *Art in America*, *Art Review*, *Juxtapoz*, and *Flash Art*.

Q: **Why did you choose lines as the expressional tools for your artworks?**
A: There is magic in creating the illusion of space, depth, and form using only simple lines.

Q: **Where do your inspirations come from? Can you tell us about some of your favorite artists?**
A: Some of my early influences were: Disney, Warner Brothers, *MAD* magazine, Underground comics and skateboard graphics. More current influences include: Ed Ruscha, Philip Guston, Franz Kline, Andy Warhol and Rick Griffin.

Q: **Could you give us some tips on how to draw beautiful lines? Does it take much practice and patience?**
A: Be confident, not hesitant. Does it take much practice and patience? The answer is yes.

Q: **How would you describe your works to the gallery, client, or potential buyers? How well do you think line art performs in the market, such as in galleries, and in the illustration market?**
A: I'd rather not answer this question.

1 **Klusterfuck**
Size: 490mm × 1,511mm
Media/Materials: India ink on paper
Creative Purpose: fine art

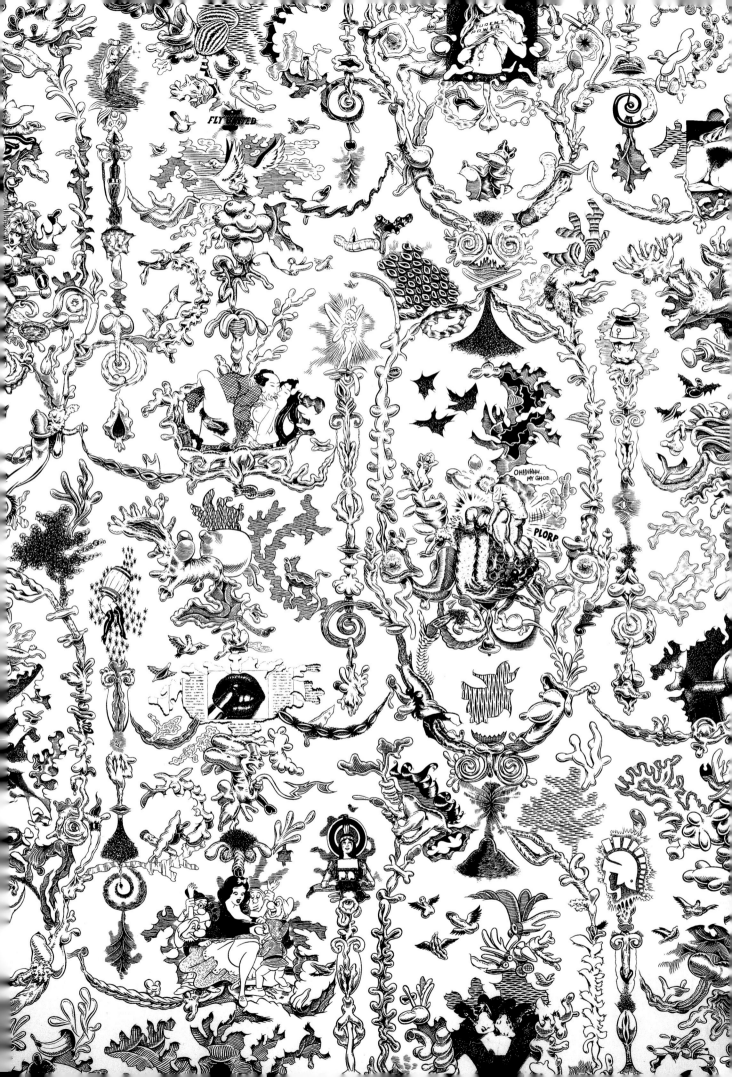

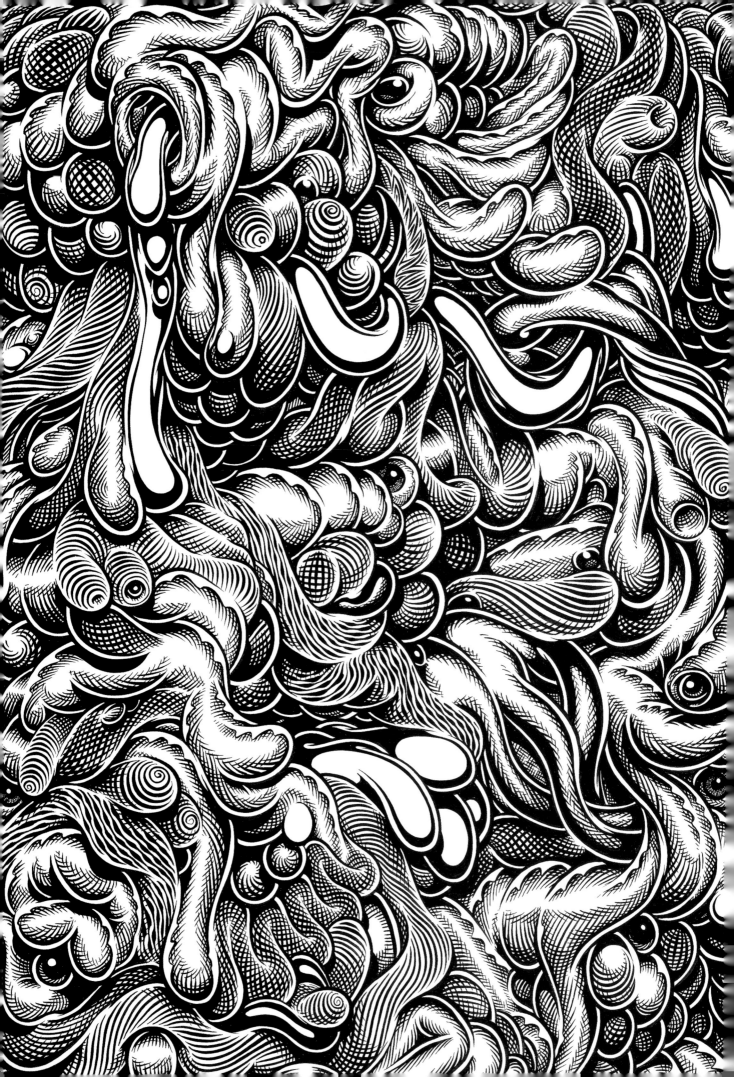

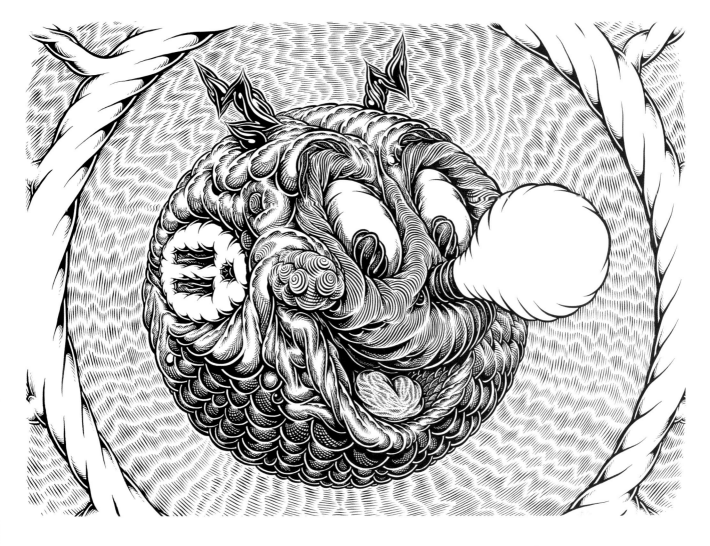

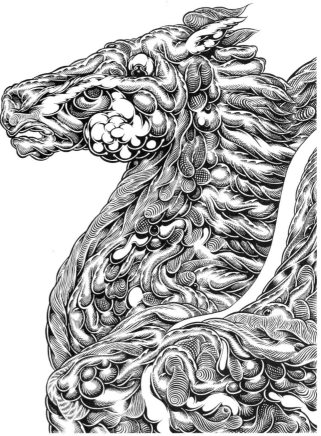

1 | **2**
| **3**

1 Pattern
Size: 560mm × 760mm
Media/Materials: acrylic on paper
Creative Purpose: fine art

2 Study for Reddy
Size: 760mm × 560mm
Media/Materials: India ink on paper
Creative Purpose: fine art

3 Study for Tailspin
Size: 560mm × 760mm
Media/Materials: India ink on paper
Creative Purpose: fine art

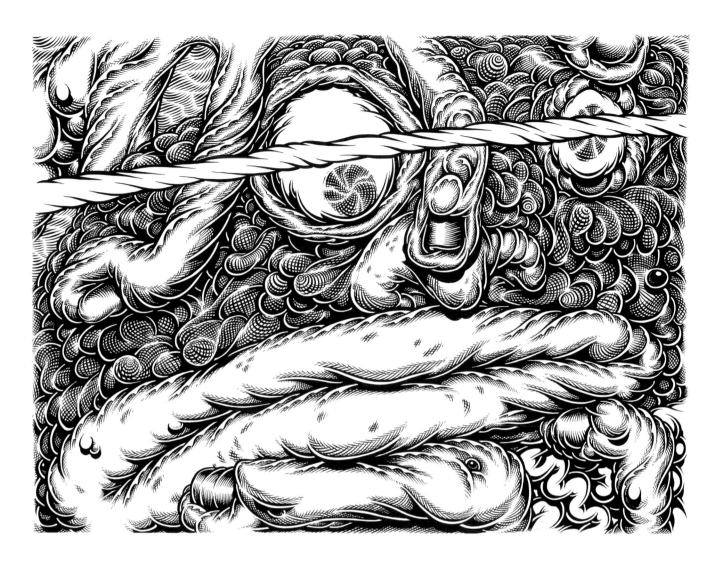

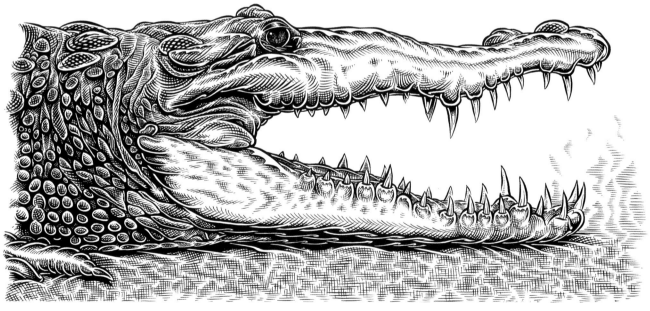

1	3	**1**	**Study for Bats Over**	**2**	**North American Crocodile**	**3**	**Study for Tweety**
2			Size: 760mm × 560mm		Size: 460mm × 250mm		Size: 560mm × 760mm
			Media/Materials: India ink on paper		Media/Materials: India ink on paper		Media/Materials: India ink on paper
			Creative Purpose: fine art		Creative Purpose: fine art		Creative Purpose: fine art

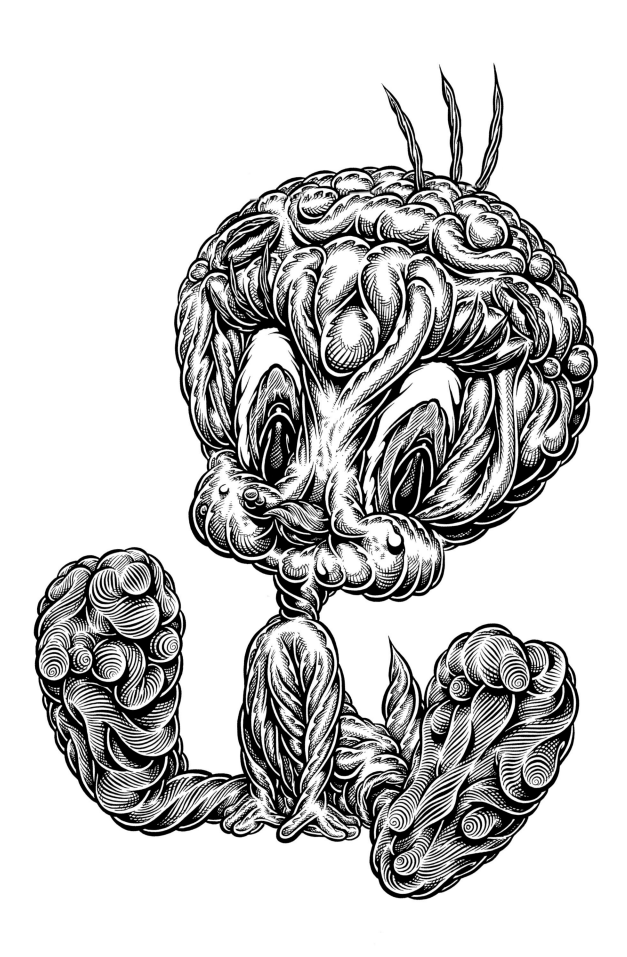

KELSEYZ

Nationality: Malaysia
troublexy.blogspot.com
behance.net/kelseyz
facebook.com/troublexy

Kelseyz (aka Troublexy) is an illustrator and artist based in Kuala Lumpur, Malaysia. Kelseyz is known for the high level of details she achieves using only a black pen. The result is a body of work made up of high-contrast manifestations of her wildly reimagining things happening around her.

The extremely bizarre and visually loud work of Kelseyz impresses even at a short glance. But put some time into breaking it down to smaller segments and you will see the many narratives that make up an entire world on a single piece of artwork.

Q: **Why did you choose lines as the expressional tools for your artworks?**

A: The strong passion I spend in the art of lines will always overtake other art styles. What I'm loving at line art is it always gives out more details and meaning.

Q: **Where do your inspirations come from? Can you tell us about some of your favorite artists?**

A: My inspirations come mostly from my travel, daily life, and different experiences while I grew up. Expressing a story in every piece of my art is the most important motivation for me.

My favorite artist is also the one who impresses, inspires me to start drawing line art from the beginning of my artist life. He is a famous Taiwan artist named Afu. His pieces of work always bring lovely and positive energy to people.

Q: **Could you give us some tips on how to draw beautiful lines? Does it take much practice and patience?**

A: I believe once you find the art style you like, the strong passion will guide you to practice with much patience on it, and you will not give up easily.

Q: **How would you describe your works to the gallery, client, or potential buyers? How well do you think line art performs in the market, such as in galleries, and in the illustration market?**

A: The clients who come to me always like my line art style, and I have crossed over with different businesses like bank and mural designs.

1 **Office Liar**
 (The different position and lies between boss and underlings)
 Size: 300mm × 420mm
 Media/Materials: Artline & marker on canvas
 Creative Purpose: fine art

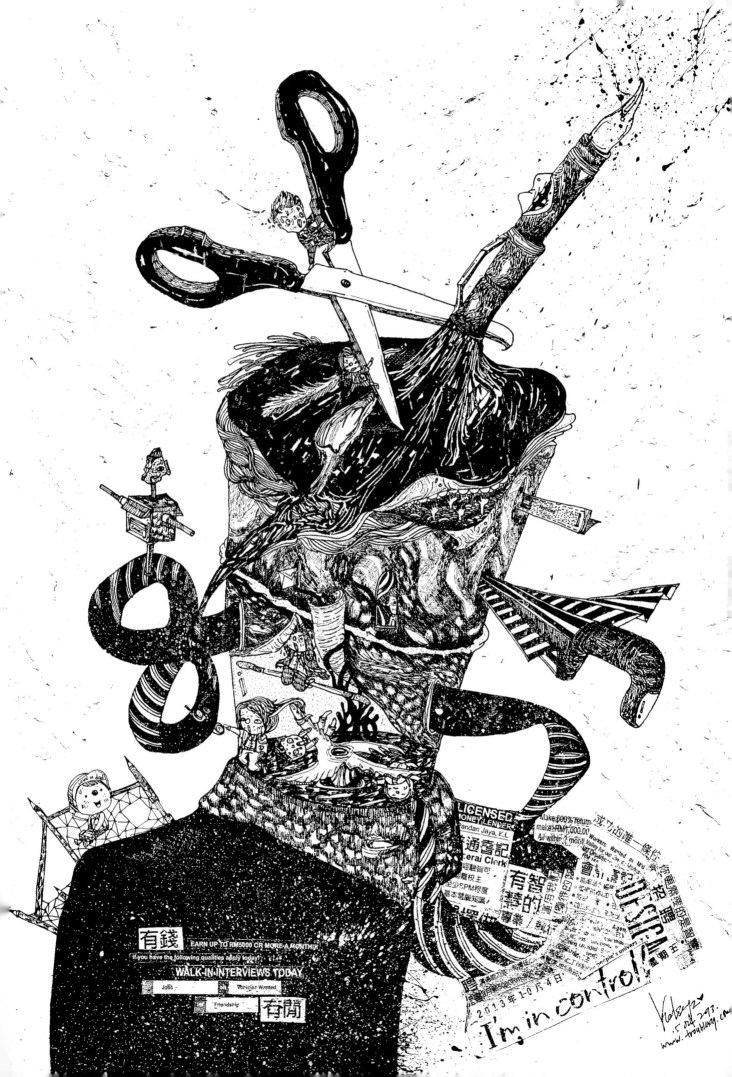

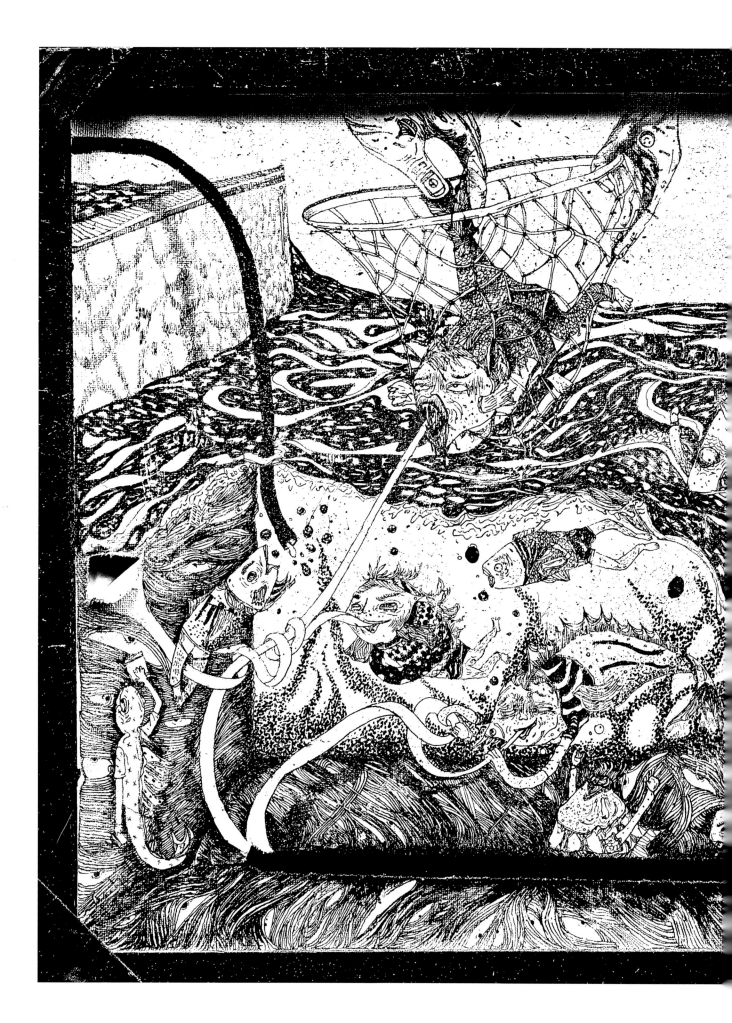

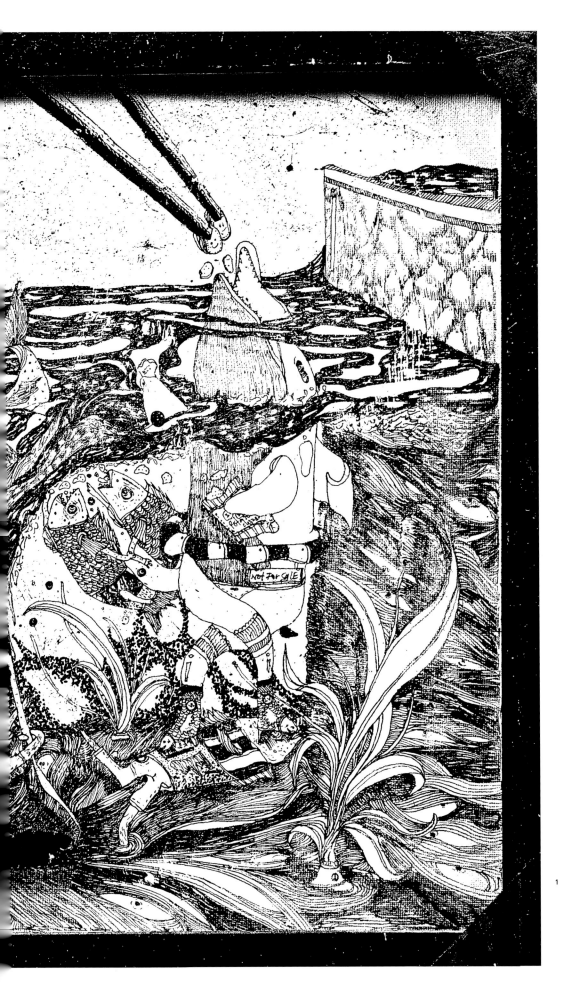

1 **Don't Eat Me**
 (Saving the life of a fish in
 restaurant)
 Size: 300mm × 420mm
 Media/Materials: Artline &
 marker on canvas
 Creative Purpose: fine art

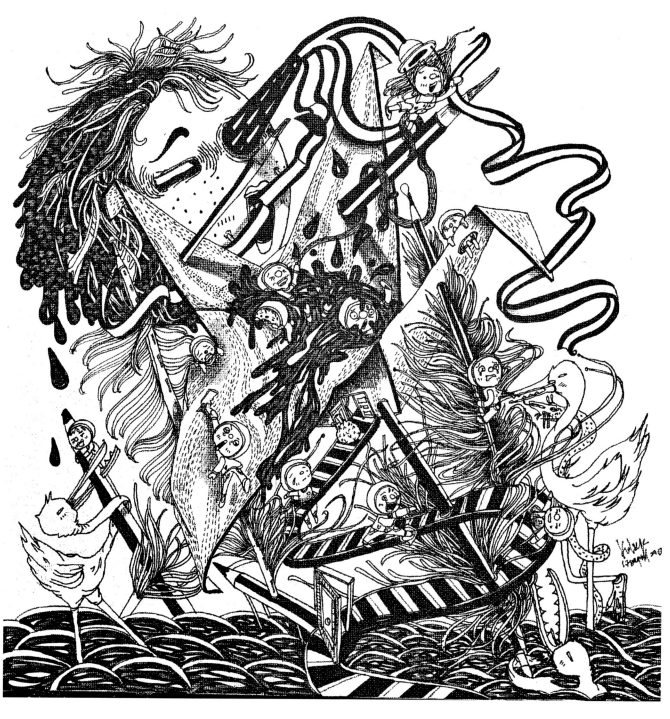

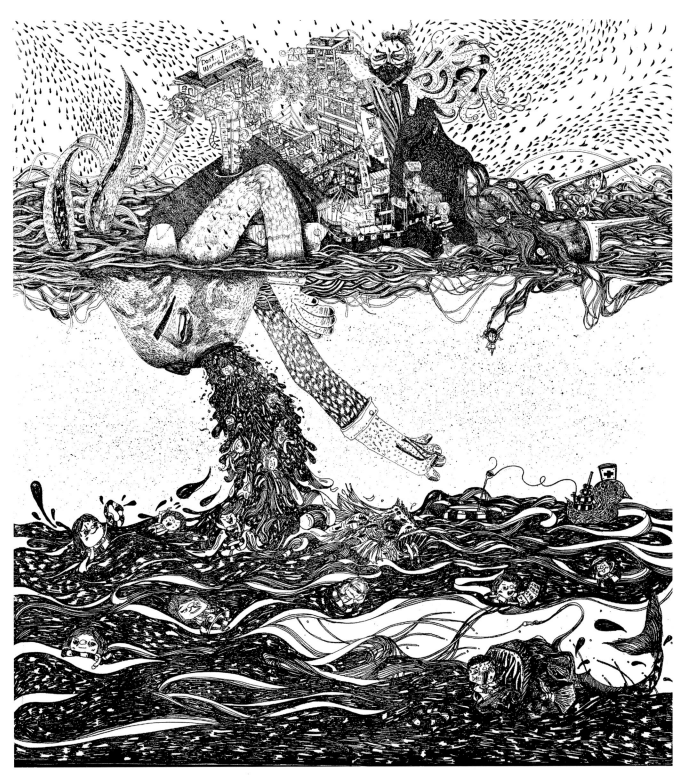

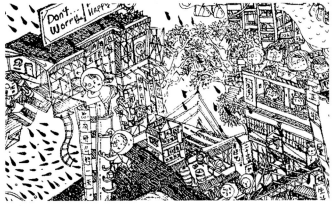

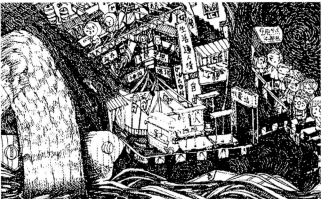

THE MAGIC OF LINES II: Line Illustrations By Global Artists

Author: Kuang Chu

Commissioning Editors: Guo Guang, Mang Yu, Chen Hao

English Editors: Jenny Qiu, Dora Ding

Copy Editor: Jimmy Nesbitt

Book Designer: Qiu Hong

First published in the United Kingdom in 2016 by CYPI PRESS

Add: 79 College Road, Harrow Middlesex, HA1 1BD, UK

Tel: +44 (0) 20 3178 7279

E-mail: sales@cypi.net editor@cypi.net

Website: www.cypi.net

ISBN: 978-1-908175-73-1

Printed in China